THE
ART WORLD
DEMYSTIFIED

How Artists Define and Achieve Their Goals

BRAINARD CAREY

ALLWORTH PRESS
NEW YORK

Allworth Press books may be purchased in bulk at special discounts for sales promotion, corporate gifts, fund-raising, or educational purposes. Special editions can also be created to specifications. For details, contact the Special Sales Department, Allworth Press, 307 West 36th Street, 11th Floor, New York, NY 10018 or info@skyhorsepublishing.com.

19 18 17 16 15 5 4 3 2 1

Published by Allworth Press, an imprint of Skyhorse Publishing, Inc. 307 West 36th Street, 11th Floor, New York, NY 10018.

Allworth Press® is a registered trademark of Skyhorse Publishing, Inc.®, a Delaware corporation.

www.allworth.com

Cover design by Mary Belibasakis
Cover photo credit: Brainard Carey

Library of Congress Cataloging-in-Publication Data is available on file.

Print ISBN: 978-1-62153-484-6

Ebook ISBN: 978-1-62153-494-5

Printed in the United States of America

Table of Contents

This book is dedicated to Shiva, my son.

Acknowledgments

This book was written with the encouragement and astute observation of Tad Crawford who solicited me to write the first volume, *Making It in the Art World*, and I am grateful for the deadlines he has been giving me ever since then. My wife and business partner, Delia Carey, is also a dreamer like me, and one of the dreams we have achieved is to do what we like and not work for a traditional boss. She is an entrepreneur like myself, and together we have built our art careers and the business of helping other artists through our website, www.theartworlddemystified.com. Conventional wisdom says you should not partner with your wife or husband in business matters, but for us, it has only helped our relationship. The fact is that after sixteen years we are still in love. We are lucky, as we are growing together and meeting challenges that are stimulating. We both feel that husband-and-wife collaborations can be rewarding on many levels.

Introduction

I am not a saint or a sage, or a marketing writer with a recipe for success. I am an artist and I have interviewed hundreds of other artists, curators, critics, and other members of the art world. What I know, they have taught me. As an artist myself, I have also learned a lot by asking for things and failing to get what I want. I have learned that asking is often the hardest part—asking for a show, asking for a grant, asking for support.

Full-Time Artist

I am an optimist, and you will probably find this book *motivating* because I am genuinely excited about the art world and the opportunities there are for artists and arts administrators. However, I also want to present a sober and serious look at the chances of earning a full-time living off of your art and the choices you will have in the context of the interviews I have done.

In all the interviews I have done (over three hundred as of 2016), there are some common threads as artists explain their failure and success stories and curators explain their methods. Here is a brief overview of what I have heard and what seems to point at the truth.

Luck

To begin with, there are some artists I talked to who succeeded very quickly—who at twenty-four years old won major prizes at shows, and continued to win major awards, getting prestigious teaching positions and gallery and museum exhibitions all over the world. In some cases, luck was involved—but the kind of luck that happens when you visit one hundred galleries asking if they are looking for artists.

There is rarely dumb luck, and most stories about luck and great opportunities are actually about persistence and not giving up—and then suddenly you meet someone by accident, and it is a meeting that changes your life.

This has happened to almost everyone, including the gallery owners and museum directors I have talked to. An example would be the artist who has been asking gallery after gallery for a show, and after months of rejection finds that her roommate is opening a gallery that then shows her work in the first show, launching her career. Those kinds of things happen all the time, but the failures that the artist was having and that her roommate was witnessing were also significant—and something you cannot force by replicating her failures. That is one the most complex aspects of building a career in art—how can you force the hand of luck? You can't, of course, but you can tilt the odds in your favor so that more

possibilities arise. You can see that this might mean you have to keep your day job until something better happens, because this is a process to be dedicated to—for life.

Day Job

Unlike most other careers that I can think of, art making is one that usually requires a second job. One that often relates to the art making, but not always. Traditionally, this is a good thing—have a job that doesn't demand too much of your time, and spend the rest of your free hours making art. Most of the artists I interviewed, but not all, had day jobs like teaching, painting portraits, being a doctor, or some other kind of work they might also enjoy. Some wanted to quit their day jobs, but most didn't, feeling it gave them freedom to explore in the studio without the financial pressure of having to sell their art every week or every month.

The wisdom of many artists on the day job is that it should not be viewed as a negative aspect of your life, but one that must be adjusted correctly to support yourself enough so there is still time to make art. It does not mean that you should not aspire to be whatever kind of artist you like, as well as to the large financial gains of which you might dream, but that the day job should not be seen as a measure of your success. Pure success for an artist means making work in the studio on a regular and ongoing basis that is always changing and rewarding to the artist in terms of aesthetics and challenges.

How much you earn does not determine your success as an artist at all. We know this is the case from the hundreds of artists from history who were not financially successful at all

in their lifetime, but ended up in the history books because their work is good—or great—and has some real aesthetic value that can still be enjoyed.

So whatever your day job is or is not, be proud that it is the sponsor of your art career and that you are following the path that artists have taken for hundreds of years. Does this mean that if you simply make good work, the world will eventually notice it?

Meritocracy

If you simply strive to make good work, you are doing your job as a professional artist. If, however, you feel that the quality of work alone will "rise to the top" so to speak, and that by merit alone you will find professional opportunities, you will be disappointed. In this day and age, excellent work is needed and required, but not alone. You will need the support of your

peers, a good dose of networking, some charm, and the ability to write.

This is the third book I have written for artists to develop their careers in a professional manner. More resources are online at www.theartworddemystified.com. The difference between this book and the other two, *Making It in the Art World* and *New Markets for Artists,* is that this book focuses primarily on demystifying the terms and ideas about what the "art world" actually is and how it functions. There is also a great deal of practical advice and clear directions in this book to build your professional career as an artist; essentially this book was written to clarify misconceptions that can burden an artist and drag them down by simply being mysterious.

This book also contains interviews with artists and curators that help define how their careers are managed. Their words and advice are valuable in the sense that they give a direct view into the lives of professionals in the art world. In the past two books, I was using my experience in the art world to write from my particular perspective as an artist, and in this book, I am looking at the perspectives of others in the art world. This book features interviews from my Yale radio show, *The Lives of the Artists, Architects, Curators and More*, and you will hear some of the world greatest curators, writers, and artists talk about the art world from their own perspective. In chapter one we begin with an interview with Robert Storr that dives right into the depths of art criticism and how a Master of Fine Arts degree might influence your career. Then there is an interview with John Currin, who explains his rise to being an art star and a record-breaking-selling painter. Currin explains

his early frustrations, the nature of his struggle, and the way he got his first show and pushed himself to network. There are several more interviews throughout the text, and I hope you find them as inspiring and interesting as I do.

Chapter 1

Perspectives on the Art World

There are two opposing views on how to navigate the art world. One view, which I have articulated in different forms, is a corporate-type structure where networking, an elevator pitch, and meeting the right people is what it takes to reach success. Depending on your point of view, that is either a good path or a bad one. For many students graduating with a Master in Fine Arts, or another degree, this is precisely the path they want to be on. It is also the path for all the artists who want to earn a full-time living, or something close to it, from their art. The desire to make money is not a bad thing of course, but it gets complicated when applied to the art-making process.

The other view of navigating the art world is one of exploration and investigation into life itself, and money may or may not play a major role in your success—which is defined

differently in this case. It is art for art's sake, for the sake of making it and the pleasure the artist gets from that—supported by a second job or a day job, if you will. Most artists and curators that I have talked to—highly successful ones—say that art making should not be about money first, because that can distract you from making great work that might be disturbing or confounding to the viewer. Can you do both? Yes, there are many examples of that, but you must understand the traps of the market combined with the pursuit of profits.

Making Money

In most cases, the reason artists want shows and success is because they want love and attention. They want good reviews, and they want buyers who admire their genius and talent. That is a very different goal than the businessperson who wants to make millions. You don't know the names of most hedge-fund managers because they are not interested in fame, they are interested in money and they do not equate it with self-worth.

However, an artist who is looking for attention, love, fame, and ego satisfaction, encounters what appear to be endless cruelties. There is the bad review, the show that doesn't sell, the collector that returns work, or a negative comment that is obsessed over. All of these elements, familiar to any artist, can send some into a tailspin of sadness and depression, because instead of receiving love and praise for their art, the opposite seems to have happened. The psychological pain from this is acute, because the goal of wanting love and attention has been reversed, and now it is easy to think that in fact your art is not likeable or lovable, and since you made it, it follows that

that applies to yourself as well. It becomes a dark day indeed!
This is a feeling that you will recognize immediately if you are

an artist reading this book. Can you withstand these slings and arrows throughout your career? Have you done so successfully already?

This approach to art making is the first model, and in this book, the explanation of terms and the interviews will help you to navigate those rough waters, but it is essential that you take the larger perspective and recognize the size of your task and the psychology of your need to exhibit.

When taking those things into account, you can seek out support and guidance from books like this and from your peers. It will help you to see a larger view of yourself and your internal struggles so you can better manage them.

The first model is to have a day job, and to make art because you want to and need to, but not to make a pile of money or even exhibit regularly. The second model is about meeting people and making the right connections—in a word, networking. This is the model I use and find success with regularly. I will talk about the second model after the following interview with art critic Robert Storr.

The Art Critic

Of all the figures in the art world, the critic is probably the most controversial. What is a critic for and why do we need them? What is the role of criticism? I have interviewed several critics, some more well known than others, but Robert Storr is one critic that is not only an artist himself, but is also the Dean of the Yale School of Art, was a curator at the Museum of Modern Art, and has written extensively about artists. In this interview, he tells us two very valuable things: his opinions on current art critics, and his views on art education—in

particular the Master of Fine Arts degree and what he feels it takes to survive as an artist. He is actually using both methods—he is an artist that has not sought the market for his own work, yet he has extraordinary connections that have helped his professional career. He is very frank about other critics and is one of the few people who can give a unique perspective on how art is seen and digested by critics and the public.

The Interview

Carey: *I think I'd like to talk about the role of the critic. I've interviewed the late Arthur Danto, Barry Schwabsky, Dave Hickey—they all have a pretty varying idea of what it is that a critic does. What's your perspective on the role of the critic?*

Storr: I think there are many different genres of criticism for starters, and there are different audiences for criticism. And I think the first choice a writer who wants to write about art has to make is decide for whom or about what they would like to write because there's no one-size-fits-all definition of what a critic does.

Arthur Danto was basically a philosopher who wandered into criticism because his wife was an artist and he was interested in the visual arts. He was intermittently a very good critic and often really way off base because the undertow of philosophy and the desire to make sweeping statements was just too great to resist.

Dave Hickey is a very able essay writer who is actually not a very good art critic at all and has devolved from being an interesting spoiler in the context of the art world to being a tea partier, basically. He mobilizes resentment against arts

and he mobilizes people's sense that it's all a rigged game and plays off on that to give himself a reputation as an outsider—but he's an outsider with a PhD in English literature. He is not a tough Texan—he's a kid from Fort Worth and he's created this persona which is actually an artfully constructed persona, but he's not at all what he pretends to be.

He loves to go after academics and curators and assume that they're all, you know, sold out and so on but he's the guy with the PhD, not me. And he's the guy who has advised Steve Winn and he's not known as a great Medici. And in the meantime, he's actually not very good about art. He wrote a whole long essay about Larry Pittman without mentioning Larry is half-Hispanic and gay, which is an awfully big thing to miss when you look at the work. So he's another type.

Barry Schwabsky is a poet and a successful poet, a good poet. I would say he belongs to a belletristic type of criticism and he's terrific. At least he's written nice things about me so what can I say? I mean as a painter, but you know, there are all kinds of critics.

The theoreticians Hal Foster and Benjamin Buchloh, and so on—I think they have a lot of problems, as does Dave Hickey with actual art history. They know almost none. They're technically art historians academically but they know very little art history. They've done very little primary research. They don't know history very well because they read theory about history but they don't read history.

So they will write articles predicated on certain sweeping generalizations about the 1930s in Europe and then apply them without any adjustments to circumstances which are not those. I admire all of the Frankfurt people but I don't think

the American version of French theory or a Frankfurt school in contemporary art criticism is of much use to anybody. [Laughs] That's being a critic of critics!

Carey: *Understanding the different roles is helpful to a lot of people. And then there's someone like Jerry Saltz and Roberta Smith who write for* New York *magazine and the* New York Times, *respectively.*

Storr: Jerry is appalling. He's the class clown. He is somebody I've known a long time, since Chicago days, and he's turned into a travesty. And the idea that he should be running around being the conscience of the art world and at the same time playing the game of the art TV show that he did—and that he should be championing women and then dissing the first African American woman curator to do SITE Santa Fe. All these things are about Jerry, long and short. And about Roberta, it's all about Roberta, long and short—and it's too bad because they are punchy writers and again, they draw interest because of the contrariness, but there are no principles, and they're not fighting long term battles for anything and never have.

Carey: *And how does that figure in with these other schools of criticism? I mean, Jerry, he's also achieved this popularity that's . . .*

Storr: He's playing to the peanut gallery. He's playing to an audience that actually doesn't know about art, that doesn't really like art. Roberta's the same way. I mean, she's writing

for the *New York Times* and she's writing insider writing for outsiders. If you read her criticism carefully, and I have for very a long time, she's constantly playing into myriad battles about the art world—who's in, who's out, and who she has a grudge against—but she's publishing it as if it was information that everybody needed to know, does know, etc., which it's not.

If she would write about the art right in front of her, if she would suspend her own sense of self-importance long enough to really give more attention to the complexities of being an artist, she'd write better, and Jerry the same.

Carey: *But that's not going happen because that's part of how they . . .*

Storr: Because they get paid for it.

Carey: *I suppose that has something to do with where journalism about art is today.*

Storr: Journalism now is at the lowest it has ever been. There was a time in the fifties when you had [Clement] Greenberg who was an empire builder but a very gifted one, and Fairfield Porter, Donald Judd. Bob Morris. A lot of people were writing a lot of stuff that is still worth reading, you know, and I can't imagine how much of this stuff anybody will read ten years now. Mostly, you can't read it a week after it's published.

Carey: *And why is that? What's happening? Is it kind of the dumbing-down of journalism? I was talking to a reporter not*

long ago who was saying everything is about comments now. It's about how many comments you can get in an article, and the way that you get comments is by saying something inflammatory, and has this affected the art world and critics, too.

Storr: Totally, it is like critics have gotten confused about the issue of what their role is. I mean, they're there not just to admire or just to observe but they're there to weigh and think and look better than the average person in order that the average person can be tested and [then] do better themselves, right?

So if you set a model of what it means to look hard at something, think a while about it before you open your mouth, and then articulate it carefully—you will have done your job as a critic and then you can write about anything you want.

There are many critics I read with whom I fundamentally disagree, but I always learn from them. But today it's about instant response. It's about the number of likes you get on your Facebook page. It's all about the ego popularity presence

of the critic. And frankly, none of these people are interesting enough to really merit being a presence overall.

Carey: *So is there a way out of that? What is the future of writing? It seems that we're devolving into this kind of popularity contest. What's the hope for that?*

Storr: Charlie Finch was the pioneer of this kind of vanity criticism and spoiling criticism. And, you know, does anybody read Charlie Finch? Now? No. Does he even write? No. What's the future for it? Not much.

I'm a craftsman; I may have many faults and I'm sure I do, but I'm a craftsman, and I work very hard at writing well and I work very hard at looking before I write. And I do homework and I listen to artists and I do everything I think I need to do before I sit down and deliver an opinion that I hope would be thought about, not agreed with.

One of the people I greatly admire, Virgil Thomson, was a composer and critic and he wrote for the old *Herald Tribune*, and he wrote something I think is my motto. He said, "Never overestimate the information base of your reader and never underestimate their intelligence," and most of the people we're talking about do both—but backwards.

Carey: *Are there other critics that you admire who are walking that road?*

Storr: There are a lot of people that I read. I used to read Peter Schjeldahl with much more interest than I do now because I think he's burned out. I like Christian Viveros-Fauné, who, I

think, is actually trying hard to write a principled criticism. Martha Schwendener I like reading. I really admire Holland Cotter, he's doing a very good job. Mike Brenson tried to do the same thing at the *Times* but he was basically driven out. Chris Knight in Los Angeles.

Carey: *Let's talk about the academic environment, why does an artist need to go to school? What is the importance of that? And I know that some of these are obvious questions, and you can take this anywhere, but a school like Yale, the MFA program in particular, in one sense carries this kind of mythic weight in the art world—and then there's plenty of artists that come from Yale that don't move on to mythic careers.*

Storr: Most artist don't move on to mythic careers and the importance of getting an arts education is not measured by the fame index. To be able to sustain yourself making your work over a lifetime is an achievement in and of itself. It's very hard to do. To become a good teacher of art is very hard to do. To gain enough from your work, from all angles, to be able to do it properly is very important in and of itself.

The fame factor is very disturbing, right. Some people got fame very early. Jasper Johns got it very, very early, relatively. Frank Stella got it even earlier.

Jasper has been famous since 1957. It's a long time, and to stay on top for that long is a very hard thing to do. Most people don't, most people have a relatively short run and many of those people have very short runs early, and the ability to stay in the game, to make good work, to hold your head up and so on and so forth, it's a real accomplishment and I think—to

go back to your initial question—one of the things is that in art school you meet a certain cohort of your contemporaries and very often they become very important people for the rest of your life. And it's not like college alumni buddies in other fields.

It is a group where the struggles and the difficulties that you face are shared in certain ways. These people are often more reliable as friends later on.

Carey: *So you are talking about peers, classmates at school.*

Storr: Yes. I think most good arts schools are distinguished by the dynamic among the students, and the teaching is secondary. The schools that are fostering energy among the students are, in a way, yielding to them in letting them do it themselves—those are the great schools. And often they don't have great teachers or sometimes they have one or two great teachers.

Carey: *But that also assumes that they're going to get together afterwards, which seems is beyond the school and may or may not happen. When I interviewed John Currin, he told me he graduated, making paintings that nobody particularly liked and he was painting houses and at one point four years out of school thought, what am I doing? He's crying on the scaffold thinking, I'm wasting my time, and he did essentially what you're saying—called up some friends from school, started meeting regularly and saying, "How can we help each other out here?" But that wasn't something that was even fostered by the school, really.*

Storr: It's because you create a situation where these bonds can grow, right. Of course it depends on the individuals and John's story is actually a fairly common story and I think that the people who go the course often find themselves in situations like that.

Before I came to Yale, I did this as an experiment: What was it that students made here before they made the works for which they're known? Nancy Graves was making Braque-like paintings and Chuck Close was making kind of Claes Oldenberg paintings.

Once when I did my first dean's talk here I put a drawing on the screen. It was a drawing of a kind of a lumpy, middle-aged woman, standard, you know, life-drawing class kind of thing. And at one point one of the female faculty members said, "Why do you have this nude woman up on the screen?" I said, "I'll explain in a minute." And at the end I said, "Okay, this is a drawing by Eva Hesse." So first, it was the female gaze on a nude woman, not the male gaze. Secondly, it was a drawing nobody would have pegged as an Eva Hesse drawing, but it allowed you to see the enormous leaps that she took while she was here, and she was one of Josef Albers's favorite students.

Now, she took those leaps while she was here and that gave her the ability to leap altogether when she left here with Tom Doyle and went to Germany. She took a series of major leaps so that when she came back—she had a very short life, you know, she died when she was thirty-four years old—she crammed more really serious art making into just a few years than anybody I know other than Félix González-Torres. I think it's the kind of sense of seriousness of vocation and the

risk-taking that needs to be done that occurred here that made that possible.

Carey: *That makes sense and, of course, those are success stories and then there's the stories you hear that I think Robert Gober touched on a few years ago when he gave a talk here at Yale. As he put it just kind of blatantly, he said, "You know, a lot of my assistants come from the MFA program and as far as I'm concerned it fucked them up. They can't make work now." Now this is not the case for everyone, but there is a phenomena where people get out of MFAs and I don't know whether it's not being able to withstand crits, but some students feel that they can't produce work after that.*

Storr: I don't want to sound like a social Darwinist, but if they can't, then they're not made for this profession. People have got to have a kind of need to do it. And they have to have, not

self-confidence as a sense of knowing they will succeed, but a fearlessness about the possibility of failure. Franz Kline once said, "The artist is different from people because they have a higher tolerance for embarrassment." People who come to programs like this and think only in terms of success and don't think about failure are really ducking the issues, right?

How do you deal with failure? What do you with failure? How do you retool failure to turn it into something else? How do you just withstand the emotional strain? I've had a lot of failures in my life and that's why I'm tough and that's why I'm still at it. I think a lot of kids now are hothouse flowers. They come through very high-powered programs in secondary school and college and then they arrive and they just think they're going to continue succeeding. It's not like that. It's not like another profession where you can sort of get on the escalator and just go up.

Carey: *It's so complex because of that, and I understand that as an artist and writer myself, but is that part of what they're learning here at Yale—how to manage failure? How to retool failure? Even the emotional stress of what that means to someone?*

Storr: There was a kid who was here, a few years ago. He was an Asian man. He was gay. He came from the South and he made work that was, I thought, quite interesting but many people did not. And there was a very famous gay photographer who was in the room and who took him apart, really took him apart. And did so from a position of an older gay artist saying this is not the way to deal with these issues—and

he did it, I think, out of sincere regard for the guy but it was really rough and I cringed, you know, partly because I kind of liked some of his work more than the other person did.

I saw the student a couple of days later and I asked him, "How are you doing?" And he kind of had this wonderful plucky attitude and he clearly didn't get wounded—anybody would have been wounded, but he had that ingredient. He had what it takes to bounce back. What it is, is hard to say, but you know who's got it and who doesn't. Some people do it by grinning and bearing it, some people do it by smiling through the disaster—he's more of the smiling-through-the-disaster type—but there are people who are just not going to stop and you can feel it and you know it. And they are the ones who become artists.

Carey: *In conclusion, you've done an awful lot in the art world. You're an artist yourself, a writer and critic and commissioner/ curator of the Venice Biennial and, of course, this is your sec- ond term as Dean—what's next for you? Those seem like peaks in the art world for an academic, for an artist, for a critic. I can't imagine doing more, but what would be next?*

Storr: I'm going to do what I started out to do, which was to make my own paintings. Most of the jobs that I have had, I did not compete for, they are things that people asked me to do, they were jobs I did because I needed to make a living to support my family. So now that I'm kind of at the age where I have enough money tucked away, I don't have much else to do professionally, I'm just going to make my paintings. See how we go from being a quite well-known curator and critic

to being a totally unknown painter and I'm really going to like it a lot.

Carey: *So let's just hear a little bit about what's happening in your paintings. You've been consistently painting, haven't you?*

Storr: I've painted always, though very little in recent years. I've done some print making. I've never, ever said I was not an artist or stopped being an artist because I know the minute you turn the switch off that way—you're done. Inside, you're done. So I'm always giving myself projects to do and I went to Yaddo—and I spent half the day writing a catalogue and half the day making drawings. I've been giving those drawings to benefit auctions ever since. There's not a lot of work of that type but there's enough so that I can work and say, "Yeah, this has got something going for it." And so now I'm just going to go in the studio and make lots more. We'll see.

Carey: *Drawings?*

Storr: Those are drawings but I'm a painter, basically.

Carey: *And what do they look like now?*

Storr: Abstract, geometric paintings on paper. Once upon a time, I was a realist painter, an observational kind of new realist type. I was a big admirer and now still am a very good friend of Philip Pearlstein, friend of Alex Katz, admirer of Katz. So that was my neighborhood for a while but I just decided I didn't want to do that much describing so I was

much more interested in the spaces in the paintings than I was in the things that occupied them, so I shifted over. We'll see, who knows, maybe I'll come out wild and wooly and do something else.

Carey: *We'll look forward to that!*

The Other Path, the Other Way

Before that interview, I wrote that there are basically two ways of navigating the world as an artist: networking for pleasure and profit versus the less aggressive art making with fewer exhibits. The first, which is more aligned with a corporate structure as I see it, is what Mr. Storr was articulating here. It is the most common model because it is about making a living from your art in most cases. It is about networking with peers and others who can help you. It is about being able to withstand the critiques of your artwork and to continue to make more.

There are always exceptions to this rule, of course. Robert Storr might be one of them; perhaps because of his intellect and his ability to write, he never competed for a job because it was always offered to him, and he took it to support his family. Other exceptions might be writers like Gore Vidal, who did not do much self-promotion of any kind but found himself in a very successful position.

But in the majority of cases, most artists follow the path that Mr. Storr articulates, that is, they find ways to meet people that might help them with more opportunities, like exhibits, studio visits, and other ways to get artwork out in the public. We will get to specific tactics soon, but first is an interview I

did with John Currin, who is one of the most successful artists today, with paintings selling in the high six-figure range. He is a figurative painter, does not paint what is popular, and has not turned his practice into a more conceptual mode; he is simply making the paintings he wants to make and has met with criticism as well as great success with the subject matter he has chosen. In the interview with Robert Storr, when I mention this interview and how John Currin worked with his friends to build his career, Storr said his story was a common one—that is, gathering support from your peers can be a key to success and what it means to "network" within the art world.

The Interview

Carey: *You gave a lecture recently and talked about living in Hoboken when you graduated school. That's where you had your first studio and were living, is that the case?*

Currin: Yes, I was sharing it with Lisa Yuskavage and Matvey Levenstein. I think they hadn't married yet but they were living together there, and they're the ones who first got a place because I stuck around painting houses for a year. They moved out there. They had a room, so it got me out of New Haven, although it wasn't exactly New York City, but I could see New York City from my studio so that was the good part and the bad part, I guess.

Carey: *So you were you doing house painting—how did you get your first show? You're an artist, you're in Hoboken, you can see New York, what were you doing to try to get a show? How did the first one come about?*

Currin: Well, I didn't get a show when I was out there. Lisa and Matvey looked at my work and we kind of starved and starved and froze together there. All of my other friends had moved to Manhattan, to the Lower East Side and I was painting a house one day and, you know, literally had tears rolling down my cheeks on the top of the ladder. I'm thinking like, "What have I done? I'm such a loser." I remember looking into a *Village Voice* and getting a sublet on Ludlow Street and when I moved there I was sort of hanging out with people and I guess maybe Julian Pretto, who was an art dealer, and he's the first art dealer to come to my studio ever.

Carey: *That was your first studio visit in Manhattan?*

Currin: Yes, I think so, he came to my studio and I don't know if he was interested or whatever but he told Bill Arning who

was running White Columns to come over. So I got to sort of jump the line of kids waiting to have him come over and I got a show at White Columns.

Also, there was a kind of crummy gallery that took a bunch of my paintings, you now, the crummy Broadway gallery. And then when I got the thing at White Columns, Bill said, "I'll give you a show at White Columns if you don't do a show at that gallery."

So my friend, Sean Landers, and I kind of did a commando raid on the gallery, we just kind of showed up at the back of the gallery and broke into it and walked into the back and took all my paintings out. So that's how I got my first show.

Carey: *And you remember how Julian Pretto came to you at the studio? How were you getting people in the studio at that time?*

Currin: I think probably because I was a good-looking guy and Julian liked good-looking guys. I mean, I think that was part of it and just being in the cohort of people that kind of knew him. You know, it was really just a kind of a social thing actually.

It was going to parties and going to openings and kind of standing around and hanging with your friends and then you end up knowing more and more people. Just kind of like that. I met Andrea Rosen at that time through that same circle of people.

Carey: *So tell me a little bit about that, you had the show at White Columns which was really your first show in the art*

world and that's a great space. Bill Arning's a really good guy. How did that show go? That was before you had any other gallery shows in the city, is that correct?

Currin: Yeah. I had been doing paintings, more joke paintings. Kind of all over the place and every painting in a different style and which—actually, it was kind of a good thing when I had that studio because it was entertaining, I think, for the people who came over just to see these kinds of stupid, different, silly paintings—but actually when I got that show at White Columns, I decided to do like five paintings of the same style and those were those ones I did from my high school yearbook.

I kind of decided to play it really straight with those and just to see what would happen if I made kind of anonymous-looking paintings rather than super goofy-looking ones. They turned out to be more interesting, and weirder than anything I had been doing. I think they got noticed when I did that show—it was a great response and I sold them. I sold paintings. For the first time I started making a little bit of money.

Carey: *You sold them through White Columns, which is kind of unusual because they don't really sell work there, it's a non-profit space.*

Currin: I think it was a place where younger collectors would go and buy things. It certainly got you exposed to art collectors. I think Andrea Rosen probably was helping. She didn't have a gallery yet, but I think she sent people over and arranged a whole lot of sales. It was only five paintings, and

they were really cheap, but it was probably her doing more than anything.

Carey: *Somehow she was helping or suggesting to collectors to buy work there and White Columns wasn't taking a percentage?*

Currin: Well, no. I think they did take a commission. I can't remember. It was like $1,300, you know what I mean. I was so excited to be selling something that it didn't matter to me. Then I had a show about a year later at Andrea Rosen's, and that went really well, too.

Carey: *That was one of her first shows obviously.*

Currin: She opened up in SoHo and started with Félix González-Torres, who immediately became a big star. That got the gallery a lot of attention and it meant that when I had a show there, it was a place people walked into. I started selling paintings and I could get off of the ladder and get out of the house-painting jobs.

Carey: *Can you tell me a little bit what a studio visit is like? When you had your first studio visit, how did that go? People are coming in now, looking at your work, that's kind of difficult for a lot of artists. How did you manage that or handle that?*

Currin: I would say that—to give a sort of plug to Yale—it helped for me to try to make funny paintings that would be easy to talk about, which I guess sounds cynical but it wasn't. I

enjoyed it. I wasn't nervous about it. I think it was just because from just so much of the talk, talk, talk at Yale it seemed pretty easy. And I just felt really excited that somebody was there. I mean, I've had some studio visits that people just didn't like, but see, again, after Yale I was used to that.

Carey: *How did you manage that? That's also an interesting thing to talk about because that's difficult for artists. You do a studio visit, people don't like the work.*

Currin: Or worse, somebody buys, somebody takes something to their house—this happened once—somebody took a painting to their house and then called me like a week later and I had to go get it. They didn't want it and I had to go up there and take a cab back with my painting in my lap. It was really humiliating but, you know, that didn't happen that much.

One time I had to meet Andrea Rosen and this art collector for lunch, right around that time, in a really expensive restaurant. I was really excited to be taken to lunch by the collector and everything. It was a really expensive restaurant, and lunch was over and neither of them had a credit card and I had to pay. It was like a week's earnings. I had to pay for the lunch! But generally there were no terrible experiences that way.

I was just happy to be an artist again, to have people, to have a studio, you know, such as it was. With a futon in the corner but people were coming to see work.

Carey: *John, that's an amazing story. They take you out to a beautiful lunch and they don't have credit cards. How do you account for that?*

Currin: You know even one of them was like, "I don't carry any cash." So it's like, you know, but imagine it's like the movie scene where the girl ends up doing porn or something instead of the modeling shoot and that was my really low-key version of that, I guess.

Carey: *Were you showing with Andrea then or that was before that?*

Currin: I don't think I was officially showing with Andrea but I kind of was. Like—that's another thing, it never was really like an official thing, it just sort of became the norm that I showed there.

Carey: *So she never said to you at one point, "You are now represented," or anything like that?*

Currin: We were boyfriend and girlfriend for like a year and a half and so it kind of happened like that. Then we broke up but I still showed there. We were still friends and everything, so I kind of slept my way into the art world, I guess.

I imagine for young artists it's a lot more official now when you get taken on or when you join a gallery. It's kind of a big deal, but there really wasn't anything official in any of my dealings, there wasn't. Later on there was, but not then.

Carey: *That sounds a bit official. The dealer became your girlfriend, right?*

Currin: She wasn't a dealer at the time but she became one—it's more like she became my girlfriend and then, lucky for me,

she became an art dealer with a really good gallery. So it was a lucky thing that way, but I knew her anyway.

Carey: *You were out there looking for friends though, so to speak.*

Currin: I'll bet if you're a pretty good artist, people are hungry for that, and if you sort of hang out and nurse your drink all night—I think it's the way you get noticed—people will notice you if you're good.

Carey: *People also have to come to your studio first. So you're nursing a drink all night—people are wondering where to go to nurse those drinks and who to invite to their studio. That's kind of a key. I mean in a way things may happen naturally, socially, but you're after something and you're trying to go to places where there are interesting people to talk to.*

Currin: Well, I also met a lot of different artists. That was another thing—that was most of what my studio was—there were just other artists coming over. They were my core group of friends that would come everyday because we all lived in the same neighborhood.

I kind of remember a guy named John who became a friend. He was a writer at the time for art magazines that don't exist now, but he came over and then that's probably how Julian Pretto came over, it was through John.

Julian Pretto was the first real art dealer and he had a little gallery that showed a lot of young art. I never showed there but it was like you talked to people, and it was very casual,

but it worked. I don't want to make myself out to be like Patti Smith or something—"Oh yeah, me and Robert Mappletho-rpe just sort of hung out at the Bottom Line and then I became a rock star." It was a lot more casual.

Carey: *It was your friends—a group of friends that were sup-porting you—but also you're saying that still happens now. Going to openings and events and hanging out with people, talking to people and showing your work is still what it's about really.*

Currin: Yes, and your friends from school. They were the only people I knew in New York. That's also actually how I got jobs. That's how I initially got house-painting jobs, was through the Yale network as well. The sculptors all became carpenters and the painters all became house painters.

A girl who went to Yale with me, her husband turned out to be a contractor and I did a lot of plaster work with him, which was a big deal. It meant I could kind of work when I wanted to. I didn't have to have a real job.

Carey: *How do you see the world of artists now? It was a dif-ferent world when you were entering into it. Now with online and social networking, do you think there's more advantages to artists reaching out and meeting collectors?*

Currin: I don't really know. It's so much bigger now than when I started—that's both a good thing and a bad thing. I think it's harder to hang out and develop in kind of secrecy. So if you're thirty or thirty-two, I think there's much more

pressure on people to try to make it very quickly. And it's so much more expensive that they do need to make it more quickly. You'll starve if you hang out in New York without a way to make money.

There are probably five times as many galleries as there were then, maybe ten times. The other thing is that right around that time, there was a big crash right when I started into the art world. When Saddam invaded Kuwait and all the galleries closed in like two weeks. It was really amazing. They all just shut down especially all the galleries who'd been showing young people. It just got real quiet for like three or four years. That's another aspect of when I was young, I guess. I was very lucky to have Andrea through that time.

Carey: *Right, because it's similar now in some ways. I mean there was a crash, things are coming back, but artists are grappling with an economic tightening in New York. It's more expensive to rent space in New York but I think many opportunities and, certainly, some of what you're talking about is possible.*

To conclude, is there something that you want to say to artists that are out there? Some of them have been out of school for several years, some not; some living in New York, some aren't.

Currin: I think the most important thing is in a way what people say, "Oh, it's who you know. It's who you know." Well, it is who you know because that's what's going to make you a better artist, having friends that are interested in what you do.

I think it's very important for people to work at their art—even if they have a job, to work at night. And try not to get too wrapped up in your day job—try to stay full of shit in your day job and full of ambition and seriousness about painting.

It's a very daunting and a hard thing to enter the art world in New York but it can be done. The most important thing is your friends, really, it is the other artists you know. That's more important than knowing collectors and art dealers because if you have a group of people that push you, you'll get noticed no matter what.

Carey: *That's a really great point. Some people separate from their friends after school, some people don't, but you're saying to cultivate that, to keep those friends together and to keep visiting everybody's studios. Is that what you're saying?*

Currin: What I mean is friendship based on being ambitious—don't feel bad about being ambitious and wanting to be successful and a famous artist. That's the whole point. You should want that. There's no real point in moving to New York if you don't want that. Having a group of friends who are also ambitious and also struggling is incredibly important, I think, psychologically and emotionally, to make it in New York.

I know I'm sort of talking only about money and making it but that's all I thought about when I moved here. It was, "How the hell can I do this? How can I not sink?"

That interview of John Currin was one of the interviews that I think most clearly lays out the steps for an artist on his or her path and how you can go from a house painter to one of

the best-selling painters in the world. The details are all at the beginning. He moved to a place where he could meet more people and he was not afraid of being ambitious and wanting a lot. By talking to people, going to galleries, and getting small shows in nonprofit spaces, he was noticed and then got the exhibits he needed. It couldn't be clearer as to the path an artist can take, but the variables are in the relationships that you make by hanging out in galleries and even bars, as he says, while nursing a drink all night.

You could say there is an element of luck involved, but that luck was created by being in places where new relationships could start. It is also the case study that proves what Robert Storr was saying in his interview about the importance of friends in your success. The networking that John Currin was doing paid off.

Letters Not Answered

Hopefully those interviews have lent some insight into the workings of the critic and the artist, and later in this book we will discuss more about what Currin said, but for the artists, the practical side—which this book is devoted to—may come down to something fairly mundane: like what happens when you send a curator (or any professional) a letter and he or she does not write back for over a week. On one hand this may seem simple—the curator doesn't like your work—but on the other hand, there are many possible reasons for a lack of immediate response. However, there are two ways of looking at this example.

One is psychological, and the other is practical and professional. On the practical side, there is a professional way to

handle this situation until you get a response of either yes or no. On the psychological side, it is much more complex. When someone doesn't respond, just like a date you may have had, we all begin to project our fears and insecurities onto what the silence means: "She or he doesn't like me. She doesn't like my work. She saw my Etsy page and was turned off. I knew I shouldn't have made that page. I did something wrong." We can all go on and on with reasons why we were given the cold shoulder. In this particular case, there are several things to consider.

Fear vs. Possible Realities

In a situation where we do not hear from someone, like a curator, the mysteries of the art world rise up. What does a curator want to hear anyway? To begin with, there are two aspects that must be considered carefully. One is the professional response and how to write to someone and follow up when you don't hear from them. The other is the information you need to know about what the person you are writing to wants to hear and how to craft that letter. The minor aspects to consider, which can often be huge hurdles, are the psychological issues of what it means to reach your goals and also what it means to feel rejected or to simply be turned down. There is your own fear of rejection, and then there is what is actually happening on the other end of the equation, and the truth of what an unanswered letter means or does not mean.

Answers to Expect from This Book

This book will discuss all of those issues and will explain how the various aspects of the art world work so that you

will know how to approach galleries, museums, curators, and many other aspects that are new and growing.

Then there is the opposing strategy that is not about networking. Alternatives include the possibility of not having major shows but smaller ones, and perhaps being exposed online and finding awards, grants, residencies, and other ways of sharing your work without the prime directive of making a living or a serious income, but instead, just living the life of a professional artist supported by another job as well as supported by a community of artists and those who appreciate art.

Since networking is the focus of this book, not the option above, you will understand how to get a letter answered, how to make friends with curators, dealers, patrons, and more. You will read interviews with artists who have struggled and succeeded on their own terms, and you will hear directly from the gallerists and curators.

Chapter 2

Why So Mysterious? The Art World Defined

I am an artist myself and have also worked with hundreds of artists over the past ten years through my online courses and mentoring with my website, www.theartworlddemystified.com. One of the questions I hear most often is, "Why is the art world so mysterious?" It is a question that is troubling to most artists and one that has no easy answer. However, we can ask the same question of other vocations or ways of living. For example, "Why is creating an online business so difficult?" or "Why is publishing a book fraught with defeat and rejection?" or "Why is life not more simple, more straightforward?" The truth is that it is not difficult to understand, just as starting a business or publishing a book is not as difficult as it seems when we are familiar with the process and the steps to take.

The "Art World" Defined

If you are reading this book, you probably know what the term "art world" means to you, but for the sake of everything I am about to write, it is worth defining. The "art world" is a relatively new term. Arthur Danto, the late art critic and philosopher, coined the term in 1964 in an essay in the *Journal of Philosophy*, where he was also defining what art meant—because at that time, with Andy Warhol making silk screens of soup labels that were considered art, many people began to wonder where art began and ended. You know what art is because you are more than likely an artist yourself—or as George Rickey, the sculptor, once said, "Art, my dear, is what I make."

For the moment, that will suffice to define art, but the art world itself is another matter. The artists that I work with define it as the commercial as well as noncommercial aspects of exchanging artwork, and the entities and persons who represent and facilitate those exchanges. That means not only galleries, gallery owners, and other online sellers of artwork, but it includes perhaps most importantly the world of nonprofit institutions and exhibitions.

Art Biennials and Nonprofit Centers

Those nonprofit exhibitions such as the Venice Biennial, where artists are chosen to represent their entire country with an exhibit, are a big part of the art world because it is a way for artists to become known internationally to all the other entities that sell art and write about it. The Venice Biennial is the pinnacle of artistic success in the world of nonprofits,

but there are now biennials all over the world and art centers that allow artists to exhibit work that is most often chosen by a jury. Critics who write about art, including artist–critics, are also part of the art world because that is also how the work of an artist is spread far and wide. The two aspects of commercial sales and nonprofit exhibits contain the whole of what we now call the art world. This book will continue with defining those elements and how to interact with them.

My Career

I began my career as an artist when I graduated from college after studying art. I went to SUNY Purchase in New York, and it was during the graduation ceremony when I heard the artist George Rickey recite the quotation above—that the definition of art was simply the art that he made. As a young artist I loved hearing that because it gave me total freedom to make what I wanted and not to think of external validation. I also liked his humor and mild arrogance because he felt so secure about what he was doing. Like many artists I wanted to feel more secure about my work and direction in life.

Block Island

Then I moved to Block Island, a small community where I used to spend summers, and I opened a gallery and published a small magazine—knowing nothing about either industry, and without any financial backing (though I did learn to ask for donations, sell ads, raise money)—and also worked as a carpenter throughout the winter months. I learned a great deal by having a gallery and seeing things from the other side of the desk as artists gave me images and statements to review.

New York City

When I moved back to New York in the late nineties, I was hungry to find a gallery or museum and get exhibited. I continued to do carpentry in New York City as a "handyman" to make a living. Every moment I had free I eagerly went to nonprofit spaces and asked artists and administrators of nonprofit spaces how it all worked. The answers I received were disappointing. Even the nonprofit centers were very inarticulate about how to get a show. The general feeling I received was that it was difficult to nearly impossible to be an artist in New York City. Through my experience over the next ten years, I learned that this was not true at all, as I figured out how to get exhibited in galleries and even museums, and was invited to be in the Whitney Biennial a few years later. I also learned how to find and build relationships with patrons that supported my art. But why did I not get better information when I asked?

Information Deficit

The reason the information was not easy to get, I believe, was partly because of the egos involved in the art world. Also, it depends on how questions are phrased and asked. Now I have a radio show at Yale University and I interview artists who have represented their country in the Venice Biennial and ask them exactly how that happened and they explain it to me. I have gotten better at asking the exact questions I need answered. Also, when I talk to artists who have very satisfied egos (like the ones who make a full-time living off their work, or even the unknown artists who make a living online), they tend to be more generous with their knowledge because they generally

know that there is plenty for everyone. By that I mean that when you ask people who work at nonprofit centers and who may be frustrated artists themselves, or when you ask artists who are just beginning to have some success in their careers, they are not yet feeling secure about their choices, and the response you will get when asking them about the process of success will probably be coming from a place of insecurity about their identity and they will give you a negative response or one that lacks sufficient information. Thus, the more accomplished and satisfied the professional is that you are talking to, the more likely it is that you will get a useful response.

Interviews

The interviews at the beginning of this book are a prime example of two major figures in the art world who aren't pulling any punches and are saying truly useful things for artists.

Conversely, the less accomplished the artist or administrator of whom you ask questions, the more likely you will get a response that is the opposite of helpful. It can be summed up in the paradigm of scarcity versus abundance: if you are afraid there will not be enough career opportunities for you, then you will think it is not helpful to share; and if you think there is plenty for you (as evidenced by success on your terms), then you will be happy to share knowledge and expertise. So perhaps the art world is seen as a mysterious place because many people in it do not understand what is happening there, and worse, they are insecure about the power of their artwork or their job, and thus they purposefully mystify a situation to feel more powerful.

It is a strange behavior, but a common one—when in doubt, act arrogant. It works on a superficial level, but soon it wears thin, and no level of arrogance can replace real knowledge and real connections with people who care about you and want to see your art career grow. As you search for answers and information, asking the right questions is important, as well as sensitivity and generosity.

The Right Questions

In most cases, if you ask a question very directly, after a few preliminary questions to break the ice, you can get almost any information you need. It is a technique used by people who are pros at asking questions, like Oprah or Barbara Walters. Their technique is to first build trust. Ask a few questions that are easy to answer and are genuine and sincere. Then slowly but directly move to the harder questions. In the case of major celebrity interviews, the celebrities are often well prepared

to deflect a question, and it is usually asked again if it is not answered.

Raising Money

I once worked with an artist who also happened to be a private banker and owned several companies, but couldn't get his art exhibited or sold. His job, not unlike some artists, was to raise money. Unlike artists, he raised money for companies that he thought needed more funds for research on scientific ideas he thought would be profitable. His job was to find people with money to invest and then "ask them the right questions." The reason that he could not just tell them about the exciting research, and ask if they would be interested in investing, is that he would sound like every other person wanting money and it would not be persuasive enough. To improve his chances, his strategy was to ask the "right questions" and get the person he was after engaged in a conversation, thus building a relationship and giving him the opportunity to present his idea and ask for funding. Of course you are wondering what the right question is. That is the area where my client had to be creative. As a side note, I have to say working with this particular client taught me a lot about how creative the business world is, especially on the highest levels of financial engagement. For this particular man, the first step was not convincing the person he wants to meet to invest or watch his presentation, but to simply engage him in a conversation. As Dale Carnegie said, "You will make more friends in two months by taking an interest in someone then you will in two years by telling them to take an interest in you."

The right questions tend to begin with what truly interests the person you are asking. The more research you do on them (via the web), the better prepared you are for developing the right questions.

Business World vs. Art World

Even though this person was in the high-level business world, it is no different for artists because it is not enough to just have great art, or a great business investment; you must also be able to engage a potential gallerist, curator, or art buyer with the right questions. We will get to those questions soon with specific samples, but it is up you and your personality to create questions that reflect who you are and what you want to accomplish. And it comes down to a personal style that is truly sincere when asking people questions about who they are and what they do.

I was working with a young emerging artist who would go around meeting gallerists and after asking about their gallery and what they did, he would go home and take notes about details—like the names of their children, favorite artists they mentioned, and other tidbits. Then when he would see them again at an opening he could say, "How are the twins?" and that got a very warm response indeed!

Am I Good Enough? Do You Like My Work?

The artist that I mentioned who was a successful business man wanted to exhibit and sell his work. He hired me as a mentor. At first the answer seemed obvious to me—if he applied his business skills to his art, he would be very successful. If he used his charm, his good questions, and his huge beautiful

Manhattan studio, he would get far. However, things did not progress that easily. He found many stumbling blocks in his way. When he had calls to make or galleries to visit, he often was too busy to do it. When he did meet people and introduced himself, it started off well, but he tended not to follow up, and even when he did, rather than "asking the right questions" he would ask the person he was talking to if they liked his work. They would not know what to say, and then he faltered and became less interested in networking. He would say, "I didn't like their response, they didn't seem to like my work enough."

One reason is that the absolute wrong question to ask is, "Do you like my work?" Because it does not matter initially if the collector or gallerist likes your work, what matters is if they want to buy it or, in the case of a gallery, if they want to sell it. The other reason this man was retreating was that his self-esteem was getting lower every time he went out to meet people and didn't get the answer he wanted. When I explained to him that he was getting in his own way, he recognized that and we worked hard to move through that by examining what he was doing and carefully changing the language he was using. Once he began asking the right questions, not the wrong ones, and presenting plans and ideas, his success grew dramatically.

Building Your Own Hurdles

What was he doing wrong? What did I mean when I said he was getting in his own way? In that case I meant that although he was doing all the right things, he was undermining his potential success by self-sabotaging his situation. This is not

uncommon for artists to do, or, for that matter, anyone to do, but it is particularly common with people in creative fields. Unlike most jobs, being an artist means you have to believe in your own work, and you have to truly believe that it is good and worthwhile to pursue. In the case of the businessman, he seemed to have no doubt that his work was good, even great—but did he really believe that? I feel that he did not believe in his work entirely. In some respects, this is the job of the ego and how it gets in the way or helps. We all have doubts about one thing or another and sometimes, to compensate, we act as if we have no doubts at all, perhaps even acting arrogant in some way. That is natural, but can also be problematic because underneath what appears to be a confident ego is a doubt, a crack in the façade that is being generated, and when that is exposed we retreat. This is most likely familiar to the reader, if you are an artist. The businessman/artist was

acting confident, but did not truly believe his work was valuable, unlike his belief in the companies he represented.

Personal Strategies

I have noticed a similar pattern with many artists that I work with. At first when I design a strategy with them to reach their goals, which may be getting a gallery show or a grant, everyone is excited and ready to do the work. As they put themselves out into the world and begin to apply for grants or submit work to galleries or invite more people to their studios, inevitably it begins well—and then there is a rejection. The rejection may be subtle, like an email or phone call not returned, or less subtle, like not getting the grant, or a gallery that says they are not interested at this time. This can cause a tailspin, and all the energy they had to go out into the world fades. If they were selling cupcakes they might not feel so bad, because sales involves rejection, any salesperson knows that, but in this case it is their own art and it is so closely associated with the artists' personalities that the rejection is taken personally. The crack is then revealed—you have a doubt—and the ego protests and fires back that there is *no doubt*, it is the gallerist that is wrong. The conclusion, even if not consciously revealed, is that the world is against you. You react so strongly because the mistake you made in thinking about yourself seems to have been revealed. That is a painful experience that everyone has felt. It is also a mistake in thinking, because the galleries and granting agencies are not rejecting you—it is not personal, and it is not a judgment on the quality of your art.

Confidence Game

Confidence is one of the more profound aspects of building your career; how do you get out of your own way? How do you shatter your own glass ceiling? It is an issue in practically all fields of commerce, and the methods to move forward and up in spite of yourself are various and often culturally specific.

An artist's worth in terms of prices that artwork has sold for, is a barometer of how the artist perceives the marketplace of art and their place in it. However, we have all seen artwork, which you know to be substandard, fetch huge prices and vice versa, so there is something more at play in terms of how an artist prices their work and gains confidence. Consider the following case history of one artist I worked with.

Case History: Jim

Jim is an artist that made small paintings on wood panels. He worked at more than one job, working at a restaurant, at a bar, and as an artist's assistant. He lived in a borough of New York City and found a gallery that sold his beautiful small paintings for about $1,200 each. The gallery would sell three or four a year, sometimes more, which made him happy at first, but was hardly a salary. He assumed the rate of sales would naturally increase. He would ask the gallery to raise the prices but they said customers wouldn't pay any more. The gallery began selling fewer paintings as time went on and Jim got frustrated. His jobs were not paying much so he moved back to his hometown in the Midwest. He felt that he had not "made it" in New York, and just wanted to live an easier life with his wife and children.

Bold Move

Back at home he became a carpenter's helper. A friend came by and looked at his work and asked how much a small painting was that he had recently finished. He thought about the sales in New York and what he really wanted, and he thought about how good that little painting was, and he said confidently, "That painting is eight thousand dollars." As he told me, he thought, "What do I have to lose?" The friend said he wanted to think about it, and thanked him. Jim assumed that was the end of the sale, especially since the friend did not have much money, but he felt good about saying what he thought it was worth. A day later the friend came back and bought the paintings for the eight thousand dollars that was asked. That friend was not rich, and had to figure out how to get the money for something he really wanted. And if you really want something, you can usually find the money, even if it is by using a credit card or getting a loan or liquidating an asset. Isn't that how so many go to college and afford new cars? In this specific case, the friend liquidated some of his retirement savings. Since then, Jim's career has grown and his prices have not gone down. He does sell original wood block prints for under two hundred dollars, but the paintings remain the same price or higher. The turning point for Jim was not just raising his prices but feeling good about it. I often work with artists to raise their prices, but if the artist is not ready they will not do it. They might feel that they will lose customers or simply not make sales anymore, but unless you really want to change your prices, it won't happen on its own. His old gallery would not raise the prices because they did not have the ability to sell at that range or the belief in his work. He had no choice but to leave that gallery.

Mystery

The game of selling art is not so mysterious, but our personal reasons for lacking confidence often are. As you read on, you will see various institutions and jobs within the art world deconstructed so you can navigate this world easier. There will also be more help in discovering and overcoming your own mysterious issues that come from unknown sources, but as sure as there are words on this page, your career can be remedied with patience and practice. The case I just mentioned was unique and special, just as yours is. What is not unique is a lack of confidence and overcoming it. Patience is needed because it doesn't happen overnight, and practice is needed because it takes doing a task repeatedly to make it work and to believe in it—like raising your prices. In this case, practice comes in the form of asking multiple galleries over and over if they want to work with you.

One common myth that will be explored is the idea that a gallery can do it all for you and then you are set and sales will roll in. In reality, you do most of the work, because you do not want one gallery, you want several galleries representing your work in different states or countries. When you have several galleries selling your art, it is easier to actually make a living—whereas one gallery, even if it's successful, can ruin your career if it closes. The mystery of the inner workings of sales is easy to dispel, but the hard work on your part comes in the form of building new relationships—and many of them. Museums are a world that seems inaccessible to most artists, and the hardest to break into, so next I will talk about exactly how to do that.

Chapter 3

Museums and Nonprofit Institutions

How do museums operate and what do they hide in terms of policy and access to artists?

In this chapter, I will discuss the public role of the museum and the ways in which an artist has access to the museum. How do museums and their staff work with artists? Do you need to be well known to be in a museum? How do nonprofits work or residencies and cash grants—and is it competitive?

Museums are filled with public servants and you have a right to access and speak with staff in my opinion. That does not mean that you can be rude or arrogant, of course, but it does mean that the staff of a museum and a nonprofit institution in general should be accessible. If they are not accessible, I think you have the right to say so. I believe in fairness and access, and once I was tested and was surprised at what I found. Let me tell you the story of how I brought a

nonprofit to its knees begging for my help! It's an odd story that illustrates how much power an artist can have when dealing with institutions.

Manhattan

I have always applied to different residencies and awards and exhibits through nonprofit organizations in Manhattan, where I live. It is a competitive process, but not as competitive as you might think. For example, the Guggenheim Foundation, which gives grants of up to forty thousand dollars of unrestricted funds to artists, gets about eight hundred applicants a year for the fine arts category, and picks about thirty winners. Other organizations that are lesser known sometimes get more applicants. The Lower Manhattan Cultural Council gives artists residencies (studios) every year, and, last I checked, has roughly three thousand applicants for about one hundred spots. That is about as competitive as it gets, but it is still not as tough as most top colleges, and this is New York, where there is a huge concentration of artists. Almost half of most application-oriented opportunities are dismissed because of a lack of material provided, so the odds are better that what they appear to be.

Confrontation

Once I applied for a grant from a nonprofit organization in New York that gave studio space and exhibition opportunities to artists. I had won the grant in the past with them, more than once. Then one day I wanted to call the director of the organization and talk to him about an idea I had for making their website look better. I went to their website to find his direct number or

email. I was surprised to find out that there was not a listing for contact information for the director. I was surprised and called them to ask for his email or number and was told they do not give that out and he does not have a direct line. I was shocked because, in my view, here was an organization meant to serve artists and yet the director was so difficult to reach. I felt this was hypocritical and it got me upset and determined to not only access him but to tell him why I thought it was wrong to have no email address for him on the website.

The Email That Was Sent

Since I could not gain access to the person I wanted, I sent an email to the secretary whom I had called and asked her to pass the letter onto the director. In the subject I wrote "Critic of [organization name withheld]." That way, without opening the email, it could be easily seen that I was the equivalent of an unhappy customer. In the email I explained that I was very unhappy with how the organization was structured, and if they wanted to help artists, they needed to change a number of things, and I needed to talk to the director about this. I got a quick response from the director saying he was sorry I was unhappy and asked me what the problem was. I said I had to tell him in person. I said that because I felt the issue was personal, and that it was about a style of management, most likely his. I explained I wanted a meeting with him. He made a date to talk to me and I arrived in his office on time.

A Nervous Meeting

I was apprehensive before the meeting and wondered why I was being so confrontational, and what I had gotten myself

into, but I said to myself that I believed in fairness and access to all artists and detested what I perceived as elitism in this organization. When I went to his office I found the entire staff of the organization was present, which took me by surprise. I shook the director's hand and sat down. I told him this was a personal issue about management style and I didn't think he would want the whole staff here for the conversation. He dismissed the staff and we were alone. I thanked him for the meeting and explained that I was upset by the lack of contact information for him personally. He said, "Is that all?" I said that was the main part, but that it started with how difficult their website was to navigate, and on a more personal note, how difficult he was to access, which to me smacked of elitism, because this organization was here to serve artists, so how could they justify not being easily accessible? He got defensive, but was polite and savvy. He said that they were going through changes and he also thought the website was bad. I countered that it was a

deeper problem to resolve than website design, because the organization should give the overall impression of a welcome mat for artists. He listened to me and asked what they could do to change that. It caught me off guard to be asked for a solution, but I began to brainstorm. I said his own voice on the voicemail might help, and something that was truly friendly on the website that invited more people to interact. He said he thought those were good ideas and asked if I would help the organization, and he would pay me for my services. I accepted his offer, and was quite surprised at the result of the meeting.

Lesson Learned

That meeting taught me a few things about the world of non-profit organizations that also applies to museums. The lesson for me was that everyone is accessible if asked the right questions, and in this case it was being a critic that drew attention and got me a meeting and a freelance job. Even a large retail business doesn't want a vocal critic, so if you have an issue, the top employees and managers want to solve it before you make it a publicity problem for them. In this case I was also paid to give them ideas for a better interaction with the public and artists in particular. I have rarely been so confrontational since then, but I haven't had the need to do that very often. In the case I mentioned, my relationship continued to evolve with the organization in positive ways. I am not saying the way to access nonprofits and museums is through confrontation, but if it is necessary and you see something wrong, why not? After all, who else will bring light to an unjust process or even one that is just a bit arrogant? Next is a similar lesson

with a museum that ended up with them buying one of my artworks.

Museum Purchase

It happened shortly after I graduated college, and like the above example, I was a little green in many ways about how things worked. Now I would handle it very differently, but this case illustrates how a passionate and even an emotional response can get quite a bit accomplished sometimes.

I was just a few years out of college and had moved to Rhode Island. I went to the first museum I could find, which was a university museum, the Rhode Island School of Design Museum, or RISD. I went to the front desk and asked if the museum ever bought the work of new artists, and they said, yes, sometimes. Then I asked who was responsible for that and they said different curators were responsible, depending on the medium. I was making monoprints at the time and they gave me the name of the print curator.

Meeting the Curator

I called the number on the card and the curator of prints answered. I explained I was a local artist and wanted to show her prints for possible acquisition. The curator was very polite and kind and told me to come down and show her my art. So we made a date and time and I brought a portfolio of several large monoprints that I was working on. She looked over the prints and we talked about the process and how the prints were made and she said she liked them very much and was interested—she said she'd like to hold on to three or four of them because she would like to have them for the museum

and would contact me at a later date when a final decision was made. She said the price I asked was fine, which at that time was $1,500 for each 20 x 30 print.

The Decision

I received a call from the curator about two weeks later and she left a voicemail that thanked me for bringing the prints by, and then asked that I stop in to pick them up, that she didn't have to be there as she'd left a note for me, and that the museum did not want to acquire the prints.

I was surprised, shocked, and saddened. I felt that she was going to buy the prints and perhaps I was being a little bit naïve but that was how I experienced the conversation—she seemed quite interested and I assumed that the museum would purchase the prints. I was torn about what to do and I thought I should just go down there and pick up the prints and get it over with, but at the same time I wanted to call the curator back and ask her what happened or at least tell her how I felt. So I decided to call the curator and I left a voicemail for her because she didn't pick up the phone. In the voicemail I said I received her message and I was upset by her decision since I thought she was interested in the prints. I was saddened and frustrated that the museum decided not to acquire the prints because I had assumed by her interest in our conversation that the museum was indeed interested.

Decision Reversed

The next day I received a call from the curator that said she received my voice message and that she would like me to come down—she was sorry that I was disappointed. I returned to

the museum and to my surprise she said she was purchasing the four prints for the price that I had asked.

I was thrilled that she bought the prints, and it was truly unexpected given her initial voicemail, but what it taught me was that everything is very personal—the curator took it personally that I voiced my dissatisfaction and that I was upset. As in many interpersonal relationships, when someone is upset the other person tries to make them happy or comfortable in some way because that's what is comfortable for all of us. In this case, the curator of the museum acquired my prints based on my emotional response in part, and in the case of the nonprofit that I mentioned above, my sincere and emotional response about the management of the organization resulted in a paid position. To be clear, this is not the way I handle situations now, and as I write this it sounds to me like the passionate response of a very young artist; however, it illustrates

a point that I think remains true no matter what your strategy is, which is that personal relationships carry an enormous amount of weight, and sincerity communicates very clearly and directly.

Museum Meetings

Now that I have exhibited more and made much more work, my approach to museums is quite different and what I would recommend to artists in general would be quite different. I still think speaking your mind and being clear about how you feel is important, but now I see there are many other things at play and that there is a polite and professional way to have access to museum staff.

The museum staff at most major institutions is composed of people who either went to school for administrative management in nonprofit institutions, or volunteers and people who are interested in the arts. The curators in most cases have degrees in art history as well as curatorial studies, and are sometimes artists as well.

In the case of the museum I mentioned, it was a college museum (RISD), and an important one. There are many college museums throughout the United States and the world that have wonderful collections and can be approached in a similar manner. You can simply ask at the front desk or call and talk to the curator who is in charge of acquiring prints, paintings, sculpture, or photographs—whatever it is that you make. Major museums such as the Museum of Modern Art in New York or the Guggenheim Museums around the world and other large-scale museums can also be easily reached but maybe not quite as easily as the university museums.

For major museums you can still look at their staff and decide who is it that you want to meet. You may think that you want to meet the top curator of painting or sculpture, but that is usually the person that's hardest to get in touch with. I would suggest meeting with a curator that is at a lower level— someone who is more accessible, like a curator of events or an assistant curator.

How Museums Work

Museums are nonprofit institutions that are regulated under strict tax guidelines from the government. In Europe it is very similar; they have to operate under a strict set of guidelines in order to maintain their tax-exempt status.

Unlike galleries, they are not free to choose how policies are interpreted and how they manage their staff and audience. As a nonprofit institution, their activities are a matter of public record and their mission is to serve the public—which of course is quite different than galleries, whose mission is simply to sell art. The essential mission of any museum and nonprofit is education. It is the education of the art-going public. These institutions are not there to judge or validate your art, they are there to potentially meet you and learn from you as an artist.

Exhibiting at a Museum

To have an exhibition at a museum requires an understanding of which exhibition spaces are available at museums. In most cases museums have a schedule that is booked for two to three years in advance. However, museums also have what they call "special project" spaces where shows can be installed and

these are sometimes more flexible spaces that are not booked years in advance. Research the museum(s) close to you carefully, and look at what their exhibition schedule has been like for the past year or so. You might find that they have mostly major artists being exhibited. But look carefully to see if they work with other spaces; sometimes it's other nonprofits, sometimes it's even commercial establishments who want to give part of their space to the museum for exhibiting artwork.

For example, the Whitney Museum of American Art in New York generally exhibits major artists in its museum space. But for several years they were using the lobby of what is called the Altria, a space that is essentially a corporate building owned by Phillip Morris, the cigarette manufacturer. In agreement with the corporation and the owners of the building, the museum would mount different exhibits within this lobby space. The reason they did that was because it allowed them to have more flexibility in programming. They could have live events there as well as visual art exhibits. It allowed them to show the work of younger artists as well.

Most museums have something like the space at the Altria, but if not, it is possible to propose a collaboration if you are so inclined. For example, it is possible to suggest to the museum that they mount a show in collaboration with another institution. The lobbies of office buildings are one possibility, but there could be others. In New York, the Museum of Modern Art was asked if they wanted to collaborate with a nonprofit exhibition space in a former school called PS1. They did indeed collaborate with them because it gave them the ability to showcase new and emerging talent. After several years the museum entered into a full partnership with the former school, and now that alternative space is called MoMA PS1.

More details on exactly how to propose a show to a curator at a museum will be discussed right after I explain educational proposals in detail.

Public Education

Museums are always trying to expand their audience, so collaboration with other institutions is one way to do it. As I said, the mission of museums is to educate the public about the arts, and any way they can accomplish that is of interest to the museum. That does not mean that they will partner with any alternative space, but it does mean that they might be interested.

In order to get the attention of a museum, besides wanting a work of yours bought by them, one way would be to propose an exhibit and explain its educational value. Galleries also want to educate the public to some degree; but it is important to understand that museums have a fundamentally different role, and that is to serve the public, whereas galleries can essentially do whatever they like and are not regulated by the government in any way. When a nonprofit institution or a museum receives tax-exempt status from the government, the guidelines are quite clear. In most cases, nonprofit status is given to institutions whose goal is primarily education, and moreover, there has to be a board of directors, as opposed to an individual, in charge. So the way a museum or nonprofit must be designed is to state their mission and what they are contributing in terms of education, and then they must assemble a board of directors, which will guide the museum and its policies. In most cases, that board of directors is composed of at least seven people who are also donors to the museum.

They are people who are interested in the arts, probably have art collections of their own, and believe in the power of art as an educational tool and as a cultural force. Again, this is very different than galleries which will be discussed in the next chapter.

One way to get involved with a museum is to propose something for their educational department. As opposed to their curatorial department which is focused on exhibits only, the educational department focuses on workshops and lectures for the public. If you have a question about exactly what this means, just go the website of your local museum and look for their "public programs" which will give you a list of events, workshops, and probably lectures for the public.

Proposing a Public Program to a Museum

If you are interested in proposing a public project to a museum, I strongly encourage it, because it is a great way to get involved with a museum. You would be engaging the museum's educational department, which is separate from the curatorial department as I said previously. Both are still under one roof and communicate with each other, so a gig in the educational department increases your visibility in general with the museum. It is also usually a paid gig. Here is how it could work.

First choose the museum you are interested in, preferably one fairly close to you, and look at their website to see how they describe their public programming. It is most likely a range of activities from museum tours to lectures, panel discussions, workshops for children and/or adults, and other educational possibilities. Those are in the range of what you

can propose to the museum. That means that if you want to do a workshop or a lecture, look carefully at how the museum describes their current and previous workshops or lectures, because you want to propose one with similar language to what they are using on their website.

Your Proposal

When deciding what to propose a lecture or workshop about, first look into the museum's future. See what exhibits the museum has going on in year from now, or at least six to eight months from now. Let's say there are several exhibits, but one draws your attention—an exhibit of Surrealist drawings from the museum's permanent collection. Let's just say that piques your interest. Now if you design a lecture, workshop, or another similar program, it could be designed to be offered during that exhibit of Surrealist drawings to support that show. Perhaps you became interested in that show

because your photographs or paintings have often referenced Surrealist work. There should be some reason that you are interested in a particular show in the future of the museum. The next step is to describe your workshop, lecture, or seminar in the same way that the museum describes the show on their website.

In the example I am giving, perhaps you propose a workshop to students or adults using photography and dreams to help the participants make and understand Surrealist images. You could also propose a lecture as well, but personally, I like workshops because they are hands-on and you can choose whatever age-group you prefer.

Contacting the Museum

Now call up the museum and ask who is in charge of public programming in their educational department. You might be able to find that person's name on the website as well. Once you have the person's name, either email them or call and ask for their email address from the museum. In your letter explain that you would like to discuss a public program proposal that would coincide with a museum exhibit (state the date and name of that) in the future. Explain that you would like to meet with the person you are writing to about this. I would suggest a meeting in the museum café or something very close to the museum.

There are two advantages to doing this type of proposal. One is that it can turn into something enjoyable, and, as in the example, let's say you did a workshop on creating Surrealist imagery, that might have something to do with your art, and it might stimulate your own process—and you will also

get paid. The second advantage to doing this type of proposal is that if the museum accepts it and pays you, then you now have a relationship with the museum. You can propose more workshops in the future, and you will also have a chance to meet more museum staff including curators and will learn the details of how this museum operates and what the possibilities are for exhibiting there in the future.

Curatorial Department / Asking for a Show

Regarding museums and other nonprofits, I have just written about getting your work potentially acquired by a museum, challenging nonprofits to be accountable, and proposing a workshop or lecture for a public education program at a museum, but we haven't talked about proposing a show at a museum. Now I will tell you the method I would suggest for getting a show and the story of my own proposal and how it worked.

Exhibiting at a Museum

If you started with an educational proposal for a museum and produced that, it is a good way of getting to know the museum staff. Then the next step might be a curatorial proposal. That is, you want an exhibit of some kind. The first step is to determine which museum you are approaching (university or public) and then contact the museum by email and arrange a meeting with a curator. To make the meeting and get the curator's email address and phone number, you must do some research. First, after deciding on the museum you will pursue, research their curatorial staff, and decide who you would like to talk to. Perhaps you want to talk to the chief curator of the

museum. I would suggest that rather than talking to the top curator, you choose a lower level curator. The reason is that, in my experience, talking to the top curator, who is often very busy, is harder than doing the same with a new curator that is just starting at the museum or someone who does not have as demanding a role.

Writing to the Curator

So after careful research, write to the curator. If you don't have the curator's email, there is a fairly easy way to get it. All museums as well as most nonprofit institutions in general have the same format of email for all employees. You can easily see the format by seeing just one email address from the museum. If you can't find one on their website, call the membership department and ask for information to be emailed to you and you will see the address of the person writing to you. The format will be something like, first initial, a period, then last name, at [the name of the organization]. For example, using my name, that one would be b.carey@museum.org, or it could be something else, like brainardcarey@museum.org or brainard_c@museum.org—but whatever it is, that will be the format for every email address in the museum. So let's say you find that it is first initial then last name at the museum name. All you need to do is know the curator's name you are after. Let's say the name is Susan James, then her email address is sjames@museum.org. Now that you know how to get any curator's email, it is time to write a letter to the curator that you think is not too busy at the institution that you are writing to. By busy, I mean what I said earlier—not the top curator, but someone who is newer or has less power and is not so sought after.

Also, think about where in the museum you could actually exhibit. If you have found a space that would be appropriate, meaning that you have seen other artists similar to yourself exhibit there, then that might be the place you are proposing. But be sure the spot in the museum actually shows contemporary work. When I proposed a show to the Whitney Museum in New York, it was for their Altria space. I emailed the curator of live events, someone who was new to the Whitney at the time and was not a star like the chief curators. In the letter I wrote to that curator, I asked for a meeting in the museum café for fifteen minutes to discuss a proposal. She agreed and we met. I had three proposals prepared, a small one, a medium one, and my ideal one—a very large installation that would use the entire Altria space.

Talking to the Curator

When I sat down with the curator she asked me what I was up to, and I told her there were three projects (exhibits) that I wanted to have. After I explained the smallest one (a group of prints) and what I thought it was about, I asked her if she knew of any appropriate venues for that. Then I paused. By asking her if she knew of a venue, I didn't back her into a corner by asking about the museum—that way she could think about the possibilities she might know. After she gave me a few names of nonprofit institutions that I might propose to, I thanked her and we moved on to my second proposal, which was small sculptures and prints, and I asked her again if she knew of possible venues, and she again named a few. Then I told her about the dream project—a large installation with sculptural and architectural elements and explained that it

would need at least five thousand square feet. I spoke with great enthusuiasm about this idea. Again I asked if she knew of possible venues for this. Then she mentioned the Altria space and said the top curator might be interested, Shamim Momin. Then she told me she could mention it to Shamim, or I could send her something about it to pass along. When I got home I wrote up a description of it for her to pass to Ms. Momin, the Whitney curator of the Altria space. After several meetings with Ms. Momin, the show was on.

Images

Incidentally, I never showed any images in that first meeting. I could have brought some, but I thought it was better to focus on the ideas of what I was doing rather than images, and as you can see, that worked out fine. When I had the subsequent meeting with the chief curator, working out all the details, I brought one image of a rough mock-up. Truthfully, that image showed very little of anything, but that was intentional on my part, because I was not sure how the whole show would come together, and that image was obsessed over by the curators, who were trying to read more into it. Essentially what I did is something you can do—talk about your ideas and why they matter.

Your First Letter

In your initial letter to the curator you have chosen, I would write something that shows you know who they are. Mention a show they curated or something they have done and then explain that you would like to meet them and discuss a proposal. If they write back that they would like to see the

proposal first, then send them a letter about your idea and be brief but ideally interesting and engaging so you get the meeting to explain more.

Break Rules, Try Something Different

That was how I did it and still do. My overall tone is always polite and persistent. I never get upset if turned down, and even when breaking the so-called rules of presentation, I do it politely, which has worked wonders for me.

The late James Lee Byars is an artist I admire, and he came to New York City in his late twenties in the 1970s and wanted to meet Mark Rothko. He went to the Museum of Modern art and asked how this could be arranged. They could not meet his request, but he did meet a curator on that day named Dorothy C. Miller. He talked to her and must have had a strong yet effective way of talking since she later wrote about him that he had "certain very sound ideas about simplicity and directness, both in art and in living."

Byars began writing her letters regularly, often enclosing small drawings. He asked her for a show, and was refused. Then he asked her to consider a show of his drawings in the emergency stairwell at the museum. As odd a request as that was, he was doing what I have been suggesting—get to know the curator, and know where you might actually have a chance of exhibiting, like a special project room, or an unused portion of the museum. He did get that show in the stairwell, and after his death there was an exhibit at MOMA that showcased his letters. Byars wrote his letters on shaped, textured, folded, or packaging paper. He often used different kinds and colors of tissue paper, and handmade Japanese paper.

Today this method would still be very effective in the age of email where so few people get letters that are handwritten. If you have a specific curator that you wanted to meet, this would be an effective way of reaching out and starting a relationship.

I often hear artists asking if there is a list of curators somewhere that they could send packets to in bulk. If there is such a list and you do such a thing, what could possibly be the result? Perhaps something will come of it, but you are not building a real relationship with someone, you are sending out work like it is a product to be picked in a multiple choice test. So consider something more rewarding, more intimate, and more satisfying, like writing real letters over time and developing relationships that will last.

One artist I was working with wrote a nice letter to another artist—James Turrell. Almost a year later he responded with a phone call and after that they began talking and texting. That is not uncommon. If you write a real letter that is from the

heart, so to speak, it is likely you will get a response. Wouldn't you write back to a nice letter that is thoughtful? Everything I advise in this book is essentially about creating lasting relationships that can benefit your career. It is what every artist that has achieved any level of success has. Your personality can enter into it, and you can be quirky as well, but always polite and respectful.

Next I will talk about galleries and will also feature an interview from a dealer that explains her history, the history of the art world, as well as how she likes to talk to artists. In her case, she favors artists who are their own character, who create their own world, and even those who are eccentric because that is interesting—as opposed to a straight, bland, and undermining question such as, "Do you like my work?"

Chapter 4

Galleries

As a young artist in the New York art world, I asked many questions and got few answers from other artists and art administrators about access to the art world. I assumed it was impossible to get into unless you were "picked" by a curator or had a windfall of opportunity. This chapter will discuss phrases like what it means to be "discovered" and/or "chosen" by a gallery, as well as the notion of the "starving artist," the "struggling artist," and other catchwords and phrases that make success in the art world seem difficult or impossible.

Gallery Types and Tiers

I hear so many questions about how to get into galleries from artists: "What do they want to see?"; "How do they choose artists?"; "Do they want to see one body of work, or more?"; "How many images do they want to see?"; and the list goes on. Galleries are a mystery to most artists, and there is definitely

not a clear book of rules. However, if you look at the questions above, there is one flaw in how they are being asked. Artists tend to group all galleries together into a common or at least very similar institution. Thus the word "they" in all of those questions doesn't really apply, because galleries have very little in common with each other as well as no standards of practice. Some galleries want contracts with artists, others refuse to sign contracts, some galleries want to see a consistent body of work, while others do not. In short, the word "they" does not apply to these questions because there is no "they"—all galleries are run according to different business models.

Top-Tier Galleries

Consider the top-tier galleries like Gagosian and Zwirner in New York City. Those two galleries as well as others like them (selling work for more than $100,000) are not looking for artists at all, in the traditional sense. They do not review work. The way they find artists is by looking at other galleries that have hot artists and then stealing them! They are not in the business of taking any risk. It is the highest level of the art world, and they are like traders in fine antiquities; they know exactly what they want and pursue it. Every other level of the art world is accessible. Having said that, it is possible though not probable to be in one of those galleries under special circumstances. Perhaps you know one of these gallerists, or have a connection to them through a collector. It may be like trying to meet the Pope, but if you can get a meeting with someone like that, it is possible that you could make a proposal that is powerful enough to gain their interest. One possible proposal

is that you want to stage a one-day event that you feel will garner tremendous press. Even though the gallery will probably not sell work on that day, if you convince them that it could generate a lot of attention, then it is indeed possibly valuable to the gallerist. That may be a long shot, but it is one way to achieve the impossible. If that succeeds, then you are getting the attention of that gallerist and a door may open.

Possibilities

Let's look at galleries that are not top tier, where more possibilities lie. As I said earlier, there are no standards among galleries for the most part, because there is not a protocol that they need to abide by, unlike museums and nonprofits. I'm sure you have seen it yourself in the wide variety of galleries out there. There is the frame shop gallery, that makes framing its main business but sells art on the side. Those galleries do not have traditional shows, the work just changes

every so often on the walls. The frame shop gallery is usually not pushing the sale of art, they are selling frames. Could you show in a gallery like this? Yes, probably. They do not want to see a body of work, or a philosophy, or a great idea for an event, they want to see art that can sell in their price range. You can walk in to one of those places and simply ask who the owner is, or who is in charge of selling the art. Then you can ask if they would like to look at your art for selling in their shop. It is very straight forward, there is nothing you need to do but be confident and show your work—ideally work on paper or small canvases.

Commercial Galleries

Then there are galleries that sell everything from vintage posters to signed prints by Warhol and contemporary art as well, all jammed together on a wall. These galleries can be aggressive in their sales techniques, to the point of being tacky, but it works for them. This is probably not the kind of place you want to be in, unless you see art on the walls that is similar to yours. Like the framing shop, these owners are hardball business people most likely, and if they like what you have, and they think they can sell it, then they will. No need to be shy here, just walk in and say that you have art you are interested in selling and you want to talk to the person that handles that. You can show originals if they are small enough to carry, or images on an iPad or phone. Like all galleries, even the most commercial never buy art directly from you; they usually take it on consignment and take anywhere from a 10–50 percent commission. There are dozens of variations on this type of gallery, which is essentially a straightforward store

that also sells art. There is no shame in selling art in these places, though it will not be a stepping stone to biennials and larger galleries in most cases.

Small to Mid-Size Fine Art Galleries

The galleries that are in the middle of this range are probably the ones you are looking for. These are the galleries with white walls, a largely empty space with a small desk in the corner for a receptionist, and art on the walls that does not have prices hanging from it, but instead, there is a price sheet at the desk.

These types of galleries also have a range in quality and ambition. They may all look similar and be in gallery districts or even in rural areas, but have different management policies. Again the idea of what "they" want doesn't apply here because they are all run by different people who are making up the rules of their own business. So some of them will offer a contract while others will not, and some will be friendly and open to submissions while others will not be. The advantage to the "white box" gallery described here is that their primary business is selling art. There are no frames or posters or boutique items, they are simply selling art. That is something you generally want in a gallery. Of course, nonprofit galleries and museums are another story and generally do not sell work at all, as that is not their mission, but we talked about that in the previous chapter and will discuss it more later in the book.

If this is the type of gallery you want to pursue, then one thing to keep in mind is that it is ideal to have several galleries like this as opposed to one. Most galleries will sell some work some of the time. That means when you have a show

with them your work may sell but probably not on a steady basis after your show. And even if the gallery represents you, that does not mean that they will sell your work on a regular basis, so if you have different galleries in different areas of one state or geographical area, you have a better chance at making a consistent income. Also, if one gallery closes, you are not out in the cold, and do not need to start looking for a gallery again. Most artists that are selling work on a regular basis are managing their work at several galleries.

The method for approaching galleries is something on which you will hear different opinions, which makes sense since there is nothing regulated or common in how they run their business. I have worked with many artists over the years and have seen many of them begin doing business with one or more galleries from start to finish. This is the method I would suggest.

Method for Approaching Galleries

Approaching a gallery with your work is now done with new technology and simple words. I would like to preface this by saying that when you approach a gallery, you are not con- cerned with whether or not they "like" your work. That is not the issue, and if you are bringing work to a gallery, you already know that it is good work. To ask a gallery if the work is good in some form or another is to prejudice how they will perceive you no matter what your work looks like. The reason is that when you ask a form of the question, "What do you think of my work?" it is similar to saying, "How do I look?" That ques- tion is so fraught with subjective assessment and awkward overtones that it would be hard to get a clear answer. Rather

than ever saying something like that, keep in mind you are trying to sell your work to the gallery, so they in turn can sell your work. Can you imagine a salesperson of any kind saying, "Do you think this is a good product?" Or being on a first date and saying, "Do you like me?" That would usually be awkward and would put the person in a difficult position. Instead, the attitude and approach you want to have is that you are looking to sell your work. You want to know if they are interested in selling it. This is the simple and straightforward way of doing just that.

The Question to Ask

You can walk into a gallery (the white box kind) and say to the person at the desk these exact words, "Do you look at the work of new artists?" In almost all cases, believe it or not, they will say, "Yes." However, if their answer is no, then you can just say "Thank you," and look around the gallery and leave. There is no harm in a "no" as it does not have anything to do with your work, it simply means they are not looking. The more popular response to the simple question, "Do you look at the work of new artists?" is "Yes." I will give a case history in a moment, but let me explain the process in detail.

Asking at the Front Desk of a Gallery

If after asking that question above, the person at the desk says "Yes," then your response should be, "Who would I send work to?" Usually they will give you a name and an email. If they give you a name only or an email only, ask for the other so you have both. The final question to ask if it has not already been answered is, "How do they like to see work, JPEGs or a

website?" The reason to ask this is that most galleries do not want a website, they want to see a few images attached to an email. The probable reason for this is that they can tell in just a few seconds of looking at three of your images if they can sell the work or not, and would then ask for more information if interested. If you follow this script repeatedly, I guarantee you will have many people saying yes, and then your next step is to email them and follow up.

There are a few other things that might happen in that first conversation when asking if they look at work or not. One is that you might be asking this question to the owner or director even though they look like they could be anyone sitting at that front desk. As is often the case, if the gallery is empty, that person might ask you what kind of work you do. You can then say what is that you do, and begin a conversation, then ask if they would like to see a sample of it. If they say yes, there are two preferred ways of showing work in this situation. One is a tablet like an iPad, the other is a decent-sized smartphone. Be prepared for this possibility.

The way to prepare is not to go onto your website and begin showing work because that can be problematic if there isn't a good connection at that moment. I would suggest making a folder on your phone or tablet with six to ten images of work you think is your best. That way you can easily bring up the work and quickly look at images. By quickly I mean that they will take no time to load and appear, but take your time looking through them. As the first one comes up, say what the size and medium is and, if you can, describe the image itself or what your ideas were behind the work and wait for a response. The idea is to just show a few images and have a

conversation and you will be able to tell right away if there is interest. You may be asked what the prices are so be ready to name a price. If you don't name a price it is the sign of an amateur, so be sure to name a price even if you haven't sold many in the past. And if there is indeed interest, get his or her card and say you will follow up.

The very important thing to remember about that last piece of advice is not to show work to someone who does not ask to see it. You could experiment and break this rule, but unless you are asked to show work I would suggest you do not offer. What you can normally expect is that when you ask if they look at the work of new artists, they will probably say yes, then ask how to send work and to whom, and get a card or write down the name and email of that person.

Mid-Career Artists

I have interviewed many artists about how they got their first gallery and there is a very wide range of responses. I have interviewed emerging artists and artists that have major careers. If you are an artist that is already mid-career and has had a gallery once, you may think that this is not the method for you. Perhaps it isn't, but in all the research and interviews I have conducted there are not many options. Sometimes if there is a particular gallery you are interested in, you can see who the artists are that show there, and if you make friends with one artist, it is possible they can introduce you to the gallerist. However, introductions by artists are not always effective since the gallery owner may assume that the artists do not necessarily know what the vision of the gallery owner is or what sells. But connections have been made this way.

It is not an easy task for the mid-career artist that once had a gallery but no longer does, because pride is often an issue. It is easy to think that you are above that kind of door-to-door asking.

When I was working with one mid-career artist who was in her early sixties, she told me she had not made art in several years due to life tragedies and wanted to get back in the scene but didn't know anyone anymore. She did what I explained above, going to different galleries and she did in fact find a gallery and is now represented and has shows all over the world.

The lesson is that she also felt it was a daunting task, and was not the way she wanted to do it. But with practice she got what she wanted, and it helped that she was consciously upbeat when going into a gallery, and her enthusiasm helped.

Let me share another case of an artist that did not work at all. She was also in her early sixties and living in the same city. She, too, had a career with one gallery for many years and then the gallerist closed her gallery and she had nowhere to turn, but kept painting for several years. No one came and knocked on her door asking for a show. So she asked me for help, and though I tried, I could not help her, and this is what happened.

Failure

First I suggested that she have an open studio and invite people on her mailing list from the past who might have been collectors to see her new work and rekindle relationships that could help her. She countered that writing to people would

sound desperate, and she didn't like the idea. As much as I tried to convince her that she needed to begin making relationships with people who liked her art from the past, she refused. I understand that everyone has different methods, so I let that go and suggested a different road. This time I suggested she walk into galleries and ask them if they look at the work of new artists. She said that was not for her. So then I suggested she just walk into galleries and write down the galleries that she felt would be a good fit for her work. She did do that. She also told me it was depressing to see all these artists showing work in galleries because it wasn't good work for the most part. I understood her feelings, and we looked at her list and talked about methods to approach those galleries. She would not walk in again so we decided to send them letters instead, which she was also reluctant to do. In the end she sent emails and told me that no one had written back. I explained how to follow up, but she said she didn't like the idea of chasing people. So we dropped that too for the moment.

I was trying to find a way she could meet people on her own, so I suggested going to openings and meeting people or finding poetry readings where I knew there would be people that would help her. In the end she said she didn't have the time for that kind of thing.

I have a lot of success stories that I will tell throughout this book, but she was not one of them. I share it here so you don't think that everyone I talk to succeeds (her art was excellent by the way). She did have collectors and a gallery in the past, but was now hindered by pride or other issues I could not penetrate. I am used to success when I work with artists so this was hard for me to see, but it is a reality that many artists

must confront. I usually don't see this kind of artist because when people come to me they are usually ready to take risks and go into areas outside their comfort zone.

Barriers and a Gallerist Interview

I am sure you see what her barriers were, and probably relate to aspects of them as well. However, there are always ways around situations like this if you are determined to find them, and next I will discuss blazing your own path, your own way, with your own gallery. But first, here is an interview with the legendary gallerist Betty Cuningham in New York City. Cuningham not only explains how she operates, she gives us a concise history of the art world since the 1960s.

The Interview

Carey: *I want to talk about your gallery and its history. What show do you have up now?*

Cuningham: Right now we have Gordon Moore up. He's an abstract painter. I've worked with him for a long time.

Carey: *Rackstraw Downes is also someone you've been working with for a long time. Is that correct?*

Cuningham: Since '82, that's when I had a gallery in the seventies and then I joined with Hirschl & Adler, and I had a couple kids. And Rackstraw was at Hirschl & Adler—he joined probably around the same time I did, probably '82. And Philip Pearlstein and several others who I've worked with at Hirschl & Adler are also here.

Carey: *So let's go back a little bit to the beginning of the gallery because it seems there haven't been many galleries that have done such consistent shows for so long. What was it that got you involved in wanting to open a gallery in the first place in the seventies?*

Cuningham: I guess I've always been interested in art and I was doing my masters in nineteenth century American art at Hunter and I switched to doing it on the attitude of collecting contemporary art upon the appointment of Henry Geldzahler. So I got involved with the contemporary field and I switched only because I was getting a museum credit at the same time I was getting my masters and they wanted me to do something about a museum. So I got my masters at Hunter which was just unbelievable because I had great people for my teachers, like Tony Smith was my painting instructor, and I had Leo Steinberg and Bill Reuben, Howard Davis. Davis was the renaissance scholar.

Carey: *That's incredible!*

Cuningham: It is incredible because I was doing it at night. I was extremely lucky because I had been working in a law firm and I met this lawyer who said we had to save art in Europe which of course I was interested in because of the nineteenth century studies in art. All the professors at Hunter were interested in what was going on. The flood had hit Florence, Italy and I was over in Florence doing the publicity for them and got to work for some amazing renaissance scholars but at the same time, I'm still taking my masters. So I had a lot of things going on at the same time.

Carey: *The flood seemed absolutely devastating. I remember seeing images of that, Renaissance paintings floating, an incredible amount of damage. That was emotionally overwhelming, those pictures I saw.*

Cuningham: It was, it was. There was a wonderful film, I did not create it. I wasn't part of it but I was responsible for moving this film which was a 35mm film narrated by Richard Burton. It was called *Florence's State of Destruction* about the flood and was about what was going on. Foreign camps from American universities were over there putting talcum powder between the pages in the Bibliothèque nationale, working on the Cimabues and all these things.

Carey: *What was the next step for you after that?*

Cuningham: I moved back up here [New York City] because I wanted to get back to New York and I was very clear that I

wanted to go for-profit, not nonprofit—not because I thought I'd make money, but because I thought I knew I had the energy to figure that out. I became a registrar at Marlborough for about a month and they hired me and I was only there three months until Jim Harris asked me to come down to work and that's how I started out. Jim quit and Dave Hickey came in and Dave remained a good friend and we worked together and God knows what else hit but a lot of things hit. We had the blood show, we had so many things going on. About a year and a half later and I walked across the street and I said to a friend, "What am I gonna do?" and he said, "You're moving upstairs." So that's what I did and I was there for a long time.

Carey: *And moving upstairs means what exactly?*

Cuningham: I had a gallery from 1972 to 1982.

Carey: *So you're just beginning. It wasn't something you understood before and what was the blood show, was that Hermann Nitsch?*

Cuningham: Nitsch came to that, it was a John Freeman show. After that, I guess he continued his art somewhat but it was something that Jim Harris wanted to do. John Freeman brought in buckets of blood. Containers of blood from the stock yards in Chicago and he had catheters of blood. One of the catheters of blood exploded and it went through the floors. And it covered one person's paintings, his name is Jerry Hunt. He's a British painter. It covered his paintings and it covered the paintings of another artist, and meanwhile, Jim Harris has quit. There were horrible reactions including the health depart-

ment and the editorial against us in the *New York Times*. And so those two artists really suffered a loss and oddly, Jerry Hunt did these paintings that were all white with very fine lines. He comes upstairs, I'm alone in the gallery. We have four floors. We had what turned into J.Crew and then eventually the hotel and we had the next door space as well. And we had two basements. He comes out from the basement, his face is covered with blood. He's crying and I think he's like thirty-eight. He said he will have his representative call me about the loss of his paintings and I go downstairs and literally, the paintings were a gutter of blood. So we poured the blood into a tin can or a tin wastepaper basket—it's a really long story. Anyway, the bottom line is he goes back to London and his representative calls me and I pick up the phone and it's a lot of talk, and I guess he was going to try to get some money back for Jerry Hunt and I don't know what happened it was just like chaos. Anyway, I moved across the street and I took over the space.

Carey: *How did that go? What was your first show then?*

Cuningham: We called it Betty's Bowling Alley, it was very narrow and it was just a funky little space and I showed five artists and then I went on and I showed some other people, we showed a lot of people. We had some good shows, mostly painting.

Carey: *What are the years that we're talking about here? This is 1972 until 1982, correct?*

Cuningham: Yes.

Carey: *So that's a time of pivotal change in the art world. There are more galleries popping up in New York, it's still a small art world, and its gathering place is the Broome Street Bar in SoHo.*

All these things were happening and then that's moving into the eighties where there's another shift, which is that the art market becomes something that it wasn't before. How did you manage that shift in the growth of the art market so to speak?

Cuningham: I would give myself way too much credit for understanding what was going on. It's very ironic because I think of myself as a pinball machine you know. I hit the side then I go the other direction, I hit the side then I go the other direction.

There was Robert and Ethel Scull who had been collecting works of art, and when the sale of their work came up, what happened in the world was that suddenly contemporary art became liquid. It was liquid money, you could invest in it. And you can get an instant return by putting it up at auction and that really changed the art world. I would like to say that I knew this was going to be the change in the art world. I didn't have any idea. And I think that the Scull sale was the change. And then when that happened, people became more generally informed that art was an investment.

I remember the resentment of artists about auctions and how they were terrified to go there. It was like a meat factory, like selling a bull off the land or something, you know. None of them would show up for any of the auctions and then they would sometimes try to get another artist to buy something if

it ever came up because if they get no bids it would not look good. But that was the beginning of what changed this into a money commodity which is really depersonalized.

I mean that the individual artist became kind of lost, he became less important to the art world and the art became more important.

Carey: *As the eighties moved forward, you continued to have exhibitions and were there noticeable changes in how they were being mounted or sold?*

Cuningham: I think for me it was a change because I joined Hirschl & Adler and they were showing representational art, which is never shown, which is really ironic if you look at what I do today. I had mostly been involved with abstract things.

So when I went to Hirschl & Adler, I remember seeing some things on the wall—and I won't name the artist, he'd kill me—and I thought, "Oh God, what is this all about." But it was a very, very good thing for me because it really gave me something.

I had one child who was just born and I had another child when I was in Hirschl & Adler. We had some amazing shows and I was lucky to be part of them. At that time, I met Pearlstein and Rackstraw, whom I adore and they're both really brilliant and they're really stimulating to talk to about art and painting and they're generous to talk to. They like other people's work whether it's like theirs or not.

And so I got to know a lot of these people and it made me realize how important it was for artists to do what they have to do rather than what is expected of them. It's important that each person in the gallery has his own voice and that

the gallery doesn't reflect only one voice. And so what I try to think about is that mostly the artists in my gallery have a type of energy, an independence, and are risk takers. In other words, they're willing to do something that the world doesn't ask them to do. They're going down their own path and I find that it's absolutely super exciting.

Carey: *Your current space in Chelsea is beautiful—how did you find the space?*

Cuningham: I got this space with the help of some backing. I started this place in 2004 and we're now at the end of our lease here so as of this moment, we're negotiating my lease. [Gallery moved and is now located in the Lower East Side of Manhattan.]

Carey: *Is the pressure of sales changing the way art is handled?*

Cuningham: I think the economic pressures make you make decisions that you wouldn't ordinarily do. I don't think it's healthy for the market because it becomes, well, it becomes "What's the easiest thing to sell?" I had a visitor to the gallery just the other day who said something to me which I really hadn't thought about. He made a comment about one of the artists we now show, and he said, "You know, this will be worth more, you sell it at $35,000 but tomorrow it will be $135,000, and the next day it'll be $150,000, or maybe it will be $250,000." He only said that because of the Christopher Wool that just sold at a very high price.

I certainly don't look to my market place and give them what they want. I mean people that come in and say, "Do you do something like flowers or something?" and I think, "God, that's right, I don't."

Although I guess there's a flower now and then.

I think there is an art market and I think there is an art world. And the people on the outside are really interested and I think these kids that come in and enter art school are rightly being told how to manage their career. But maybe they should try to think about their work more.

Carey: *Of course you're right, perhaps artists are coming out of school thinking of the market and focusing on the market too much, which brings us to the last point—where does that leave artists today and how do they move into this new world that is so focused on the market and also has certain amount of pressure, as you were saying, and stay focused on their work?*

Cuningham: I think there are a couple things. Years ago, we used to say, never give up your day job. Of course today it's hard enough to get jobs—but anyway, that was one thing so that you can paint what you wanted to paint. You go to your studio and you have one side of the studio which is what the artist is trying to figure out, the excitement of what they want to do, experiments, and then you have the other side where the artist thinks, "This will sell."

And I don't mean that my artists say that to me, but one thing that came up recently—I was hanging a show here and the artist that I was showing was saying, "Why did you take

out all of those works? I thought they were the most salable."
And I thought, "I didn't think of that. I didn't even think of
that."

But I'm thinking now what's happening, and this is the
younger artist who said this. I think now what's happening
is that the artist is also feeling this pressure that they have to
fit in, which is a totally noncreative art point of view. But they
feel that they have to, they need to.

First of all they have to pay the rent and that makes them
suddenly realize that they have to be able to make this work
and then their parents say, "Oh my God, don't be an artist.
If you are going to be an artist, you better do this." So when
a young group comes in here, students, I tell them never be
afraid of what you're going after. That would be the first thing.
And never let anybody tell you you're not going after the right
thing in your painting. I mean let them tell you, but you know
there's a great story about Chuck Close who got told he wasn't
doing the right thing by Al Held. Al Held started painting on
one of his paintings at Yale and Chuck never let Al Held come
back into his studio. But a lot of kids at Yale get that, they start
trying to paint like whoever was there.

I don't think there's anything wrong with graduate
school, but I do think that there's something wrong with the
emphasis on marketing and career, because, after all, paint-
ers should be doing what they really love and be excited by
it, and they have to figure out how to pay their way in a very
expensive world and still have the freedom to do what they
really want do.

Carey: *Do you often visit artists' studios?*

Cuningham: I find it really interesting, going to studio visits. If I understand it right away, OK, and if I don't understand it, that's more exciting.

Carey: *Betty, thanks so much for talking with us today. What you just said was very powerful and it reminds me of what you said a little bit earlier in our talk around the time of Hirschl & Adler, when you were talking about the emotion of an artist being not so much part of a group or a trend in thinking. You didn't use those words, but that they each kind of created their own sphere of thinking and it seems to me to be about artists' choices as the opposite of what may be taught often in schools and MFA programs—which is that there's a way to do things, a way to approach things, when in fact it should be the opposite.*

Cuningham: Absolutely, and beyond that, I've often said that once a movement is named, whether it's "pop art" or something else, it's over.

Carey: *Any advice to the artist reading this?*

Cuningham: Just be yourself. I mean as a dealer, I hope I stay myself. No matter how big the space is or how small the space, I hope I stay myself.

Never let the gallery be bigger than you are. Never let the person next to you tell you what to do. The truth of the matter is, Yale doesn't make artists. They are who they are. That's what I feel.

Carey: *I know the question that everyone's going to ask or think about. They'll read this interview and think, "It's wonderful.*

Betty sounds like a great person and that she would be a great gallery to be working with." How do you handle artists being interested in talking to you or having a studio visit? What is your policy on that and how would you suggest—to anyone who may be thinking after this interview of coming to see your shows and contacting you—they handle that situation?

Cuningham: Why am I in this business? Because I really do believe in artists and maybe if I were lucky, I would have been an artist myself, though I don't think I would've been a good one.

Right now we're saying we're not looking. So that would be the first thing to say, to tell you that I'm not looking. But the truth is I look all the time and I try to look and see things. But right now, my time is much more stretched out unfortunately, like everybody else.

What would I advise? I would go back to the other thing, get a day job. Do I think it's important to live in New York? It's nice to be available, because it really does make a difference if I have to go to a far off place to see an artist. But I don't think it's essential anymore and I'm not sure that New York is the center anymore. I think the center is in your studio.

That interview was a direct account of what one gallerist went through and is still going through in a very important gallery in New York City. I think the important points from what she said are the fact that she continues to look at art, even if she says she doesn't. She also emphasizes a point that is often heard: be true to your art, because an artistic compromise is failure. I think it is worth noting how Cuningham saw the

market and how her space is not just about making money, though she of course must pay the rent and survive.

Garage/Apartment Galleries: Starting Your Own Gallery

There are so many stories of artists starting their own galleries in collaborations with other artists as a way to show their work when other galleries wouldn't, and also as a way to launch their career. You could call this a pop-up show, but it was done before that term existed.

Recently I was interviewing Jorge Pardo, an internationally renowned artist who has won a MacArthur Grant and is represented by one of the most prestigious galleries in New York City. When he graduated college, after working a few years in a library, he wanted to have a show with friends, but there were few galleries that he felt would show his work then.

He decided to work with a few friends and open an exhibit in one of their homes. The house was not in a commercial

area, but they just did it. He credits those shows with launching his career and the careers of other artist as well.

Michelle Grabner, a young artist who was also a curator in the 2014 Whitney Biennial, the prestigious show hosted by the Whitney Museum of American Art, launched her career and her public profile by not just making art, but by curating shows in the suburbs because she and her husband felt that there can be good avant-garde art in the suburbs. Her first gallery that she launched as a not-for-profit venture in 1999 was the Suburban, in Oak Park Illinois. From 2009 until the present, she created an exhibition area and a residency for artists called the Poor Farm, which is in Wisconsin. Both of these ideas were essentially nonprofit galleries that were far away from any major city. The idea was not to become a dealer, but to showcase interesting work. Those efforts got her very, very far. She was the first artist ever to be co-curator of a Whitney Biennial. She is interviewed later in this book.

There are more examples of galleries in garages, apartments, and homes, but you get the idea—find a place and make it happen. The reason why this is a good model is that you do not have to wait for any gallery to look at your work or sell it. You can show work with friends in a setting that you control. This has many advantages, including the opportunity for you to be "discovered" by a gallery or curator. There are many ways to create this model, and you can be as creative with this as you would like. Artists have created group shows and solo shows with friends in warehouses, storage units, unoccupied real estate, museum bathrooms, and as mentioned; garages, homes, apartments, and even abandoned buildings and public parking garages.

Working with friends on something like this is a good idea because it makes the work easier and it also draws a bigger crowd. Graffiti artists have done this, as well as contemporary artists of all rank and medium. It puts the power in the artists' hands. If you do create a show like this, the next step after hanging it all is to promote it and get some people there who can spread the word and "discover" you.

Promotion

When thinking about promotion these days there is the obvious: a Facebook event that targets a local audience. You can run an ad for an event that will only show up on the pages of people who are near the event. Another way to promote the event is to create a spectacle of some kind—a performance, a local band, or something much more wild! There was a graffiti artist recently whose signature style was a painting of the man on the game of Monopoly holding cash. He painted it everywhere, and at his first self-made show, he sold the paintings for thousands of dollars—but only accepted Monopoly money! Stunts like that can get you press and attention.

Of course it is not necessary to create a stunt, but it helps. If you want to get a particular collector there, invite them. You never know who will show up, and the more you make it sound like a special and unusual event, the more likely it will draw curiosity and an audience.

You can of course sell art at these types of shows, but in most cases you are creating what amounts to a nonprofit showcase, so that the art looks its best and might get reviewed

and sometimes bought. Another version of this is to start your own commercial gallery.

Starting a Commercial Gallery

Another alternative is to start your own commercial gallery in a storefront or garage, or any place where you can draw traffic. In this model, which I will explain in detail, you can launch your career and possibly the careers of other artists while earning money off gallery sales. The difference here is that you must know how to sell art, which is a skill that can be learned, but usually does not happen on its own.

After I graduated college with a BFA, I began to submit my art to different juried shows and had very little luck in the first six months. I was naïve, but I was also feeling a bit desperate since I had told my parents this was going to be my career. I was looking everywhere for answers on how to begin my career but was finding little to support my quest. That summer I went to Block Island, a small vacation community with a residential population of eight hundred just off the coast of Rhode Island, a place where I vacationed with my parents in the summer.

Both my parents were teachers, and the house we lived in for the summer was modest to say the least. It had an outhouse for a bathroom, no running water (a hand pump on the sink and a system that collected rainwater for drinking), and was falling apart. I say this to be clear that I did not come from wealth; my parents were middle-class teachers who had a bohemian streak and found a way to buy land and live inexpensively on this small island. However, the island drew a large summer crowd that did have money,

and they rented homes for the summer and spent days on the beach.

As a young teenager, I spent my summers there and worked at restaurants to earn some money. Now that I had graduated, I spent a summer working and thinking about my next steps. I decided to open a gallery with my girlfriend there, and we called it Square One Gallery. I learned a great deal from this experience, and it is a model that you could do as well. The gallery flourished, and it gave me enough money to survive easily and continue to make art.

I will explain exactly how that worked, but first I want to tell a story that Dave Hickey, the art critic, told me during an interview I did with him. Early in his career he opened a gallery called A Clean Well-Lighted Place in Austin, Texas. He said he knew little to nothing about selling art, so he asked his friend Leo Castelli, who was one of the great art dealers of all time, how to sell art. This is what Leo Castelli told him. Dave Hickey explained the method of selling art included a "poser" and a "hoser," which is a rather crude way of saying a salesperson and someone as a type of bait. He explained the process of a sale. He was in the position of the "poser," and that meant that when someone walked into the gallery that looked like they had money, he would begin to talk about the work with them. As they honed in on one piece in particular, it was his job to explain that although the work was beautiful, it was already on hold by the Prince of Wales who had called in. He would compliment the buyer on their taste, saying he wished he could sell it to them, but that it was taken by a prestigious buyer. Then he would call to the back room and ask his wife or whoever was the "closer" or "hoser" and

they would come out and say, "Yes, it is sold— oh wait, it is on hold actually, should I call the Prince? This was his last day on hold." And thus, a sale was made. Does this sound unethical to you?

I was not nearly as tough or manipulative as a salesman, but this is a technique that works. Dave Hickey is a respected writer and art critic and his stint as a gallery owner included this sales technique, which is what was happening in New York in the biggest galleries. Leo Castelli was a great dealer and had a fantastic gallery, so think about that when considering this hardball technique for selling. Dave Hickey is a powerful thinker and no lowly salesman, but he too used this technique to his advantage. As you are contemplating the ethics of this, let me tell you about a current artist and salesman that is making millions off of his photographs and has his own galleries. These are like high and low stories of selling art. Leo Castelli is perhaps as highbrow as it gets, while David Hickey was just a rung below that, and then of course I was way below that and very naïve in my sales techniques, and the photographer I am about to discuss is Peter Lik, who only shows his own work in his own galleries but sells them at a tremendous pace.

If you are going to open a commercial gallery, you might as well make money. This is one way it is done, and it is as close to a recipe as you can get. Peter Lik is a photographer of mostly landscapes; he started out his photography career by working for a tourism company, and then he made a line of postcards that were successful. A few years after that he opened up a gallery selling his art, and the gallery failed. Then he opened up another gallery in Maui, Hawaii, and it was very

successful. He was selling his photographs of landscapes, and although he was unknown in the art world, meaning galleries and museums, he was selling through his gallery that only sold his work. That gallery in Maui was opened in 2003, and since then he has opened up several more galleries. In 2014, he sold one single image for just over six million dollars. That sale was a record for photography and he received an incredible amount of international press from that. The *New York Times* wrote a piece on him that essentially made fun of him for being so focused on sales, which in my opinion is unfortunate and hypocritical because the late Leo Castelli was never faulted on his hardball sales tactics, and between the auction world and retail galleries there is plenty of unethical business dealings going on, because art is not an easy sell, and the buyer must often be taught how to collect and how to appreciate a work of art. Having said that, please understand that I present these techniques so that you can modify them to your liking, but also so that you can choose as a financial goal to make hundreds, thousands, or millions through your gallery. You will see it's possible with this example, and then you have to decide how far you want to go, because, especially in the art world, almost anything is possible.

Print Sales and Pricing Techniques

To continue with the Peter Lik story, he has several galleries operating, twelve in total as of this writing in 2016. What he did and still does, is hire a sales team that he trains to sell his work. Since everything he does is photography in limited editions, he used a system that galleries have been using for years. If an artist creates a photograph or any work on paper

for that matter, they are usually in limited editions of seven or twenty-five or a number that is determined by the artist depending on the process for printing. In most higher-end galleries there is tiered or "elevator" pricing, which means that if a photograph is made in an edition of seven, the price increases as the photo sells.

For example, if the photograph starts at five hundred for the first print in the edition, the second one might be six hundred and the third, seven hundred, until the last print is more than double the price of the first. All the prints are virtually identical, but the reason that the pricing goes up is carefully calculated. In one sense, the buyer who is first, is taking the biggest risk—he or she does not know if this will be a popular print or an investment, so they get the bonus of a lower price for taking a risk and being the first. The second buyer still gets it for less than the rest of the buyers, but the last buyer of the edition pays the most because they are taking the least risk of all and are jumping on a bandwagon that is already rolling, so to speak.

The reason this sale is effective and used by many photography galleries is because once someone is interested in an image, it is easier to sell them that image by saying it will be worth more the next time they come in.

Peter Lik trained a team of sellers in all his galleries to employ this method aggressively. When someone was interested in a print, the salesperson would explain how wonderful it is, what good taste they have, and if they didn't buy it right now, it would cost more the next time they came in. That is his whole sales technique which you can read about if you search the *New York Times* online for his name. Again, the *New York*

Times pokes fun at him because he is a millionaire artist that is not known in the museum world or the at world, at all. However, whatever you think of his images or his sales techniques, this is one method that truly works.

My Own Gallery

When I opened up my own gallery, I didn't know any of this. I wasn't really sure how to sell anything, I just knew what I wanted the gallery to look like and I hung shows that looked good and had a price list available. My experience in terms of making sales was mixed. While I didn't actively "sell" people, what I did do was hang plenty of work in the gallery and in most cases, about two-thirds of the work would sell, but not always. Since it was in a community that had a lot of traffic in the summer, I had openings every two weeks which was a lot of work, but also kept the sales coming in. The irony was that even though I was selling a lot of work at my gallery in the first year, I wasn't paying all the bills or making much of a profit!

The reason I wasn't making a profit was because my overhead costs were high. The rent on the gallery for the summer, spring, and fall was seven thousand dollars. The spring and fall were not as active as the summer. So I had about ten shows each season and the artwork was priced between $300 and $1500, which seemed like a reasonable range to me. What I didn't factor in was how much I actually needed to make in order to thrive. I was not alone in my naïve thinking, because many new entrepreneurs and store owners make this mistake. Instead of actually figuring out how you are going to make a profit, you just get excited and fill up your space and start sell-

ing and base your sales sense on what you see in other stores or galleries.

Here is the financial breakdown of why the gallery wasn't profiting. The rent was $7,000, then the costs of openings (ten of them) was about $150 an opening for wine and snacks, then there was electricity and sales tax, and I didn't include a salary for myself or my girlfriend who were the owners—I just figured we would split the profit.

So the total overhead was about $10,000 for the season, and I sold about $2,000 worth of art at every show (which seemed good to me, that's $1,000 a week). Most of the work sold, as I said—about two-thirds of what was on the wall. I found that when a show was more than half sold, people tended to think that the best pieces were taken, and maybe they were right.

Back to the figures—I was totaling about $20,000 in sales, and my overhead was $10,000 without salaries. After the artists got their cut (50%), my profit was a little more than $10,000 since I always showed and sold my own artwork, as did my girlfriend and partner at the time. So I was left with $10,000 profit which just paid for my overhead—I had broken even. Then there was sales tax and other minor costs like repainting the gallery regularly to make it look good, and I was now losing money. I ended the year in debt even though the artists made money and the gallery appeared to be successful.

My error was that I needed much more work to sell! In every show, I should have had twice the amount of work as I had to sell. That means I should have been able to pull work out of the back room or take it down as soon as it was sold and replaced it. I wanted the gallery to operate like ones I had

seen in New York, where the work stayed on the wall until the end of the show. The problem with that model is that you need to either sell work for high prices or have much more in the back room.

This was a big lesson for me because when I saw work selling every week, I assumed I was doing very well, but in fact I wasn't. The next year of the gallery did better. The prices of all the art was raised, and there was much more on hand to show people. I began to earn a profit and the gallery lasted for several years.

As you can see, there are many ways to engage a gallery, and this last way is one where you can start your own gallery, and is a very different model that is being used more and more these days. If you look up the story of Peter Lik in the *New York Times*, you will see his recipe for success in this arena explained quite clearly. If that is something you are interested in, I would suggest you consider having a partner or two in the business.

For all the other methods of finding a gallery that are mentioned in this chapter, keep in mind that it is ideal to have several galleries showing your work and not just one. I often hear artists saying a version of, "I have sent them work and am waiting to hear the response," but do not wait to hear the response of one gallery; keep following up until you get a response. As I have said, there is nothing uniform or regular about what galleries want, so don't hesitate to walk in and just begin talking to people and asking if they look at the work of new artists. There is no harm in asking, and the truth is, the more ambitious you are and the more you ask, the better your chances will be at showing and selling work through a gallery.

Be bold, get out there, and don't ask for advice from galleries or ask if your work is good; just be enthusiastic, use your charm, and know that your work is good already and the only question that has to be answered is if the gallery wants to sell it.

If you are still wondering if having "the right introduction" is what you need, or "knowing the right people" or something like that, then you might be waiting a long time. To get a gallery now, and see things happen soon, you need to pursue the galleries you want; and if you want an introduction, then become friends with an artist in that gallery—otherwise you might be waiting a long time, and who has time to wait? You need to exhibit now!

Chapter 5

Myth-Making Basics

T his chapter will discuss how art-
ists as well as curators create mystery around their work and
projects so that it intrigues and engages the viewer.

Historically, this is what artists have done for ages to cre-
ate interest in their work, and you will learn how to do this
yourself, in your own words, so that you can add mystery in
a meaningful way. Mystery may mean simply that you have
a truly interesting idea or way of working, or that there is a
lingering question about whether or not something actually
happened.

I say all of that with a smile, because as much as it seems the
art world is "mysterious" and this book is meant to "demys-
tify," I believe that sincerity is always the best policy in busi-
ness relationships like working with a gallery or museum, or
presenting your ideas. Nevertheless, there is a place for mys-
tery, and it can be done in very creative ways. Allow me to use
the example of a relationship between a man and a woman.

Initially, while courting each other, the man and woman do not want to reveal everything about themselves. It would be "too much information" and a turnoff in most cases. So instead of going through their resumés of past relationships and family life and what they do for a living, they talk about something else. That "something else" is what builds your personal mystery and makes you potentially attractive.

Of course this is about your personality and style. So if we stay with the dating analogy for a little longer, how would you spin a little mystery without divulging all? Perhaps you would tell a story, or even better, ask questions. If you tell stories, they should be brief since this is a conversation, not a lecture. Maybe a story you tell will be about something funny that happened to you yesterday. In the telling of it, you are giving details about who you are by the way you deliver the story, and the observations you make point to what is important to you and how you see the world. If it is an entertaining

story that makes someone laugh, it is immediately attractive because laughter puts us at ease and we let our guard down.

The other method is to ask questions of the person you are dating. The questions do not have to be about who they are or what they do, but could be more philosophical questions about life, or about the origin of language or anything you are interested in. The notion of asking questions creates a mystery and an interest in who you are. Because when you ask questions, the other person must answer or at least think about those questions. It moves the conversation and the relationship into a mutual territory where ideas are shared instead of personal information. In a sense, the ideas you are sharing with each other carry hints of your personal preferences and interests, but not directly.

This is also true of presenting yourself as an artist and creating a mystery. When I was writing letters to museums and the Whitney Biennial curator asked for an interview, she said to bring a resumé. Instead of bringing a resumé, I went empty-handed. Part of the reason I didn't bring a resumé was because I did not want her to know all about my past. It wasn't that glorious, and I wasn't represented by a gallery though I had owned a gallery for several years. At the interview my wife and I were both asked to attend since we work as a collaborative, the curator asked for our resumés, and when we said we didn't bring them, she asked about our past.

The reply we thought of in advance was that we would tell her we didn't believe in the past, and that we were only looking to the future. We told her this and she smiled and was also probably a bit frustrated. This was a big interview, and I knew it could be the show of a lifetime. The truth is that my wife

and I are very sincere and straightforward people. We do not appear arrogant to most people and will easily give the details of a situation if asked. However, we were being calculating in this instance, even mystifying by not revealing our past. Just as in the dating analogy—you might not want to explain all your past relationships—we did not want to talk about past shows, largely because we didn't have too many of them.

The curator asked us different things about how we made art together and how we started this project, which we answered in a very straightforward way. But by not revealing our past or discussing it, there was a mystery in the air about who we were and where we came from.

At the time we were living in New York City and the last thing I wanted to say was that I was on Block Island for several years where I owned a gallery and frequently gave myself shows. In retrospect, if I was doing this today, that might be a good thing to say because galleries in urban areas curated by artists are in vogue now. As the conversation progressed and we avoided talking about our past, she ended the interview by handing us her card and saying to keep in touch, and if we could send her something (with a tone of exasperation) about our past, such as universities we have attended, she would appreciate it.

We left feeling excited and nervous, but had to think of how to respond to the question asking us about our past. Do we just give her a resumé? We decided to write something that was not a resumé but more of a biography. What we sent is below, and though it is all true, it is our interpretation of events and presents our life and work in an unconventional format.

These are the biographies that were sent to the curator who ultimately chose *Praxis* (my wife and I) to be in the biennial. We chose to title the document this way since we had already said we did not believe in the past:

The Erased Biographies of *Praxis* (partially recovered from a damaged hard drive)

Delia Bajo was born in Madrid, Spain in 1974. Her mother was (is) a dancer and a psychic and her father an airline engineer. The last daughter of six children, she came of age in post-Franco Spain.

She began studying ballet at the age of three and continued to practice through her adolescence. Attending Catholic schools, she was known as a rebel, challenging authority and asking too many questions. At ten years old, she asked why the Pope was wearing so many rings and surrounded with such luxury if he was trying to emulate the life of Jesus.

She was an undergraduate at Escuela Superior de Artes y Espectáculos. She studied acting in Spain under various mentors and began working in experimental theater. Some of the theater groups she worked with include, Grupos Oscuro, Compañía de Teatro Tierra, and Gran Teatro de Ayer.

At twelve she began meditating on a regular basis and reading philosophy to move herself into a world that she found more peaceful. Developing a love for all animals she also became a vegan and adopted numerous cats.

In 1995, she moved to New York City to live and work. Her first job as a waitress in a restaurant didn't last long because her English wasn't fluent and she asked all her customers to write down their order, which she would hand to the chef.

She studied theater at the Raul Julia Training Unit and continued her focus on it, while making a living as a lounge singer and dancer.

Performing her compositions unscheduled on the street became some of her first "actions," which would lead to more street performances that she did alone. Composing "Symphonic Flamenco" music became a passion for her as she began collaborating with other artists.

Moving into a larger studio so she could work more on paintings, her work began to incorporate various media creating "theatrical" installations.

Viewing all her work as "in progress" she did not pursue gallery representation. Rather, she viewed her processes as hermetic and wanted to safeguard them as well as let new ideas germinate freely.

Her sister had also moved to New York City and together they began designing avant-garde clothes under the label of Elena Bajo. Delia helped organize and create elaborate multimedia runway shows and always performed in them. The clothing line became successful and the shows received much press attention. Throughout this period she would often draw portraits of subway passengers and sketch intensely in public. She began to write about all the behavior she was witnessing and combined it with her drawings. This was the beginning of what she would later call her "Sangré Period."

In the spring of 1999 she met Brainard Carey and almost immediately began performing with him in the streets as well as at other venues.

As their work and lives began evolving together, she devoted herself entirely to developing a new language for

communications. This meant reading about gestures and languages from cultures all over the world to improvisational experiments that helped her create a new way of understanding body language through intuitive and analytical processes.

In the last three years she has continued her collaboration with Brainard Carey creating *Praxis* and performing extensively on the street as well as in their studio.

Brainard Carey was born in Manhattan in 1968. His father is a composer as well as a doctor in music. His mother is a musician and teacher. He was the third and last child.

As a young child, some of his favorite pastimes were talking to himself and his secret friend, following around his older brother hoping for a ride on his go-cart, and taunting his older sister in various ways. His older brother died at fifteen years of age when Brainard was seven years old. This death had a profound impact on him that would manifest itself in artwork later in life.

Attending an alternative high school which taught a process of learning without classrooms, he began to explore bookmaking and photography.

Upon graduation, he attended SUNY Purchase for undergraduate work. There he created a multidisciplinary degree. He wrote a thesis on the homeless in NYC, which included a participant study of the homeless whom he lived among for two weeks. The sociology department was Marxist and this formed the basis of his critical thinking. He also wrote a second thesis on performance art which included a video of several performances he did as a student as well as paintings that were used during the performances. He worked with Antonio Frasconi and created many artist books at that time.

He performed and acted as God Killing Himself (star) in the cult film *Begotten* by Elias Merhige, who was also the director of the recent *Shadow of the Vampire*. He moved to Block Island, RI. There he founded a small gallery and began publishing a magazine and also created a lecture series focusing on freedom of expression. He did a collaborative text installation with the poet and priest Daniel Berrigan.

The magazine became a cultural examiner. That is, by exploring through texts and photographs he continually pursued the documenting of the community he was living within. The gallery was an anachronism in a community that had never seen installations or performance, nor cared much for them.

He photographed several performances he executed in private. Most notably, in *Burial*, he self-documented himself burying objects all over the island.

On Block Island he completed two major projects. The first was a series of cement tablets which he poured every week for five years. He would invite anyone from the community to come down to his studio and after a short period of unguided silence all present could write whatever they wished in the fresh tablets using a nail. When the tablets dried, he arranged them in a rough wall shape that began winding over hills and through fields. In all, approximately one thousand tablets were poured.

The other major project was the hand copying of the Book of Job. Making a unique edition of one, he used ink and a seagull feather he hand cut to transcribe twenty-eight lines a day. This project took eighteen months to complete. It was exhibited at Granary Books in NYC, at the Cathedral of

St. John the Divine, and is now being showcased in a collector's home. This project received much press attention including the *New York Times* as well as magazine features.

Both projects and *Burial* were emblematic of his dualistic approach; social and interactive as well as hermetic and meditative.

At this time he also developed a language and an invented alphabet. With a look similar to Arabic cursive writing, he would create large canvases which resembled book pages which he never translated to the public. Scrolls of this new text were also made. In several performances at alternative spaces in and around the New York area, he would read from these scrolls to audiences creating sounds that made a new context for the language, but still did not translate the texts literally.

In New York City in 1997 he created Radical Anxiety Termination in his Tenth Street studio with DJ Olive. RAT was a monthly event that allowed passersby to play with turntables with a limited amount of records in a temporary installation. These events were all recorded creating social soundscapes. The sounds of these "amateur DJs" made a compilation that among other things questioned the "skills" of DJ culture and illustrated the freshness of "beginner's mind."

The Reaction

That was long enough and probably filled with so much information that was so personal in some parts, that either the curator skimmed through it or decided that based on our conversation and work she had seen that she either liked us or not. It is an example of simply not giving away all your infor-

mation in a resumé. The curator did call a few weeks later and invited us to be part of the Whitney Biennial, which was indeed a glorious moment in our careers and lives.

You may be wondering if you should have your resumé on your website now, or if you should be giving it out so easily. In general, I think it is not needed on a website because all that information is not called for when evaluating art. You can always say that your CV or resumé is available upon request. Again, think of dating websites. Are there resumés on there? You might want to know if they have been divorced before or how much they earn a year, which is exactly why that information is left out. Instead, you have room to describe yourself in a way that sounds charming and will attract the right type of person without revealing details.

The same is true for presenting yourself on the web. Why give away so much information? Isn't it enough that visitors can see you make beautiful art? If they want to know if you went to Yale or a community college, they can ask. Like dating, you want to generate interest—questions can be asked later. Of course you can adjust this idea to suit your needs, but keep in mind that the less you say is to your advantage, because, after all, you are a visual artist.

One thing you can post is a short biography if you are feeling that you must say something. I would avoid an artist statement as that is problematic, but I will talk later in the book about that. For a brief biography, consider the form that authors use. On most book jackets there is a brief biography about the author. That is a wonderful form for an artist to use. It is usually less than two paragraphs and can either be very straight or laced with humor. It is enough to give a potential

fan of the author enough information to understand where they are coming from in general terms.

Other Forms of Generating Mystery

While I do not want to overuse the online dating format, it is important to note that there are many things you can say about yourself that are half-truths that can generate a power-ful response. It can of course be as creative as you like, and ideally something you can follow through on in person.

Other forms of creating a mystery can be more deliber-ate. Graffiti artists have practically made a recipe out of this that takes different forms. The well-known artist Banksy has made a career of not revealing his identity, which helped to generate interest, especially as his work began popping up everywhere as graffiti in public places. After he had already achieved fame, in 2013 he came to New York City and among other public murals, he had a vendor in Central Park selling his work from a stand for about sixty dollars a drawing. It was not announced, and no one knew if it was by Banksy for sure. Later it was announced through a press release that the draw-ings the vendor sold were indeed by Banksy and that very few people bought them even though there were worth ten times what they were being sold for! That is a good example of how a mystery can also be a media coup.

Other graffiti artists have done the same thing with their own twist. When the late Jean-Michel Basquiat began his career in New York City as a graffiti artist, his images were themselves mysteries, like a rebus puzzle that you couldn't figure out. As they appeared in different places, it stood out. The late graffiti artist Keith Haring did something similar with

his graffiti, for which he also became a famous contemporary artist, much like Basquiat.

The idea of doing something that is out of the ordinary of what we might expect is a way of generating mystery and drawing attention to something. The graffiti artists I just mentioned did that, but so did Andy Warhol and others. Memory experts say that it is easier to remember something when it is odd, or out of the ordinary scheme of things.

That technique has been employed by artists as I have mentioned, but there are innumerable ways of interpreting that. The latest trend in making YouTube videos memorable, it to use odd non sequiturs or strange cuts. I was just watching a video of one business coach who is using this technique. She is talking about time management and saying what most people say about it—make blocks of time available in your calendar, and make to-do lists. She also said to remember that time is on your side, as opposed to the opposite. The talk

might not have been so interesting if she hadn't cut to funny illustrations. When talking about time, she cuts to a quick clip of her singing with friends, "Time, ah, ah, ah, is on your side, yes it is," and it caught my attention. This is not directly creating a mystery, but it is creating a memorable impression that has little to do with content, and more to do with delivery and humor.

Artists have also simply made up stories entirely! Events that never took place, relationships that never happened, accidents that never occurred. There are also embellishments—perhaps the event was real, but it becomes exaggerated and made into something much larger.

One example of an embellishment would be to tell a personal story and add more drama to it, maybe even something incredulous. Joseph Beuys is a well-known pioneer of conceptual art, and he wrote an artist's statement worthy of revisiting. I have used this example before concerning artists' statements, but I reprint it here to compare it to Duchamp, whom I have not written about before.

The quote from Beuys is as follows:

> Had it not been for the Tartars I would not be alive today. They were the nomads of the Crimea, in what was then no man's land between the Russian and German fronts, and favoured neither side. I had already struck up a good relationship with them, and often wandered off to sit with them. "Du nix njemcky," they would say, "du Tartar," and try to persuade me to join their clan. Their nomadic ways attracted me of course, although by that time their movements had been restricted. Yet, it was they

who discovered me in the snow after the crash, when the German search parties had given up. I was still unconscious then and only came round completely after twelve days or so, and by then I was back in a German field hospital. So the memories I have of that time are images that penetrated my consciousness. The last thing I remember was that it was too late to jump, too late for the parachutes to open. That must have been a couple of seconds before hitting the ground. Luckily I was not strapped in—I always preferred free movement to safety belts . . . My friend was strapped in and he was atomized on impact—there was almost nothing to be found of him afterwards. But I must have shot through the windscreen as it flew back at the same speed as the plane hit the ground and that saved me, though I had bad skull and jaw injuries. Then the tail flipped over and I was completely buried in the snow. That's how the Tartars found me days later. I remember voices saying "Voda [water]," then the felt of their tents, and the dense pungent smell of cheese, fat, and milk. They covered my body in fat to help it regenerate warmth, and wrapped it in felt as an insulator to keep warmth in.

It is a wonderful story, isn't it? But it never happened. Perhaps it is not a "wonderful story," but a memorable one, and helped people to understand his work and turn him into the cult figure he became. But now I want to compare that to Marcel Duchamp and Chris Burden, both legendary artists, now deceased.

Marcel Duchamp was a highly intelligent man, a chess master at a young age and an avid reader of mathematical theories. He felt that in general, what he called "retinal" art was art that was seen with the eyes and was dull in that respect, because the eyes were so easily tricked, as was the mind. As his work is revisited and reevaluated, he begins to have things in common with Beuys, especially telling half-truths or total falsities in order to engage, mystify, and create a cult of himself. He often made works that he said were ready-mades, as if he took them off the shelf and just exhibited them, but on further investigation, he altered almost every object he showed, though it was not always apparent. Rhonda Roland Shearer, a Duchamp collector and art historian, first explained this to me. She had numerous examples of his art in her collection to show that what Duchamp said the artwork was, it in fact was not, but everyone believed him nonetheless. One example will suffice. In one work called *3 Standard Stoppages*, Duchamp dropped three one meter threads, he said, and preserved their shape in glass and wood. It sounds simple enough, and who would investigate this? But historians have, and those three lengths were of different sizes, and not equal in length as he said. The reason this is important, is that long after his death, people are still debating about why he would say one thing and do another. Not unlike Beuys, he was creating a mystery that would survive long after his death.

Chris Burden is a sculptor who died in 2015. One of his mythic performances of the seventies was when he had himself nailed to the roof of a Volkswagen, crucified in fact by driving nails through his hands and into the car's roof. There are images of this, but it is hard to see the actual nails going

through his hands, though most people believe it happened. There are images of him on the car in black and white and though it looks like he is crucified on there and it is a memorable image, it is hard to see the details. But we will never know if it actually happened. Burden, like Beuys and Duchamp is a cultlike figure whose following hinged on mysteries like this that have taken on historical significance.

These may or may not be things you want to try. I would not suggest you crucify yourself! But there are ways of creating mystery and a lasting impression that may fall somewhere between Basquiat, Beuys, and Duchamp. I know it seems bold and even unethical to some to use this type of technique, but it also is effective marketing. There are YouTube videos using a similar technique all the time.

Have you ever seen the video of the cell phones placed on a table near kernels of popping corn? The video shows the phones ringing at once and then the kernels pop. It is an illustration to show how cell phones emit radiation strong enough to pop popcorn. It also went viral and was completely fake. Another video was made to show how it was done, resulting in yet another popular video.

I make the comparison between high and low (Duchamp versus popcorn video) because similar tactics are used no matter what the content is. There are more ways to create a mystery, so next I will talk about a type that involves less gray area than these examples of half-truths.

Mysteries of the Soul

As you present work or tell others about your working process, which is essentially what Duchamp, Beuys, Banksy and

other examples have done, you could also talk or write about things that are truly mysteries of how you think, feel, and work. There are no half-truths, just the nearly ungraspable nature of the creative process. By that I mean that instead of making up a historical event or describing your work as something it is not, you can present it as a way of investigating something more existential, like the nature of your creative well itself. Some artists talk about their working process as if they are possessed by another entity, or like channeling a spirit of some kind. Books have been written where the author claims to have been told what to write (the Seth books to the Gospels) and many artists have spoken of a similar experience. You don't have to be religious or even spiritual to think this way, because creativity itself is a mystery, and no one really knows where ideas or inspirations come from.

In this version of creating a mysterious and an intriguing version of yourself, you are saying something very sincere indeed. Think back to the dating analogy, because all of this chapter is about presenting yourself to a curator or dealer of some kind and making an attractive presentation so that they want to know more about you. In this version you can discuss the ideas that stimulate you, the source of your investigations, or the questions you continually ask, or even wear your heart on your sleeve and talk about the intimacy of your art.

Sincerity is what this version is about, and it can take an intellectual, emotional, or psychological direction. Just as in the date conversation, it can make a memorable impression so that more is asked of you, and that is what you want when you begin a relationship with a potential supporter or gallerist.

Chapter 6

Teaching and Learning and Jobs for Artists

W hat is the role that academics play in the career of an artist? Many artists also teach, and it has a profound effect on their career. As the Master of Fine Arts degree is pursued by artists all over the world, what is the ultimate value of that degree and how does it affect an artist's career? This chapter will discuss the role of teaching and learning in the university setting and how that can affect a career in positive and negative terms.

There are more MFA graduates than ever, and now for teaching positions, a doctorate in the fine arts has also been created and is being pursued by artists. I am often asked by artists if they should go back to school to earn an MFA, which they feel would help them in the art world and would be a type of credit or pedigree that would get them further in their careers. That is how MFA degrees are sold to some

extent—you are told that this is a way to advance your career, to develop your practice. What actually happens in an MFA program varies depending on the institution, but in general, you are given plenty of time to work in your studio, and you are given "crits," which is the controversial part that can either help or hurt you.

I have worked with several artists that have been wounded by their MFA experience, and by that I mean that they are the opposite of enthusiastic about getting their work out into the world and applying for residencies and grants. I have also spoken with many artists who did complete an MFA program and felt invigorated and ready to reach out. How do these points of view become established? It is important to look at theories of this if you are to consider an MFA or if you have one and want to teach. The interview at the beginning of this book with Robert Storr also points out some of the advantages of an MFA degree which the interview with John Currin makes clear as well.

When pursuing an MFA, besides studio time and history classes and lectures, there is the inevitable "crit," which is designed to teach you how to defend your work. A "crit," which is short for "critical appraisal," is designed so that the teacher and students in a class offer criticisms of the student's work that is being shown. As the student, it is your job to defend your work. This can be a valuable skill to learn. If you are talking to curators or gallery owners after you graduate, and you are giving them a studio tour, you might use this skill if you are asked what your work is about. Or if you are told that something in your work doesn't work and you get the suggestion that your art needs to be "pushed" or "evolved."

That is the moment you most likely would want to defend yourself and explain why the work is moving in the direction you want it to, and why the person making those comments was not quite right. It is a chance to articulate where you are coming from and give the viewer a way to understand your work.

Is that training worth eighty to one hundred and fifty thousand dollars? I am not sure, and hesitate to form an opinion since some see value in it and others do not. If you want to teach art someday, then it is necessary. The only way to teach and not have a masters or doctorate is to have the professional equivalent—meaning that if you have had enough exhibits or are published widely, you can often teach at a university level without the higher education degrees. In general you need those degrees to teach, but not necessarily to make art and be successful.

The downside of the "crit" and the MFA experience is often told by artists who leave graduate school in a state of shock and with a battered sense of self-esteem that makes it nearly impossible to venture out into the art world and feel safe. The reason is that there are other ways to react to criticism by your peers and teachers besides being stronger. Have you ever experienced someone telling you that your work was not good, or worse? Most artists will easily go into a tail spin, it doesn't take much. Making art is already a delicate balance of believing in yourself and not listening to the world's opinion of you. For the more sensitive, which is the majority of artists I would say, the idea of constant critical feedback does not make them stronger: it erodes self-confidence and a sense of vision. If that happens to you in your MFA program, and then

you leave realizing that you are not sure what to do, and on top of that have a big debt and no job prospects, it is depressing to say the least.

Keep in mind that MFAs are a recent invention, and that most of the great artists from the past that you can quickly name did not have MFAs. One major issue is that there is little in the program for professional development of the artist's career. The notion of helping a college graduate with a career is a recent idea. I know because teachers are using some of my books to develop the practice. For decades, talking about building a career in the arts was forbidden in higher education because it smacked of crass commercialism. After all, it is not about making money, is it? Can you imagine telling that to someone studying to be a doctor that it is not about the money or a job, it is about helping people and that should be the focus? That doctors should get a day job to support their practice?

That is what artists are told: it is not about money, so focus on your practice and don't think about making a living. There are many sides to this argument, but in today's competitive world, it is not easy to be a full-time artist with a side job.

The artist Chuck Close says that in the 1970s, you could rent a loft in New York City and pay for that loft by working one or two nights a week at a restaurant or bar. Since then the equation has changed dramatically and artists living in cities like New York or San Francisco are working full-time just to pay the rent. So if you are not going to pursue a career in the arts aggressively, you need a full-time job that will sustain you yet give you time to make art.

One such job is teaching art at a university. These jobs are also getting competitive, so this goes back to the question of MFA or no MFA. The College Art Association (CAA) is an online resource that also holds events designed to help academics and teachers in the arts. There are job postings there for lecturers, teachers, and other academic positions.

The question about an MFA degree is about your decision to teach or not to teach. If teaching is something you are driven to do, you should pursue it, and use all the means necessary to help you. My parents were both college professors, so I have a bias there. I grew up hearing about the politics of academics at the dinner table, and it was not pleasant. I have many friends who teach, and I hear many of them talk about the stress of the job, the pressure of tenure, the pressure to exhibit and publish. It is certainly not a cushy job, as it might seem. Probably because I grew up with teachers, I also have a natural leaning toward teaching. I have lectured in colleges

but never taught in one. Instead, I write books, teach workshops, and have online classes.

If teaching is in your bones, then there are other options besides a university. Online classes are becoming more and more popular. I teach an ongoing online class on Facebook and it is very rewarding because the class begins to support its members, and that is valuable as a teacher. If you want to find a way to teach, there are now many options. Platforms like Udemy and Coursera are just a few that offer classes.

The real reason most artists want to teach is so that they will have a consistent income while making art. That is no longer the easiest or the best model for a steady job, since the field is now competitive and requires a masters and or a doctorate to gain an edge on your peers. Before talking a bit in this chapter about other job alternatives, perhaps it is good to ask if teaching is good for your art.

Most college professors are working artists, as they should be. However, the environment of the university classroom is a world apart from the art world we all experience. The well-known poet Daniel Berrigan once told me that he would never teach for more than a semester, though he is asked to teach for a full year and more. The reason he doesn't do it is because he said the university atmosphere is too cozy—there is no edge to it. He explained more: he said that when a teacher is an artist, they tend to surround themselves with adoring students, who in many cases begin to make work like them. This, he felt, was an unnatural situation in which the teacher was elevated to an illusory status. He said if the teacher is doing well, the faculty will also be adoring, and all of that is not helpful for the

artist's ego, because they will tend to want more and more of it and find it impossible to be in a situation that is the opposite.

There are of course exceptions to this idea, but it makes sense to me that teaching can surround the artist with an atmosphere that has little to do with the "real world" beyond academia. That is a question for you to consider if you are leaning in that direction.

Besides teaching, there are many other jobs that can support an artist without enduring academic pressure or the insulation it may create.

Creating a Small Business on the Side

Artists today often survive off of small businesses or products they make. That means you can be a career artist with a major gallery and biennial aspirations and still have a series of works that sell all the time. Examples of that could be something for a design store. One artist I know has a career of making installations in museums and galleries. At one point early in her career, she was experimenting with cast iron, since she is a sculptor. At first she made fruit and then she made sculptural bookends for her shelves. Other people liked them and wanted to buy them. Since she felt they were not really where she wanted to go with her art, she made a choice to sell them at local high-end design stores in her own city and then in other cities. She had children at about that time, and the pressure to meet the needs of her children and spend time in the studio increased. She resolved this by selling her bookends and having a foundry cast them from her designs on a regular basis. This made it easier for her to provide for her family

while not worrying about selling her installations at a quick pace. It was also not as stressful as most jobs.

Another example would be artists that make popular prints and sell them to interior designers on a regular basis. Some artists who get good at selling prints or designs on the side even begin a business of doing it for other artists, growing the supplemental income and still having plenty of studio time. An artist I know, Jen Durbin, graduated from college and had a problem that many artists have: she wanted to live in a city—Brooklyn—and she wanted a big studio to build large sculptures in. She also wanted time to work in her studio.

Her solution was to find a commercial building in Brooklyn and rent it by subletting it to other artists for studios so that the rent was paid. Of course it wasn't that easy. First she had to find a building that was not being used. She found an old building that was built in 1896 and had a huge vaulted ceiling and was more or less falling apart. The roof didn't leak, but she knew it would take work to fix it up to rent to other artists. She rented it and began to work on it, and in the first week she put an ad on Craigslist saying the large main space could be rented for commercial photography shoots. She had the thought that photographers and filmmakers might like it. The next thing that happened was that she got a client willing to pay a large sum for renting the space by the day for a commercial. Then more came who wanted to shoot a music video there. She told them she would fix up the space soon and paint it. They all said not to paint it or improve the interior, because that was what was attractive—it looked old and industrial.

Now she had money to make studios in parts of the building, which she rented out to artists. Then she made a nice

website to market it to filmmakers and photographers by the day. Soon she began to rent some props and add to the cost of daily rental. She had found herself in a nice situation—she used the large space whenever it wasn't rented, she also had another smaller studio, and was making an income that was paying for it all and more. The last time I talked to her she was thinking of doing it with another building and also had a child and the beginning of a flourishing art career.

Business people say if you want to start a business that will work, there is one formula to make it easy: look at another business that is successful and duplicate it in your part of the world. You could easily consider duplicating her business model in another city where there are artists and it would have a very good chance of working. If you want to see her website and how it is all set up now that she has learned a lot, search for www.the1896.com and see what she has done.

Are there more ways to make money? There sure are. I talk with successful artists all the time and I ask them how they do what they do. Many of these interviews are on the website www.artworldinterviews.com. Those interviews are all from my Yale University radio program where I interview artists as well as curators, critics, museum directors, and more. I am fascinated by how creative people build their careers and how they thrive. Unlike any other profession, there seems to be an unlimited amount of ways to survive and thrive as an artist. Either make one up on your own, design a product, or look at a model you like that works, and duplicate it.

Another example of a method that you could use are subscription plans for your work. An artist that I mentioned earlier, Jorge Pardo, who is a well-respected artist in a major

New York gallery, created a subscription plan for some of his sculptures. I am using him as an example to show that just because you have a major gallery and an international career, doesn't mean you can't do your own commercial ventures on the side without harming the purity of your art career.

He has a subscription plan he came up with—he sent a letter to his mailing list and made a subscription offer—for $6,000 per year he would send the collector a sculptural lamp he would make every two months, and of course whatever they received would be a surprise, because Jorge had no idea exactly what he would make in advance.

The first year he did this, he sent out a letter and asked people if they were interested. From the first letter he found that sixty people subscribed, and in the second letter, sent the second year, he said ninety people subscribed. Ninety people at $6,000 is $540,000 dollars—quite a large sum to receive for work that was not even completed or designed yet!

He compares this to ideas like wine clubs or other online clubs where companies send you surprises in the mail, and he felt that people like him enjoy surprises in the mail.

I agree with him, as I am subscribed to some monthly clubs. I enjoy a vinyl record of the month club, because I am sent music in beautiful packages that I would not have bought otherwise, and I love that experience.

While Jorge has a mailing list already, he found a way to leverage that list and get more people to support work before it was made. This is a concept that you could do as well. An artist that I worked with, not nearly as famous as Jorge, did the same thing with small sculptures that could also be worn. She came up with a similar pricing plan. Not as expensive as

his, but lucrative just the same. In a newsletter she explained how the sculptures would be small surprises that subscribers would get every two months.

As your career evolves, you have to figure out how to pay those monthly bills. These ideas are entrepreneurial, which the business of art generally is. At some point you have to sell your work, and no matter how you do that, it is the same as having your own business and finding clients for your business. That is largely why you are reading this book—to find out how to run your business and build the appropriate relationships. We talked about the pros and cons of teaching, producing a product line of some kind, and selling prints, but there are of course other jobs out there.

The other jobs used to be working at a restaurant or a bar to make ends meet. If you have a family, that will usually not be enough to sustain everyone. Early jobs I had were carpentry, cooking in a restaurant, and washing dishes. The problem with the best of those jobs, which was carpentry, was that I

came home exhausted. It doesn't help very much if you can only make art on the weekends, so it is helpful to have a job that is not too physically tiring or stressful.

Another example of a job that might be helpful and rewarding is working with people who truly need your help. You can be creative here, too. After my parents died, I began to think about helping people in nursing homes. I play guitar, though not very well, and began calling nursing homes and asking if they would like me to come and play guitar. They paid me for doing so, and it was rewarding and not exhausting. However, I didn't know too many songs and wanted to do something else to help that would not rely on my musical talent! I saw so many people just sitting around these homes looking bored.

I read somewhere that people in nursing homes were using the Wii game system for bowling and exercise. So I did the same thing. I called nursing homes and told them I could teach the residents how to bowl with a virtual gaming system (I had a Wii system at home) and they agreed. I would bring this small system to a home, and hook it up to their big TV and have fun teaching them. I got paid well, but that was just the start of it! Soon I worked with the director of the home and we created leagues and played against other nursing homes, which was terrific fun, and made me feel as though I were truly helping, and left plenty of time for me to make art.

This may sounds like a truly odd job to you, but I mention it because it was not entrepreneurial in the strict sense: it was a job I invented for myself, but its rewards were much more than monetary. Seeing the smiles and laughs on people who were bored in their environment lifted my spirits and made me laugh and smile as well. I was an independent contractor,

as they called me, but I was essentially working for nursing homes, able to change my schedule when I needed to, and came home every day feeling good and filled with energy.

There are other jobs I could suggest, like working in the health industry if possible, which might also give you positive feedback at work so that you don't feel so exhausted when you get home or to your studio.

Other possibilities are online jobs. You can freelance online if you can write good copy or design a logo or other kinds of website production. There is an online freelance site called Upwork, and you can essentially set up shop there and comb through daily listings of jobs in your field of expertise. I use Upwork to hire people for different jobs. You can translate text for people if you speak different languages, or you can do programming or almost any other task. In this instance, it requires expertise in a field of some kind. Or there is the current TaskRabbit, a site that can generate income locally if you want to do things like stand in line for people or assemble their Ikea furniture.

In the next chapter we will talk about a few case histories of artists and art-world figures who have done a variety of things to sustain and build their artistic career.

Chapter 7

Interviews

Here are interviews with impor-
tant figures in the art world to demystify their process: artist
and curator Michelle Grabner, critic Arthur Danto, art con-
sultant Todd Levin, and artist Allard van Hoorn.

Michelle Grabner

The first artist is Michelle Grabner, who I mentioned earlier
in the book as having a career as an artist and teacher as well
as a curator. In the interview that follows, she unfolds her
career and what it took to build it all. Her special projects that
I only briefly mentioned earlier, like the the Suburban and the
the Poor Farm are especially worth noting, as you could, of
course, do something similar.

The Interview

Carey: *What are you working on now? What's happening in
your studio at the moment?*

Grabner: A very big project. It's a solo exhibition at the Indianapolis Museum of Art which will open soon. So getting work together—it's going to range from all the past work to the present.

Carey: *So is this a survey of your work?*

Grabner: It's not a true survey. But it really is still focusing on the newer installation, some of the paper weaving projects that I've been doing. So it does run the gamut, but there are three very big rooms to fill. Then, there's some new work that has been commissioned for this as well.

Carey: *And so, how are you filling that space? I know that's kind of intimidating but wonderful! How are you managing that?*

Grabner: I'm working on a new hanging project, a new hanging piece. These sculptures that I call *My Oyster*. A curator asked me yesterday when I was on the phone with her, just what does *My Oyster* mean? Basically, "The world is my oyster." It's a sentiment of happiness. So that's a new piece that I'm into. That would be at the entrance.

And then we're moving to a gallery of paintings, and then we'll have the long hall that will have a massive platform and very colorful paper weavings that I've been working on. Another new project for the Indianapolis Museum show is actually a series of photographs. So I'm really looking forward to that project. They're being mounted right now. So that was something very specific to Indianapolis.

Carey: *Let's talk about where you came from—Oshkosh, Wisconsin. That affected how you began in all of these. Now you're a painter and conceptual artist, and have done so many projects. I'd like to get to those soon, but what was it like growing up in Wisconsin? Oshkosh sounds like the quintessential town away from everything. What was that like?*

Grabner: I have to say that everybody in my family, my uncles, my grandfather, my father, there's a lot of vernacular art practice, or vernacular activities going on, whether it was wood carving or carving decoys or natural landscape. I mean something that wouldn't be considered in the contemporary art world. But there were a lot of activities. So that kind of crafting, engagement in making things.

Carey: *So how did you get to the Art Institute of Chicago?*

Grabner: I always like to tell this story, especially to my students. I went to the University Wisconsin–Milwaukee for an undergraduate degree and then a graduate degree in art history. And when I wanted to get my masters, I wanted to go to the Art Institute, but I was never able to get into the Chicago Art Institute, and that is the department that I'm teaching in now. I have been the chair of the art department for four years, but it's the school that wouldn't let me in. I wasn't good enough to get in when I was applying to school.

So this is how it is. You just have to be patient; it's the story that many artists have.

Carey: *Did you have supportive teachers early on?*

Grabner: I had a really terrific high school art teacher. For three years, Mr. Perez was there for me and really supportive and could recognize some innate ability that one could have in terms of recording the world in front of you. And that was just supportive.

He reminded me or told me that you could go to school and actually get an art degree and that, I think, surprised me. So you know, I don't think it's a rare story, an unusual story, but Mr. Perez was there to inspire me through high school.

Carey: *Sometimes it seems it can be a pivotal moment—how a high school teacher can have such a huge influence on someone's life. That's a story that I've heard from other artists, from people who were in the middle of nowhere who ended up in the Venice Biennial because, essentially, someone said in high school, "I think you should do this."*

Grabner: Exactly, it just opens up the world, and especially at that point in your development—young adulthood—when you think you know everything and you actually know nothing. And so you need somebody who is very inspirational to see.

Carey: *I'm interested in what happened between getting your master's degree and the first project which was the Suburban, right? Then the Poor Farm, correct?*

Grabner: Right. The Suburban, which is now sixteen years old. That's been going on for a while. I was raising two small kids, I had one when I was in graduate school. And I was trying to nurture and concentrate on developing an emerging

practice. When you are in art school, as we know, it's a bubble; it's very different than when you step out into the real world and face these kind of forces and conditions that want to erode that kind of concentration, especially when you have a young family.

So we moved, and I was down here at Northwestern getting my master of fine arts. We moved to Milwaukee just because it's a smaller town, and I'm in a place where we could feel like we were dedicating ourselves—I say we, because my husband is also an artist—dedicating ourselves to a work habit. Evolving a vocabulary that was more true to our lives at that time.

We did that and then I started doing a lot of critical writing when I was in Milwaukee, too. I went to grad school, my husband went to grad school, and so there wasn't that much language or discourse happening in Milwaukee.

So we'd come down to Milwaukee quite a bit and start to curate at the museum, it was just a smaller city, so it enabled us . . .

Carey: *I'm sorry to interrupt you. But exactly, how did you do that? What were you writing for and what did you curate?*

Grabner: I actually started writing for *Frieze Magazine*. I was writing reviews from Chicago and covering the Midwest for *Frieze Magazine*, and writing for something that was a small art publication in Milwaukee called *Art Muscle*, so really kind of covering a lot of bases, and there wasn't a lot of internet presence of criticism at that point. So really publications for the most part. *The New Art Examiner*, obviously, which is a real terrific art publication coming out of Chicago and writing reviews and essays for the *Examiner* on a regular basis.

And then when it came to curating, it was mostly curating exhibitions at some of the college or university spaces up in Milwaukee. So bringing artists from Chicago, people we were in school with, bringing them up so we could have that exchange again.

So that's how I started the curatorial projects. You were in shows, you know, little shows at the Milwaukee Art Museum or little shows at Milwaukee Art & Design School.

So that's how that happened. And then in 1997 we moved down to Chicago. And that's how we started the Suburban.

Carey: *I want to ask you about the Suburban, but before we get into that, when you started saying you curate some shows at the Milwaukee Art Museum, small shows, that's a pretty powerful entry in a museum. How did you curate those shows? Did you just meet people there and propose shows? Or, how do you think that happened? That's a big step!*

Grabner: [Laughs] Yeah. It was a little in-house. So when I was writing my thesis and working on my masters in art history at the University of Wisconsin in Milwaukee, my office-mate at that time started out as a sort of a curatorial assistant at the Milwaukee Art Museum and then became the curator, the art curator there. So we had a relationship. So through that, he was the connection to curating there.

As everybody says, it's who you know, right? [Laughs]

Carey: *Right. Let's talk about the Suburban now. How did it begin? And how did you and your husband start that?*

Grabner: We wouldn't be brave enough to do it now. There was something about 1999, and still being young, and still being quite amused and curious. We just thought, "Well, if we invited people from a museum and from Europe, from St. Louis, from New York, people would come." And they did! I think that was pretentious of us but it was exciting, and it launched a tiny, little institution here, here in Oak Park. Then artists from Madison, Wisconsin, or from Florida come up. So it's been a range. I think, we're pushing over two hundred and fifty artists at this point.

Carey: *So initially it was a piece of property you owned and a building. I mean, just to ask you more details about it. And was there funding for this or did people come on their own? How did the whole thing become funded?*

Grabner: Both my husband and I were able to move back down to Chicago because we got full-time teaching jobs. So

we funded it from our pockets. We don't sell artwork. But we're not in that for profit so I didn't apply for grants.

It's our responsibility as artists to give back to artists. I really think I learned so much. I mean, there's a selfish underpinning to the whole project because artists will come and they stay with us. We'll take care of them for up to a couple of weeks, if they want to stay that long.

We just had an opening yesterday. It's a small, little space, so I should be a little descriptive here. It's a small cinder block building, a ten-by-ten-foot space. In 2003, we added two more spaces, which are little exhibition spaces that are maybe ten by twenty feet.

So, you know, they're unique, they're all in the backyard of our house in Oak Park which is a really interesting first ring Chicago suburb because it also hosts Frank Lloyd Wright's home and studio. So there's a kind of a nice relationship of thinking about the suburb as an interesting place for making work as opposed to a suburb as a place of escaping what is going on in the city.

The Suburban is giving an opportunity to artists to think through a display of the way they think through art making in the studio. So we don't curate. I mean, the closest I come to curating is maybe having to schedule somebody. If somebody has a good idea, they all approach us. As I'm traveling and I meet somebody in Los Angeles, I will say, "If you're interested, come do a project at the Suburban." We don't say, it would be great if you can make us a sculpture. We just let people do what they need to do.

And I think of a really good example would be when David Reed, a New York artist, did a project here. He had never

shown his drawings before and so he wanted to take this opportunity to do it. And he had a really great show of drawings. And within two years, he had a big drawing show.

So sometimes it's giving an artist an opportunity to think through their work differently. We're in the suburbs, so you come and stay with us in our house, the spaces are small, so you can try something out. I do see the Suburban as an exhibition space but an exhibition space where artists make the decisions. They can fail, they can succeed, they can try something out that they wouldn't if it was a commercial gallery or a proper institution.

Carey: *That's wonderful. It was also obviously very generous of you, and both of you had to collaborate on that. I mean you still had children that were growing up right? Right there in the house and you're paying for the guest and everything. So that's a lot to take, but I love that idea, too—of artists giving back to artists because that also creates a support system for them but also for yourself as well. Right?*

Grabner: Absolutely. And again, as a teacher, I'm in my studio and I make a very specific kind of art that's repetitive. Art that deals with pattern and I know that works, I understand this is true of it. But when I have somebody, when I have a photographer that is coming up, a photographer who is dealing with light and phenomena, I engage in that conversation.

So it's not a matter of the Suburban being a platform for the work that I like or that my husband likes, or something that we're ecstatically aligned with. I get to know people's process. How they think when they're installing work. How

they think when we're sitting at the breakfast table, having pancakes, before we go out and help them install.

So really this helps me, and it's fascinating. There's no cookie cutter in terms of how we do this and it makes me a better teacher, it makes me a better artist because it also takes the pressure off of my own studio when I can engage in ideas or just discuss with other artists about other ideas that they have. So it takes some pressure off of the narrow, limited vocabulary that I deal with in my own practice.

Carey: *It was also a great way to make friends. So now, let's move to the Poor Farm. You've been doing the Suburban for a while and then how did the Poor Farm start?*

Grabner: The Poor Farm is near Oshkosh quite obviously. So it's my neck of the woods, so to speak. The kids were getting older, we were thinking of a different studio. The city is wonderful, we're here teaching nine months every year but we felt we wanted to get a little cabin, or a cottage up in northeastern Wisconsin. That was the real situation.

So we ended up doing that. We bought a little studio, a little cottage up there, a little off the river near this poor farm, which is across the lake from this place that we built, and it was for sale. We looked at each other and the bank was still giving loans out in 2008. So it was early 2008. And by the end of the summer, we had it.

We often say it is the Suburban's real cousin, where exhibitions last a full year as opposed to every six weeks, every month, in terms of turning over. But the space is huge. This is a massive amount of exhibition space and a lot of land. So

if we were going to move to Wisconsin, we better create a situation where we can bring artists, give them a place to be, in a place that we love, a place that we find very beautiful. I guess it's just our character that we want to invite artists and see them work and give them opportunities.

Carey: *And was this still funded by yourselves? I mean, that sounds like a big financial undertaking.*

Grabner: [Laughs] It is—we do a lot of physical labor up there, but also, we support it. But different from the Suburban. The Poor Farm is not for profit. We're a nonprofit up there, so we can raise money or apply for grants and I want to say that the Warhol Foundation has been really supportive. So that helps us, in terms of money for exhibitions, money for artists. In terms of the upkeep of the place, we spend some parts out of our own pocket. But again, we're happy to do it.

Carey: *So these things are developing, this is a whole artist community you're creating and generating a kind of support for artists. You're the first artist that I can think of that co-curated the Whitney Biennial. Wasn't that correct? How did it happen?*

Grabner: Yes. I think so. How did this come into being? How did it fall into my lap? I think it made a lot of sense. I think the Whitney knew what it was doing in terms of thinking about the last Biennial in the prior building. It kind of throws the doors open. Bringing curators from the outside. Bringing them from outside of New York actually.

That made sense from the institutional standpoint, because I write a lot. The Suburban and its reputation as well as the Poor Farm's reputation have made their way to New York. I think that is kind of how it ended up. I always kind of cynically say, it wasn't because I make good work—and I have nothing to do with the curators liking my artwork or wanting to bring me on board. I think the sheer amount of writing and the project spaces that we've been talking about means that I'm an organized person and I was going to be able to write a catalog essay and work on some of the ideas. So I think that helped.

Carey: *And the writing that you were doing over the years, because you talked about that earlier—you continued to write for some art magazines, do reviews and criticism. Is that correct?*

Grabner: Pretty regularly. Lots of catalog essays for other artists. I say yes to almost all writing engagements. So in terms of what it does, the critical thinking that one has to go through

is invaluable. So yes, writing has always been something that I'm engaged in alongside my studio practice.

Carey: *Well, also because you were writing about all the artists, of course, that were in the Suburban and the Poor Farm. Is that correct?*

Grabner: That's right. We produce a lot of catalogs.

Carey: *So what's the future? What's next for you? Do you see this continuing engagement in the Poor Farm or is there another project like that you will develop somewhere else?*

Grabner: There's actually a kind of a big shift that's coming. This summer, I'm teaching at Skowhegan School of Painting and Sculpture. So I'll be in Maine all summer and I'm looking forward to that. But when we return, we're actually moving. We're moving from Oak Park, from the Chicago area back to Milwaukee, where we want build a building so the Suburban will continue, but it's a three-story building in Milwaukee, unlike the small, little spaces—and there will be two artist apartments above it. So you're welcome to come and stay and visit us. Everybody is welcome.

Then we will also be closer to the Poor Farm, which needs some attention. Ideally, we would like to put a geothermal system in. We'd like to be able to bring some kind of alternative energies to it. So it just means some upkeep and adding a little more love. We will go slow, and I think being closer to the Poor Farm will be helpful during the school year. I can commute, I can pop on the train and be down here and con-

tinue teaching at the Art Institute. And that's pretty terrific. So it will be fine. We're looking forward to the shift. And the Suburban will continue but it will continue in a new space in a new city. And Chicago has always been complicated to me; it still wants to measure itself against the big centers, and it is a center, don't get me wrong, but when it comes to the visual arts, I think sometimes it kind of freezes up. It calcifies a little bit and Milwaukee has none of those hierarchies. So there's a lot of freedom there and I always regretted feeling like I had to get back down to Chicago when we were in Milwaukee. I mean, this was the place for this course of action, for art making and now I think that I'm better, I can do more work. I'm much more imaginative when I feel like I'm off center. So off to Milwaukee we go!

Since Michelle Grabner is an artist and a curator, she can talk from both perspectives. Not unlike Currin, she found a way to develop and nurture friends and a community that ultimately brought her national and international attention. I think her ideas about conversations with other artists that didn't share her medium or even ideas is an important way to think about what it means to "network" among your peers, some of whom you may not relate to at all, but may have ideas worth understanding and sharing.

Arthur Danto

The next interview was one I conducted with the late critic and philosopher Arthur Danto, shortly before he died. Danto wrote for *The Nation* for twenty-five years and is credited with inventing the term "the art world." He is a critic I very

much admire since he writes through the lens of being a philosopher, and I am very fond of philosophy myself.

In reading this interview and applying it to studio practice, he gives a background of how he observes and thinks and thus, what a critic might be thinking in your studio when looking at your work. He also talks about what it means for an artist to have a "meaning" for their work.

The Interview

Carey: *To begin with, let me ask you what is it that you're working on these days, is there a particular article or writing?*

Danto: I'm working on a couple of things. I'm writing an essay on going from philosophy into art criticism. How I suddenly found myself, at a certain age, writing in a very different way for a very different audience. I did art criticism for *The Nation* for twenty-five years. So I'm writing a little, so to speak, an autobiographical study of my own feelings about that.

I really had a twenty-five-year career when basically I was at the edge of retiring from philosophy. Well, it took another ten years. Then I'm trying to write a sort of a little book, about the scale of the book on Warhol that I published in 2009, about really the simplest question: what is art?

I'd like to do that because it seemed to me that in my profession, the thoughts were laid out, like in *The Transfiguration of the Commonplace*—and that I'm part of the tradition, the traditional set of answers to the question of what is art. I think the history is that you can't get the definition of art until it's all happened, and it seemed to me that those great and important things happened in the sixties but have to be taken

into account in any definition of art all through history. And so that's a kind of a culmination of all the arguments I've been making down the years on the definition of art, beginning with "The Artworld" but then basically to *The Transfiguration of the Commonplace.*

Carey: *That was when you talked about* After the End of Art *as well, which was really when you began talking about Warhol and a whole new world of art which really carries us up to the present.*

Danto: That's right.

Carey: *We're still operating in this world of not reproducing, but where almost anything goes now. It's based in theory— which is part of your theory, isn't it?*

Danto: That's right. I mean, when you began to get the kind of cases that came up in the middle sixties where you couldn't blankly look at it and think, "Oh, that's art." You'd have to have a little bit of theory and you'd have to have, as I say, a little bit of history to see it as art. You'd have to know something about how a thing like that got to be considered art.

So that was what the theory is and how the history contributes—those were not traditionally taken into consideration, it seemed to me. My own experience of walking into the Stable Gallery and seeing all these things, boxes in particular, I thought, "I think I'm ready for that." I could see that experiences in my own history prepared me for that, but I also thought there are a lot of people who are not going to be prepared for it.

So I had this experience which I think I transcribed in one of the books. I had a friend out of Columbia who was the head of the art department, Andrei, who was a fine artist, a wonderful artist. But he told me a couple of years later, he said, "You know what I wrote all across the guest book?" He said, "I wrote, 'Shit,'" and I said, "Andrei, I wrote *The Transfiguration of the Commonplace.*"

Carey: *Was this the Warhol show? Brillo boxes is what you're talking about, right?*

Danto: Yes, but what people called different things—there were not that many Brillo boxes by comparison with others. There were eight different kinds of boxes but the *Brillo Box* was by far the star of that show. I mean, it's the only one that ever gets talked about. Nobody talks about the *Del Monte Peach Halves Box*.

Although all of the same questions come up with those as with the *Brillo Box* but the *Brillo Box* was originally designed by James Harvey who was an abstract expressionist, second-generation abstract expressionist and he was a master of lettering. You could see how influenced he was by the hard-edged abstraction of what was in the air and it's a magnificent piece of rhetoric for the contents of the box, whereas Warhol got the credit and Harvey got no credit for that at all.

Carey: *We're now almost fifty years from the sixties, when this huge shift happened in work. Now, we have students graduating school that are steeped in the theory from that time. As you*

look at art, as you look at all this time, where do you feel that has brought us now? Is it just a continuity of the past?

Danto: I don't think it's brought us sublimity. You know what I mean? I think that was in a way the end of art as far as I was concerned because you have a situation where anything could really be an artwork and the paradigm of that was Warhol's making a facsimile of an ordinary utilitarian box, and that they at least looked enough alike that you could think of them as indiscernible and, at that point, what's the difference between art and reality?

The answer to it is that what separates the two has to be invisible. You can't tell by looking at them. You can't tell by picking them out—if you read philosophy in those days and could talk about what art is, you would get a kind of Wittgensteinian answer which says that you can, anybody can just pick them out. If you had a warehouse of pieces of furniture and artworks, you could just pick them out. You don't have to have a definition. And I thought that with Warhol and Duchamp you really did have to have a definition.

Wittgenstein was very, very eager to get rid of the millennial question of what is art. Which was raised by Socrates in *The Republic* and has been going along for centuries. You can't just get rid of it by saying you can pick it out because we now know that you can't pick it out. You've got to have other ways of thinking about it.

Carey: *So now that we've inherited this, and young artists have inherited this, and most artists living today, but where is this evolving to? Are we still operating under this new paradigm?*

Danto: Yes, I think so. But people have to be taught to live under this paradigm because the question isn't an epistemological question. That is to say, how would we tell them apart? The question is an ontological one: what is it to be a work of art in contrast with an ordinary object?

That is really the problem that I worked on beginning a little bit with *The Artworld* but mostly in *The Transfiguration of the Commonplace* because in there I've identified two conditions—it's not sufficient, but two conditions of invisible things.

The first thing is meaning and second thing is what I call "embodiment." How the meaning is mapped on to the object, but then you need a third thing which is interpretation. I think the first thing that happens is you get a real vulgarization of what Warhol did, where people say, "Oh, here's a fuse box, it's a work of art." And so you have to say, "What makes it a work of art? What is it to be a fuse box?" and there what you have to do is to start thinking about the meaning and how the meaning is mapped on to the object and how we interpret it, which doesn't come at all intuitively when we're just talking about real things.

Carey: *Would you say this is what artists are working with today?*

Danto: I would think so, it's easy to back away from it because it doesn't seem very inspiring. But sooner or later—I like to think people read my books—they'll begin to see that they have to work even harder than traditional artists did.

They've got to be able to deal with meaning. I was very eager when I was writing those things to back away from the

formulas that Greenberg, for example, had introduced and where you'd hear all the docents in museums giving talks—what would that mean? What is the point of that?

My main interest was to reintroduce the idea of meaning, which was basically what Duchamp was interested in. He talked about retinal vision, retinal pleasure. He thought that most of the art that was being made—in his dialogue he says that contemporary art, everything—has been retinal art. He said that's not the way art history was. There was philosophical art. There was religious art, etc. The primary thing was not to give pleasure to the eye. The fundamental thing was to instruct the eye and he was very adamant about that.

When he talks about that—there was a dialogue at the Museum of Modern Art where he said that with the readymades, that they're surely an aesthetic, they're picked for their absence of any retinal pleasure. That's not so easy to find because he only came up with about twenty of them.

Carey: *So today, no matter what artists are doing, whether they're doing landscapes or different kinds of conceptual projects or performances, everything has to have this sense of meaning?*

Danto: That's right, and what I would say about that, Brainard, a good example was Marina Abramović performing at MoMA. I mean, anybody could sit across from another person but for it to be a work of art you've got to think about what it means and so forth. People responded to it as though they were aware of that, and it was in some way a very profound experience for them.

Carey: *Let's talk a little bit about art criticism today. You are writing, as you say, a bit of an autobiographical piece, and where you are coming from is very different from most critics, in my mind.*

Danto: Yeah, there are very few people who've gone from philosophy into criticism. I just fell into it because with my history I had set myself up as a kind of a nineteenth century philosopher. I was doing a five-volume work on the theory of representation and I began with a book called the *Analytical Philosophy of History*. I thought, why don't I just carry that out and say that what sets us apart from the rest of the world is the way we represent it. And then I did two books, one on knowledge, the *Analytical Philosophy of Knowledge*. And one called *Analytical Philosophy of Action*.

Then I got the fourth volume, which was going to be about art. I really didn't want it to be thought of as philosophy, but I found a wonderful title in a Muriel Sparks novel. And I never wrote the fifth because I felt that I was turning art into mainstream philosophy, which I would only get into arguments with, and there was no reason to finish. I did write a one volume work of the whole system called *Connections to the World*, but that was my thing.

So the treatment of art in *The Transfiguration* was permeated with traditional philosophical questions about action and knowledge and was not so traditional about history, because what philosophers mostly have done has discounted history as differentiating people. But we've got the same physiology now that human beings had twenty thousand years ago, but we're very different. So history is a really an important puz-

zle factor there. So that's not as mainstream as the other stuff was, but it was most original, it seemed to me, with my work.

Carey: *Yeah. I think so, too. Your work to me has often seemed very generous in the sense that you're probing, you're looking, you're trying to understand as opposed to critics that are very opinionated in the sense that they're putting down work.*

Danto: Yeah, there's a lot of that.

Carey: *Like the popular Jerry Saltz.*

Danto: Oh, Jerry Saltz? Yeah, I don't think that well of him. I mean, I think he's a good writer more than one would think, but he does come in as a kind of ordinary person who is responding as an ordinary person will respond.

He does a lot of that, but his wife Roberta Smith is worse. I've got an enormous respect for Roberta but every once in a while she just goes off—just goes off on a tantrum where she bashes artists of high achievement, it seems to me. So she's saying, "You can't get away with that," and so forth. Artists like David Reed or Mark Tansey, for example, or Sean Scully, and I don't know why Roberta does that but she's a good critic for the most part if she's not dealing with artists who've gone off to a higher achievement.

Carey: *And Jerry Saltz you feel is in a similar area?*

Danto: I think so, yeah. I remember a few years ago I was writing a lecture for the University of Cleveland. They had a

show of William Kentridge and they wanted me to write a lecture on it. He said there, "William Kentridge is an artist in deep trouble, deep trouble," and so forth. Why is he in deep trouble? He's trying to make art, and he is an animator, that won't work.

Carey: *That's what Jerry Saltz said? That Kentridge was an artist in deep trouble?*

Danto: Yes. Jerry said, "He's trying to be a gallery artist using these things as drawings and so forth and he's not going to make it." And I thought they were gorgeous. And I thought: What's Jerry Saltz doing something like that for? Where does he come from by saying that he's in deep trouble? I mean, this is really one of the best artists around and is doing precisely the kinds of things that I feel artists should be doing, which is to awaken the viewer to the meaning of human life and love.

That is "making it as an artist" of many kinds, and when William showed his work and became suddenly a universal star of *documenta* in the nineties, he suddenly was giving people something that they felt was deeply missing from art. That is to say these questions about the power of love and so forth. I mean, it seemed to me that Jerry thought, "I've got him. I've got him by the balls," and he didn't, it wasn't within range of him. I mean, that kind of thing. It stuck with me.

Carey: *Yeah. I've heard him speak that way about many artists. In a sense saying what they should do or what they shouldn't do or how they should make that work, which seems an unusual position for a critic to take, really.*

Danto: Yes, well I think a lot of people think that's what a critic should do, as a matter of fact. When I got started, I have to say that my first impulses were similar to find my way. At first, I really was more negative than I ever thought I had the right to be later on, but that's how everybody who was writing criticism for a national publication was, really mean.

There was Hilton Kramer who is a paradigm. There was Robert Hughes who was a paradigm and he's getting off these terrific jokes, but demolishing people that way. It was difficult and at the same time that's not the way to be a critic, and so I changed the style and really tried to say what the meaning is, how the artist lets you know what the meaning is.

That, the two things: the content and the presentation that I found in Hegel's aesthetics. There's a lot more of Hegel in my writing than you'd be aware of, that anybody would be aware of. I used to read Hegel as a guide to what I was doing.

He was a great philosopher and I came upon him really almost when I was retiring but students asked if I would take them through Hegel's aesthetics. And I thought, well, it's a nice way to wind up so I did, and I was stunned by what a great thinker he was.

Todd Levin

The next interview is with Todd Levin, Director of Levin Art Group, an art advisory firm in New York City that assists private individuals in the creation and stewardship of large, museum-scale collections. This is a unique aspect of the art world, where some of the biggest deals take place and also where interesting collections are built. Mr. Levin is well-

spoken and offers a concise education on how the world of art advisors operate.

The Interview

Carey: *Can you explain your role at Levin Art Group? Exactly what is it that you do personally in the art advisory firm that you direct?*

Levin: The art market has historically had a lack of regulation with regards to transparency, and some individuals believe this situation should change. With so much money at stake, art advisors are increasingly responsible for a significant portion of their collector's net worth, and by extension earning large sums of money themselves. This has resulted in many unscrupulous and/or inexperienced people recently entering the art market, and specifically the field of art advisory. Some of these individuals have done significant damage to the reputation of my field. Because of the foregoing, I believe

any responsible art advisor today should act as a public face for the role of art advisory practice by conducting themselves with transparent integrity.

Carey: *I know you've been in this business for over twenty-five years—and as you're saying some come and go, or do damage, do unscrupulous things. You have a track record that's very powerful and very good. How is it that the art market becomes regulated? You said it was becoming more so, but it still seems that it's something that is, to my knowledge, quite unregulated compared to any other kind of investment. Is that correct and, if not, how is it being more regulated?*

Levin: One has to be careful how one uses the term "regulation." Some people attempt to make the point that the art market is completely unregulated, as if it's the Wild West. This is a fallacy, because there are existing state and federal laws that govern contracts and transactions that take place within the art market.

As opposed to other types of highly regulated business models that demand far more transparency, however, there is a distinct lack of transparency within the art market. That allows for opportunistic advantages as well as nefarious behavior to take place, which in other professions would be addressed by those contractual and transactional laws I just mentioned. I wouldn't suggest the art market is unregulated. That's an incorrect description. I would say that from a legal standpoint it certainly is a very opaque model.

Carey: *Right, and we were talking about nefarious actions or unscrupulous deals, is that essentially selling artwork to pri-*

vate individuals or, I imagine, even to public institutions, that is not valued at what the advisor is saying? Or is not as valuable as the advisor is contesting? Would that be an example of an unscrupulous behavior?

Levin: I suppose there's many types of unscrupulous behavior one could participate in. At its core, the job description of an ethical art advisor is to constantly provide their clients the most exceptional work available at the best possible price. An advisor is only going to be as good as the sum of their past experience and expertise. In addition, I should add that the true measure of an experienced art advisor occurs when the art market suddenly seizes or severely reverses. So there are other ethical concerns in addition to correctly vetting the authenticity and/or market value of artworks.

There can also be a great amount of manipulation that has to do with the market from a financial perspective. There is a fine line between attaining the best possible financial results from a purchase or sale on your client's behalf, and being involved with market manipulations that could negatively impact an artist's market in the short- to mid-term. There are other situations where strong conflicts of interest exist. One must work strenuously to avoid conflicts of interests.

Carey: *I understand what you're saying. An example would be buying a lot of an artist's work to inflate the value of work, right?*

Levin: As far as an example, let's think of it this way. I have a client who has an interest in a specific artist. I then agree to work with a second client who also would like to purchase

work by the same artist. After this, I am later offered a once-in-a-lifetime opportunity to access what would be considered the masterpiece that this artist created.

So I'm offered this singular artwork: to which of my two clients shall I offer it? I have more than one collector avidly interested in this specific artist, and they both have the requisite monies required to purchase what would be considered the most important artwork by this artist. At that point I have a strong conflict of interest: deciding who gets this artwork. And that creates problems for art advisors. I've had discussions many times with a number of advisors whom I respect tremendously, and this is my standard query. The general response I get is a shrug of the shoulders and the offhand response, "Oh, you know, it all works out in the end . . ."

I'm specifically interested in these matters because I'm a board member of the APAA [Association of Professional Art Advisors]. And not only am I a board member, but I also participate on the specific committee within the APAA that handles ethical issues. These are the sort of queries we discuss in committee. We try to come to an understanding as to how an art advisor can behave ethically within a market that is opaque, as we said earlier, and also fraught with these sorts of conflicts of interest.

Carey: *What this brings to mind for me is hearing dealers like Larry Gagosian or other major dealers kind of vetting their clients to some degree based on their history, their collection. So if you just want to buy an Anselm Kiefer, as I understand, you just can't go in there and buy that one piece.*

Levin: In the case of a gallerist most people assume the gallerist's client is the person who walks in with the wallet to purchase the work of art. But the true client of the gallerist is their artist. It is the gallerist's responsibility to have the best interests of their artist at heart, and not necessarily the collector. It's understood that more than one collector will want a specific work in an exhibition by an artist at a gallery such as Gagosian, so Mr. Gagosian's job is to decide where that art should be placed to best serve the interests of his artist. If the artist's work is in demand in general terms, of course there would be more than one person who would want a specific work of art in a gallery exhibition. Particularly in an exhibition where a couple of the works are clearly viewed as being the most desirable. That's a normal state of affairs, so there is no conflict there.

Now, for an art advisor, who is their client? It is neither the artist nor the gallerist. The art advisor's client is the collector who is paying them for advice and counsel, and hired the advisor to access the very best works available and then negotiate the best financial transaction. As I said earlier, if an art advisor represents a number of clients, and all those clients want the exact same art work by the same artist, the advisor has a legitimate conflict of interest.

When you discuss what a gallerist's responsibilities are and what an art advisor's responsibilities are, one must be clear that these are different situations with different end goals. Whether a gallerist or an art advisor, one needs to understand who the client is in any given transaction.

Carey: *Are you only working with, or looking for, major blue-chip artists who have had a very extensive exhibition history?*

Levin: In my career I've worked with a very broad range of historical periods and price points. When one starts out, one is usually on the lower rungs of the ladder in terms of access and the financial amounts involved. If one gains experience and expertise through time, and is recognized as increasingly capable of curatorial responsibility, one moves up the ladder in terms access and financial strata.

I began with art of my own generation. I think it's natural to begin with one's peer group, and in my case that was artists of the eighties. Gradually my career broadened and deepened, and became much more multivalent. Today I would agree that the majority of my time is tied up with what you identify as 'blue-chip' art, for lack of a better term.

Carey: *I'd like to move back a little bit in time to your beginnings in art, maybe the eighties or earlier. What was it—and this could be very early in life if you want—what was it that first attracted you to art, as a child, as a young adult? Do you remember your first experience with art?*

Write a beautiful letter, by hand, and mail it to someone you admire, then wait for a surprise.

Levin: There is no distinct origin point for me. I grew up in Detroit with a single mother—a very well-respected and sought-after interior designer who was also an art collector. I was exposed to the visual language of art and design from my earliest memories. As my mother was single, I traveled everywhere with her, which meant artists' studios, museums, galleries, and alternative spaces. It was a regular part of my life since I was a child.

Carey: *That's fascinating. What was she collecting? That seems an extraordinary experience to me as a child. That's quite a vision to have as a single mother, I would think that with all the other things a parent has to go through, that building a collection is quite visionary, really.*

Levin: I think collecting was a natural outgrowth of my mother's interest in visual language via her interior design practice. And much of the art that she collected has a distinct graphic aspect. Not unlike, perhaps, design renderings or architectural blueprints. It was something that was around the house. It's something I was accustomed to.

Carey: *And you're also watching and listening which is kind of unusual to see for anyone to be going into artists' studios as a child, because it sounds like she's buying directly from artists and you're hearing the questions she was asking, and how artist are presenting themselves, correct?*

Levin: One must remember we're talking about the early/mid-sixties. A very different time and place. There was no

art market of the type that we all accept now as the norm. Going to artists' studios was a much more common and low-key experience than it is now. There was very little money on the table for a gallerist to worry about if a collector went to a studio to "buy direct." That would now be seen as a financial arbitrage depending on the artist and gallery involved. Things have changed greatly in the last forty or fifty years in the art market.

Carey: *So what happened next for you? What happened in college? Were you taking courses in art then, or learning more about the art world so to speak?*

Levin: In university I had a dual interest. I had an interest in visual art because I began collecting art in high school. I also had an interest in music, and attended university for doctoral studies in music composition as well. During my university years I developed very strong relationships with artists who I found interesting in my peer group. I was coming to New York regularly at that time because flights were very cheap and I would crash on [artist] friend's floors or couches. I was exposed to art and artists in the East Village from the late seventies forward. At that time, it seemed that every person I saw on First Avenue was someone in the art world that I either knew personally or recognized. That was my formative first-person experience which I drew upon later as an advisor.

Carey: *And the artists that you were initially interested in were, I imagine, the seventies and eighties artists. Do you mind*

saying who those artists were that initially drew your interest? Who of your generation did you begin buying, trading, etc.?

Levin: Well, my mother was collecting artists of her generation—Calder, Johns, Kelly, Lichtenstein, Nauman, Warhol, etc. I saw that she enjoyed the experience of going to studios to meet and talk with these artists, as well as their gallerists. She enjoyed having discussions with lively, intelligent people. It was important to her. In addition, my mother also felt it important to be a good community member in the arts. She participated on a number of committees and boards at the Detroit Institute of Arts.

It was natural for me to emulate this model of behavior. By the time I was in high school, I was already interested in art and collecting, but mostly on a regional level. Then, during my time in university, I became interested in artists of my own generation. And that was the reason why I began to travel back and forth to New York on a regular basis, to be directly involved in the creation of culture that interested me, in the same way I had seen my mother participate in art of her time.

Carey: *And who were some of the initial artists that you collected?*

Levin: Many of those names one would recognize today, and there are many one might not. Most were part of that eighties East Village scene, either centrally or tangentially. Basquiat, Bender, Bickerton, Condo, Haring, Halley, Holzer, Hujar, Koons, Kwong Chi, Noland, Prince, Steinbach, Taaffe, Thek, Wojnarowicz, and many, many, many more. Some names are

all but forgotten, but they still have tremendous meaning to me because of the time and place I associate with those artists or their specific works. Separately, I also began a love affair with Surrealism at that time, particularly Joseph Cornell, and began buying his work which continues today.

Carey: *Absolutely. You mentioned David Wojnarowicz . . .*

Levin: Yes.

Carey: *Amazing artist.*

Levin: It was clear when one encountered his art then that there was a tremendous amount of emotional power distilled into those works—but I only knew David in passing. We had met and talked a bit and I always thought that his work was incredibly powerful.

The eighties were a different time. There were many talented people—artists, critics, gallerists, curators, performers, musicians, writers—all crushed into a small geographic area together in the East Village, and interacting on a daily basis with one another. That sort of communal spirit has been lost today in favor of another model. There is a tendency for one to look backwards through halcyon rose-colored glasses as one advances with age. Some things are better now, and many things are worse, but it was certainly a different kind of a model specific to that time.

Carey: *Yes, it's hard to say that there's a scene like that now. I don't think the Lower East Side would be the equivalent of*

what was happening in the eighties, unless you see it differently. The idea of artists opening spaces and having conversations is something that was specific to an eighties East Village art scene that isn't happening now, is that kind of what you're saying, that kind of communal support?

Levin: Art and culture thrive best in a bifurcated economy. By that, I mean either a very strong or a very weak economy. Most recently we experienced a period that generated tremendous amounts of wealth for consumers of culture. That means there are lot of people with massive amounts of excess capital, and they have to find a place to put all that capital. They're not going to put it in the bank at one percent. Those people have decided for the moment that one of the areas they feel is a wise place to put their money is art.

Equally powerful for art is when the economy is extremely weak. In that case, arts and culture are most creative when rents are depressed and gallery space is plentiful. Curators, critics, and artists are able to engage each other in the same place. Those sorts of conditions lead to what economists call low barriers of entry. It basically means that the only requirement to participate in a cultural economy at such a time is to be creative, because in a weak economy there are no cost-prohibitive factors. This meant that huge influxes of talented artists flooded New York starting in the late seventies, and that increased the chances of more creative and interesting things occurring in New York. And this all happened vividly during that East Village period of the eighties that we were discussing.

The key point to grasp is that the economic downturn that began in the seventies, interestingly, was significantly positive for creativity in the long term.

And this is the reason that when you ask me if the current scene on the Lower East Side might turn in to an East Village model, my answer is no. It can never be the East Village as it was, nor should it be—it's an entirely different thing. The cultural world in the late seventies and early eighties was shifting from modernism to post-modernism. And that was a thumping, epic cultural sea change which only happens once or twice in a century. The previously strict adherence to art forms, and the definition of culture and cultural products were being completely reconstructed during that post-modern period in the East Village. In essence, it wasn't the Duchampian modality that "anything was art" anymore—but instead, anything had the potential to be an art form. As I discussed earlier, that meant all modes of production were in the same geographical space at the same time. And there was, for the first time, no longer a proscenium between creator and audience.

What's interesting about all this is just a few years later, by the late eighties, the market translation of culture into a consumer product began with a vengeance—what we now term the commodification of culture. All this happened within a very short time—that incredibly fertile DNA existed within a very short span and birthed an unusually powerful confluence of ideas.

Carey: *Would Detroit be an example? It's very clear what you're saying, but do you think Detroit might be having all that potential now?*

Levin: Detroit is discussed as having potential for artists is because it's cheap to live there. It's great if an artist can buy a house for $5,000, but the larger issue is that there is no centralized cultural apparatus in Detroit, and there never has been. I don't think there ever will be. I should remind you that I am from Detroit, so this is not me talking badly about my city. I would say the same thing about any other American city if applicable. New York is unique. It is a place where certain kinds of things happen that wouldn't happen in any other American city.

Carey: *Also, as you were saying, there was a sea change from modernism to postmodernism that took place at this particular time in New York and was manifested in a certain way. Whereas, in Detroit or other cities you may have inexpensive rents but there's also not this kind of sea change. I don't know exactly how to put it, but perception of culture or artistic practice was happening as well, correct?*

Levin: I think your observation is the crux of the issue. Furthermore, creativity is fundamentally about generating new ideas and new forms. And it's that cycle that I discussed earlier of a very depressed and then a very thriving economy that makes New York a consistent entry point for the new, where people go to produce the new, and the marketplace where the new can be bought and sold. The art world is simply the apparatus through which the artist is threaded into general society.

Carey: *Todd, it is exciting talking to you about all these aspects of the art world that you've experienced. And also about you*

as a collector, as someone who values and understands artists and looks into how this whole system is to some extent created and continues to grow. There are artists listening to this who are from a lot of different groups, most are students, mid-careers, older artists and they are from all over the world.

One of the questions artists have, of course, which a lot of people feel differently about, is how to enter into the market. And that doesn't necessarily mean how to enter into major collections, although it could be that, but artists are in their studios wanting to sell more work, wanting not to think about selling more work, knowing that as you say that there are all these people out there that have income that they need to spend somewhere. Without going too much into the marketing, and you can really take this anywhere you want, but if there's something you want to say to those artists about how they are managing their careers and thinking about sales, which they'll understand is kind of a double-edged sword: not to think too much about money on the one hand, but it's hard to ignore, especially in this economy—the market and its vastness as you're talking about.

Levin: That is a very broad question. On one hand, one hears artists, critics, and cultural observers talk about art and money, and suggest that they should be completely separate things. This view espouses that the artist should be divorced from transactional methodologies of any kind.

I don't think artists need to be divorced from art market financial machinations. I think the actual problem is that it is impossible to interact with art in any meaningful way, aesthetically or monetarily, if the only discussions taking place

are about its price. The meaning of art collapses under the brute weight of pure quantification of data without the requisite education and real world experience to qualify that data meaningfully. And if the meaning (one could also use the word "value") of art collapses, so will its price, sooner or later. Art has offered me a way to better understand myself. If we only discuss art as a mythical asset class, and divorce it from why it was created in the first place, then art and money exchange roles. Money becomes divine by being translated into art, and art becomes commonplace by being translated into money.

Artists who have an interest in trying to enter the art market must be realistic. There are exceptions to every rule, but the reality artists have to understand is if they want to participate in a locally- or regionally-based art market, they can do that anywhere. They can do that in Detroit. They can do that in San Antonio, and they can do that in Portland. But if an artist wants to participate in the international contemporary art market as it exists on the level of important galleries, international art fairs, and major auctions—and it's not for me to tell an artist that this is a worthwhile thing, that's for the artist to decide for themselves—then they're going to have to be willing to put themselves geographically in a place where they can participate directly. New York, Berlin, London, Los Angeles, etc. Those artists will also have to be willing to engage the financial realities of the art market—but again, that's a decision for every artist to make for themselves.

It's a real miscalculation, however, if an artist feels they can participate in a meaningful way in the international art market, yet simultaneously remain fully outside that system. Precious few artists are able to do that, and those that man-

age that rare balance usually have accomplished it by actively participating first when they were younger, and as they gain stature and independence are eventually able to set their own boundaries—artists such as Cornell, Johns, Martin, and Nauman come to mind in this regard.

Carey: *Thank you Todd.*

Allard van Hoorn

This last interview is with an artist named Allard van Hoorn, and is a fascinating look into how one artist began in his thirties, found an unusual medium, and has been a nomad ever since. I have interviewed hundreds of artists now from Europe, Asia, the Middle East, and the Americas, and the most interesting ones have found something that continues to drive them, something like a quest. I think this next interview is one of my favorites because it contains what seems to me to be the quintessential quest of an artist.

The Interview

Carey: *I'm talking with Allard van Hoorn. He's an artist that is nomadic, traveling all over the world for site-specific work that he produces. At the moment we're talking to him from Italy. Allard, thank you so much for being with us today. Let's talk about where you are now. I know you're in Italy at a residency. Can you tell me a little bit about the residency and what it is that you're pursuing there?*

Van Hoorn: Yes, this is an open module of the UNIDEE, University of Ideas at the Cittadellarte–Fondazione Pistoletto. It's

a huge old textile factory that was set up by Michelangelo Pistoletto to exchange ideas and to generate agents for social change through arts. We're doing a workshop here based on architectural principles of the sixties and current movements that work towards changing perspectives on how we relate to our cities and to public space.

Carey: *So that's kind of a fascinating idea for a residency. It is an artist-created institution or residency and it's obviously a nonprofit. I suppose it's funded by the government, but perhaps you could say a little bit more about exactly what happens. Is there a workshop? Do you have a studio? Are you working there? If so, on what and for how long?*

Van Hoorn: Yes, there are different modules. We are working in a workshop environment with artists, architects, theorists, thinkers. We are generating conversation that leads to possible new directions for structures of education, exchange of ideas, peer groups that allow for our contemporary way of communicating, open travel, and the idea of producing our work with different groups in different places in a more mobile sense than maybe a generation before was able to do.

So here, I'm currently working on the twenty-eighth iteration of my project called *Urban Songlines*. This is a project that I've been doing since 2009. It's a project in which I translate public spaces and architecture into music by generating sound, site-specifically, and then translating that into music. The idea came from the aboriginals that relate to their public space, which is nature, through singing that topography, singing the physical shape of their land, mapping it spiritually,

embodying it and managing the relationship with that as well as with the animals that live together in that environment.

My objective for *Urban Songlines* is to translate public spaces into sound in order to listen to architecture instead of looking at it or inhabiting it. And finally to talk about these ideas of co-ownership and appropriation of public space through collaborating with musicians, dancers, skateboarders, roller derby girls, and technology in the audience in order, in the end, to make our architecture and our public space ours, the cities audible instead of visible.

Carey: *So let's talk about one project that you've done. I know that there's been several with* Songlines, *but perhaps you could talk about how one was done. Like the factory where you used the fuse box as a method to generate sound. It could be that one or another one. Where you explain a little bit about how the whole event comes together and how the sounds are generated. Perhaps what it even sounds like.*

Van Hoorn: When I arrive at a space, when I'm invited to work somewhere, I go into the space trying to find either historical references, future references, or current dynamics that are embedded within this shape and within the idea of the space.

For example, if you look at the Rosenthal Contemporary Art Center in Cincinnati, this is a space designed by Zaha Hadid. It looks like a gray concrete slab that goes up through a glass square lobby of the museum slowly until that hits the back side, the back wall of the building. And there, it goes up under a ninety-degree angle all the way as a spine, as a huge

slab of concrete sidewalk, then going all the way up to the roof.

The space is intersected by huge black hanging staircases that were too big to be made within the architectural curriculum. So these were eventually made by a roller coaster company and they hang in that space as a huge X. And what I felt with that space was the idea of playing with verticality versus horizontality. That sidewalk going up straight into the air all the way up to the roof of the building, to me it felt like a game that was playing with ideas of gravity to make it less sober, to talk about what a building could be, I made it into a huge marble game in which I invited local young dance groups to work with eight-foot helium weather balloons that I filled with air. So they were able to run those down the staircases, bounce them off of the wall and used that lobby and the staircases as a huge marble game in order to give it that dynamic.

Then I ran around while they executed choreography of a marble game as a dance piece with eight-foot white weather balloons. I ran around and I recorded the sounds of the physical description of the topography of the building. So literally, the shape of the building being described by the balloons, and with a handheld I recorded myself running around them, trying to keep up with them. Then I sit down in a break, import that into a computer and a laptop and then I create live music of that sound that they generated.

So the speaking voice they generated off of the architecture, off the building, I translate it into music. This becomes the singing voice of the building and after that they re-improvised because I played that music live in front of a live audience and they improvised again to that music completing the

dialogue of the dancers with the building. Then the resulting music is eventually pressed to vinyl records that I give it away to DJs for free. The DJs, through the technique of sampling, kind of redistribute that public space, that building in this case to a wider and wider audience.

As I said before, discussing this idea of co-ownership and appropriation of public space by a wider audience that does not necessarily have to be there at the performance. And that's kind of the complete way, the cycle for *Urban Songline* to happen. I've created twenty-seven so far in places as varied as landing strips, bridges, warehouses, squares, and all around the world. Basically, anywhere or everywhere.

Carey: *And the process you just described, the sound was coming from a number of sources. You're going around with the handheld recorder but was it also the marbles you were recording with the other sounds that were coming in, as well as what you hear coming from the balloons?*

Van Hoorn: Normally, it's only the simple tool that we use to generate the sound. So when I say make the building into a marble game, it's the balloons that represent the marbles. And it's the big balloons that roll down and bounce off the walls that I record.

So it's the feet moving of the dancers, their bodies against the architecture, and then the balloons against the architecture, and that's the only sound input. There's no other external input. It has to be a one-on-one. Let's say it's a homeomorphic description that's to be a direct translation of that input, that energy, the shape the building has to be. So the idea of

translating the exact shape into a new shape that is without loss of that shape. So what I try to do is to keep intact the original situation and by slightly intervening in it and creating something new out of it but not changing it.

Carey: *It sounds wonderful. I feel like I hear lately sociologists and other people talk about how our world has become more isolated. Not necessarily because of social media or computers, though I suppose that contributes, but we don't really function as small communities that are singing together, dancing together, eating together, sharing everything together, right? We're in our homes, apartments, studios living this kind of solitary life to some extent.*

I think of your project, the one that you were just talking about, and how it comes back to an audience and DJs are re-sampling and remixing. It strikes me as beyond the project itself. There's a social element here that could be redeeming. I don't know what the feeling is of an audience but it sounds to me like it's almost as though everybody's singing or making sounds together or feels that way.

Van Hoorn: I think it's definitely part of it, because the idea of rethinking public spaces, places where we spend so great a percentage of our times, and these are specifically the places that I want to reinitiate as agoras, as places of gathering, as places of rethinking our relationships to public space through having these joint experiences. The music that comes out is pretty subversive. So the building is kind of alive and submerges the people into the soundscapes that I produce. That music is, in a sense, to bind the people together and eventu-

ally in all the places where I execute these works there is this. There is a sense of community specifically because the collaborations are local.

So it's the local people getting an opportunity to work with their direct public space, in which they live daily, and create this kind of a new relationship; to rethink their relationship to public space.

Carey: *Let's move back a little bit maybe to the roots of you having this kind of perspective, this nomadic sense. How did you get involved in art as a child? Where did you grow up?*

Van Hoorn: I grew up in a fairly regular environment. Isolated, and far from art. I did several things throughout my life. I have studied mining engineering and until the age of thirty-three I did not know a single creative person. Everybody I grew up around me in those times were doctors, lawyers, business people, and academics. Until I was thirty-three years old, I was not in contact with anybody who was a dancer, musician, artist, even a graphic designer or performer, nothing.

So when I finally decided to find my personal relationship to the world, I decided it had to come through investigating my daily environment and doing something with that. So all my work ended up being about how we relate to a public space. And everything I do comes from that kind of newborn sense of learning because I had to start from the scratch and learn in every project that I do. So every project is different, every action is different and therefore I decided to travel the world to be able to understand different cultures and see different

places, in the end traveling to over fifty countries over the last years and doing projects in many, many countries.

It became my tool of investigation and my tool of learning about these concepts of belonging and becoming as an individual. About finding your place and rooting yourself not necessarily in one place, but in many different places at the same time, through maybe a more rhizomatic network of relationships that you create not only with the people, but through this longer ongoing investigation like the *Urban Songlines*. Actually creating this interrelated network of spaces that becomes music and then carrying it around in your little backpack kind of all the information that is gathered through all these spaces.

So eventually, I let go of myself. Since nine years ago, all my personal belongings fit into hand luggage, which has enabled me to move around very swiftly and easily. For nine years I've been traveling with only hand luggage and I became nomadic. Just going from place to place, making works there and working with wonderful people, beautiful collaborations and great institutions and ways of surviving through just relating to the world in different places.

Carey: *And so how do you survive as a nomad? I mean, I'm kind of interested in how you actually get and manage these museum projects. You're traveling around the world. In the very beginning, in your mid-thirties, how did you begin to have a relationship to the art world and support yourself with that?*

Van Hoorn: In the beginning you have to walk up to places and you say, "Hmm, new gallery, or new museum, I'm an artist

maybe we should talk," and you make stuff on your own and eventually these things come together.

I'm still a Dutch citizen so I pay my taxes in Holland and there is, as we know, some really good support from the Mondriaan Fund, and eventually museums that commission your work provide networks. There's a lot of residencies that I've done through the years and I've been teaching and lecturing in many, many places, from the Architectural Association and the Royal College in London, to the Sandberg Institute in Amsterdam, and several other institutions as a guest tutor. Eventually you publish, you write and you sell some works, some profits come out of these performances although they are scarce. Keep in mind that I have a very light and easy way of living. I don't have to maintain and replace a lot of stuff, so I can live financially quite nimble as well.

Carey: *In closing, it sounds kind of wonderful and also ideal to be nomadic in this way. I don't know anyone really that is as nomadic as you're talking about. There are plenty of artists who are doing a lot of residencies but most of the time is spent in their studio, or who are home-based in whatever country they're residing in. Upon reflecting on the last nine, ten years, how does it feel to be a nomad? What is that like in terms of just traveling or being in the world? Is there anything you miss?*

Van Hoorn: Well, the thing that you would naturally miss most is your books because books are always fantastic sources of inspiration and in a way you become mental collaborators between beautiful artists and thinkers.

What I learned to do is to find many online publications and I even buy books on Amazon and then sell them, give

them away to friends and ask the author to send me the PDF. So I tell them, "Listen, I bought your real book, I'm giving it away to a friend. Could you please send me the PDF so I can take it with me in my little laptop?" And so I gathered a great many books digitally.

Otherwise you adapt fairly easily—I find people are super flexible and adapt into any kind of situation. At the beginning it was more tough than now. Sometimes you find yourself being kind of isolated in a place, but by now I have friends in any place and everywhere I go. There's a huge network of artists as well as interesting people to meet up with, to talk to, and people who are willing to take you in. They understand the idea of sharing. I think the economy in our community is changing a little bit towards that dynamic. I feel very rooted. Any place I go, I can very, very quickly adapt. I have only the same clothes, four of the same shirts and two of the same pants and a pair of flip-flops and all the rest is equipment. As you will see through my performances, I'm wearing the same clothes through the years but I have four of the same shirts. So I tend to wash them in between but otherwise there's not a lot that I miss. I became fully adapted to this idea of continuously traveling, sometimes flying to another country up to fifty times a year. What happens in the end is you become rooted in all these places and you adopt this strategy.

Weaving Your Own Mystery

T his chapter will not just help with writing, but with understanding how to create a story about yourself that invites others to ask questions.

Writing, for most artists, is one of the more perplexing tasks they face. In this chapter I will discuss approaches to writing anything online. That would include getting media attention as well as critical attention for exploring ideas and issues that may be present in your work.

Writing is not a skill that comes easily to most artists, which is why you so often hear the phrase, "The painting speaks for itself." However, thinking is something that artists must do. Thinking about the world of ideas, the world of colors and context, or poetry, politics, the environment, and more. These are all ideas that may already be present in your work or ones that you have thought of to some degree. If you can think

about these things, then you can write about them, too. Perhaps not as well as you paint, sculpt, make photographs or installations, but nevertheless, you can write about issues that are important to you.

Social Media

Think of how a social media platform like Facebook contains so much writing by people who do not consider themselves writers. I find the most interesting posts on Facebook are about what someone is thinking or struggling with in their mind. It usually doesn't relate to their work, but to thoughts and ideas we all have. The posts about loved ones dying and about how much they meant to someone is an example that resonates with most of us. But comments and fairly long status updates can include writing about art and how someone feels about a recent show, or a recent political event, or something much more personal—about struggles in the studio, or struggles with health and more. This kind of writing works on Facebook, meaning it gets comments and interactions with other Facebook users. The artists making all these posts mostly do not consider themselves writers, but are indeed writing about art and life in a way that relates to their work. Part of the reason artists seem to write well on Facebook is that they are not thinking that they are "writing," but are rather communicating to others in a way that is not so self-conscious.

Looking and Writing

Being an artist is about looking at the world in a peculiar way, a curious way, and then reflecting some of that investigation in the work itself. It does not matter if you are an abstract

or figurative painter, or a photographer or conceptual artist: the work an artist makes reflects the culture around them and how they perceive it. From the grotesque to the political to the poetic, visual artists offer new ways of looking at how we all perceive the world around us. The more every artist is aware of this process, which is often intuitive, the more there is to write about and explore.

If you are using Facebook, Twitter, Instagram, or any other social media, there is often a question of what to write and how to meet people that you want to talk to on these platforms. For most artists, the questions is how to meet collectors, curators, and others who could help them in their career.

Writing for Online Audiences

The method I would suggest for writing on Facebook and most other online platforms is to be at least sincere in what you write (as opposed to sharing jokes and videos), because if you want to meet people and attract them to your art, then show off how thoughtful, kind, and sensitive you are. When I get a comment on one of my images on Instagram, for example, and it is more than "Awesome shot," this catches my attention. Perhaps it is something like, "This is my favorite, it's beautiful," or even something longer and less vague, like, "This reminds me of those ice cream trucks when I was little and the music they played." That last one was not particularly descriptive, but it showed that the person writing had a particular memory and feeling associated with the image I posted. If someone wrote that on one of my images and "liked" a few others, I would notice. I would read their comment, and the next thing I would do is click on their name because I want to

know who this sensitive person is. Is it an artist, a curator? I will find out by looking through their images, and in my case, I will begin to look at their images and might even comment to return the gesture. It is really that simple in the broadest sense, but is harder to do than it sounds.

The Personal

An essential theme of this book, and most books on advancing a career, is about the personal contacts and friends that you make. Those contacts are often made through inbox messages on social media or email. In both cases, the writing that you do in those initial stages will make all the difference. I would try to imagine how you would feel if you received the letter you are writing to someone. What if someone sent you an inbox message that said, "My show will be up until May 15, here is the link." Does that sentence attract you and want to make you click the link or go see it if you have never

Let the path of your career wander in new directions.

heard of this person before? I would think probably not. The reason is that it is the opposite of personal. It is a directive masked as an invitation. I get messages like this often. But when I get a message that says something more personal, like, "Hi Brainard, I am really enjoying your book, and have been finishing up my website as you suggest. There was one issue I had with using an email newsletter program and integration—is there an email program for newsletters that you would suggest?"

That is something I would tend to answer because it is a question that does not require me to review a whole site to see what is going on. If you were writing to a curator, you could also say something similar, such as, "Thank you for the great work you do, I just saw the show you curated at X space, and I thought your choice of artists mixed with scientists who approached the same subject matter was innovative and inspiring. Mixing two fields of study in this way add to both, and as an artist myself, I found it inspiring."

In that note, you are not asking the curator for anything, just making them aware that you are sensitive to who they are and what they do. Since you did not leave a website, it becomes even more sincere. Anyone who reads that will probably respond with a thank you at the least and will most likely look at your Facebook page as well. Even if they don't, in your next letter you can ask a question, or even, gently, send your website, or preferably talk about your work before sending it and ask if they would like to see work. Essentially, I am emphasizing writing that is personal and meaningful and not a quick note with your website link.

Your Story

Everyone has a story to tell, a story about who they are and why they do what they do. Even if you were not an artist, everyone has a passion of one kind or another that they could talk about. In crafting your story, which could be similar to what has been called an elevator pitch, you need to tap into some kind of passion. Since you are most likely an artist if you are reading this, you will be writing about your art and your life. How you end up telling this story in a brief biography or an artist's statement is of great importance, because it is how you will be initially perceived and perhaps even remembered.

Earlier in the book I reproduced the stories that my wife and I sent about ourselves for the Whitney Museum curator when she asked. That was my style and how I approach things. In the interview with Allard van Hoorn, he is telling his story and it revolves around a specific theme that we can all relate to. He talks about wandering and trying to find out what he really wants and who he would like to become. That alone is something we can all relate to and draws us in. Then he describes what eventually became his statement or theme on the basis of his experience with Aboriginal culture and the idea of *Songlines*, which was a method used by that culture to navigate or map existing structures and paths in the world. It is a concept that in itself is fascinating, steeped in myth, dreams, and a culture that is a mystery to most Western minds. He tells it in a straightforward manner, no unnecessary theory or mystifying, yet it is interesting and memorable while weaving a line of thinking throughout all his work. It also is something we can all relate to in some form; it is very

much about connecting with our environment, the people and buildings around us. It is also sincere. No matter what your story is, that is how easily it could be presented, as a straight-forward account of who you are, and how you became that.

The Form of Writing

That is the form I would suggest when writing about your-self and your artwork. Choose something that is memorable and reach deep into who you are and who we are as human beings. The idea of creating a mystery around yourself does not have to be as obvious as what Joseph Beuys was doing in his statements and texts and work, but that is of course valid, too, if that attracts you. Many artists like to keep it short and sweet and use a piece of writing over and over for statements, but the problem with this is that it can sound too smug, and leaves little room for exploring your ideas. Part of the form your story takes should be about exploring. Like the van Hoorn example, his idea can be continuously explored in many ways. This is extremely important because it is not about just one idea, it is about how you continue to discover new ways of articulating that idea over and over again.

As I write in the next chapter about talking to curators, the idea of structuring your conversation and approach will rely heavily on how you write about yourself and your interests. A teacher once told me that artists can often be heard say-ing something like, "I wish people understood me for who I am, not what I appear to be." His comment on that was that we are in fact only what we say we are. We are not the secret thoughts and ideas we have not yet articulated, we are our words. We are our pictures as well, but to understand art we

must understand the artist, and words must be used for that. Thus, your writing should be a clear explanation and exploration of what it is you are discovering and looking for in your work. It should tell the world what you cherish most and what you are seeking to understand. It should tell the world why it is exciting to be doing what you are doing.

It is acceptable to break the rules to some extent here. That is, you can be quirky in your writing, but you must be able to communicate clearly. For example, if you are going to create a poem for your artist's statement, it should be a poem that is narrative, or something that is understandable and somehow relates to your work. Most of all, the overtone of your writing should be about an idea or ideas that you are interested in. If not ideas, then perhaps topics or cultural reflection of some kind.

When in doubt or stuck, look at the writing of other artists. Look at the brief biographies of artists that have recently won grants or awards. When artists win awards or are given them without asking (like the MacArthur Genius Award), there is always a brief synopsis of the artists' work when announcing the grant or award. Those pieces of writing are great examples of how an artist's work can be summarized in a way that makes sense to the general public and can be easily understood. Usually that is done in less than a paragraph.

Chapter 9

Talking to Curators

I n this chapter I discuss how to present yourself to curators so that they become attracted to your art and your story.

In the academic world where most curators get their directions on how to pursue their careers as independent or institution-based curators, they are taught how to look at art and evaluate it from a cultural standpoint. There are also curators who do not have academic training and are putting together shows as well, but the majority of curators that you will meet are most likely coming from a curatorial studies program at a university. That means, in most cases, they will have had art history classes and learned how to create exhibits as well as how to visit artists' studios.

When visiting studios, they are told to look at work in a cultural context. That means that as they talk to the artist and come to their own conclusions, they are looking to see how the artists are reflecting contemporary culture today. In

fact, we all reflect contemporary culture to some degree, even those who are not artists. A teenager who is watching videos on YouTube and using Snapchat and other forms of social media is engaged in a form of the culture that reflects who we are as a culture and how teens might be responding to and interacting with specific forms of media

Artists do the same thing even if they are not aware of it, and this is part of what a curator is looking for. He or she is looking at your images and their content and thinking about how this might be a reaction to current political or social trends, or even popular trends in entertainment.

Laura Hoptman

Laura Hoptman was the senior curator at the New Museum and is now the curator of painting and sculpture at the Museum of Modern Art. Her focus is contemporary art. In the interview that follows, you will learn more about what she looks for and how she finds artists.

The aspect of talking to curators that I would emphasize most is discussing your ideas—not necessarily your art, but the ideas or impulses behind your art. That will allow a curator to understand and interpret your work in a cultural context, and it will also make for interesting conversation. Here is the interview with Laura Hoptman.

The Interview

Carey: *I'd like to begin by asking a little bit about your beginning in the art world. Where do you first remember becoming interested in either of the arts or in curating?*

Hoptman: Well, I'm kind of a special case because I've wanted to be a museum curator ever since I was a little kid. I grew up in Washington, DC, and we spent our weekends at the museums. I can remember when I was about four my mother did an art show in the backyard and I watched it. So it's just something that was part of my DNA from very, very early on.

Carey: *What was the show that your mother did in the backyard?*

Hoptman: We had a neighbor who is a painter and I remember her nailing the paintings to the pine trees in the backyard. I mean, we had a very culturally interested, if not sophisticated, family, and our thing was art and we went to the museums all the time. That was something that I always wanted to do and I focused all my energies as a young person on art.

Carey: *And what was the first curatorial work that you did? Was it something as out of the box as nailing paintings to trees? I love that!*

Hoptman: I went to graduate school in New York City, but before I went to graduate school I worked in film and video on the Lower East Side, actually right around the corner from where the New Museum is now, on Rivington Street, in a place called Film Video Arts.

So I started my art life in film, video, and performance. I also worked at a place called Franklin Furnace which was a performance and book archive. Then I needed some money, so I was a waitress at the same time.

I went back to graduate school a year after I came to New York. I came to New York City in 1983 and I went back to graduate school for art history in 1984 and started my curatorial career in the midst of graduate school.

My first curatorial job was at the Bronx Museum of the Arts, and for those who don't know that place, it's a museum of contemporary art that was founded in the late 1970s as part of the largest of the Johnson administration's Great Society programs. It's a place for emerging artists and I spent three years there, and I remember in my last year I made three hundred studio visits. Can you imagine? So it really started me, gave me a vocabulary, certainly, of the regional artists in the New York area.

Carey: *Was that in the eighties when you were doing the studio visits?*

Hoptman: Late 1980s, yes. In between, I also worked for Merce Cunningham, which was really interesting. I spent eighteen months with Merce because he was a dancer who was very involved in media in particular. So I worked at the film and

video department there for a while. And I also did some time at the Whitney Museum in the film and video department, which at the time, actually, I really loved.

So I had a little bit of experience, but not in curatorial capacity. My first curatorial job was at the Bronx Museum and from there I went to MoMA, which was a quite strange experience but I was very lucky because I had this huge vocabulary of emerging artists and I went to an institution which at that time didn't know anything about emerging artists.

At MoMA, I spent six years in the drawing department, and did a lot of exhibitions.

And then I did the 2004–2005 Carnegie International, which took three years of my life. And I came home to New York. Then decided to return not to a big institution but to the New Museum, because the New Museum was opening a new building here on the Bowery and creating a whole new staff. It gave us an opportunity to sort of envision a new kind of contemporary art museum for New York. That's my life in a nutshell.

Carey: *But you've been between several mediums. You were the drawing curator at MoMA and it sounds like before then, you were focused a lot on video and film.*

Hoptman: I focused a lot on performance first, then video and film. Not because I liked it but because that was where I could get a job and it was super interesting for me. I'm just very lucky that I have been active in an era in contemporary art where that kind of division between mediums doesn't necessarily have to dictate what you do in your life.

I worked in the film and video department at the Whitney but a few years after I worked there they dissolved that department altogether. So that there's no kind of apartheid now between media in museums like the Whitney Museum. And even the MoMA, which is famous for its divisions. I was a drawing curator and learned about drawing, but I did a lot of exhibitions that were all kinds of different mediums.

I did the retrospective of the artist Yayoi Kusama, who's a great, great person but a magnificent painter, performer, and filmmaker. I did a show called *Drawing Now* which included the work of—I think I had something like twenty-four artists. There were eight sections and they were wonderful, they are wonderful artists but most of them are probably not known just as drawing people.

There was, I don't know, Elizabeth Peyton, John Currin, the sort of heavy-hitter figurative painters of my generation were in that show. You can think of it more as an exhibition of drawing but really coming from the vocabulary of people who are painters—not exclusively, but most of them.

Carey: *You talked about doing three hundred studio visits, and I'd like to talk about that a little bit because I'm interested and I think everyone is interested in how you selected those artists. How did you choose three hundred artists?*

Hoptman: That's a very good question but I have a kind of a boring answer. We can talk about it in another way; for that particular job, the Bronx Museum had and still has a program called AIM, which is an acronym for Artist in the Marketplace.

It's a program for emerging artists where every week they come to the museum, meet one another, and learn practical information on how to survive as an artist in New York. How to do your taxes. At that time, how to make a portfolio or a slide or something to send galleries. The museum arranges meetings with curators, other curators, as well as gallerists, as well as tax people, it's all kinds of things and at the end of this nine-week program you have an exhibition at the museum.

So when you leave the museum—this was the thinking at least at the time and maybe still now—you leave that museum with kind of a community that you met. Some sort of life skill for artists, and that could be an addition to your resumé with a catalog.

So the time that I did most of my studio visits is the year and a half that I was there. I was making an exhibition that commemorated the twentieth anniversary of this program. I think it's now thirty years old. So I visited the alumni of the AIM program, plus a group of the emerging artists. It was a

kind of matrix. So how do you choose? Well, I have had one tried and true method my entire career and that is that I ask other artists. I'm actually married to an artist. I've been married to an artist for fifteen years. I always rely on artists to tell me what other artists to go look at.

Carey: *That's very interesting.*

Hoptman: Doesn't everybody do that?

Carey: *Well, everyone has different methods it seems. Some people do say that they do both. They have artists to rely on. Other people will talk about meeting other people when they're out.*

It's an interesting question, because one of the things that I'm finding from talking with different people in the art world, especially the people who've been in it quite a long time, is how the world has so radically changed from the seventies, and even the early eighties, and now. We're talking of so many more artists and a very different landscape. Even without the recession, financially, for artists it's a very different . . .

Hoptman: But—I'm sorry to break in, but the first thing I would think of was the idea that we're in a post-studio landscape, and particularly in New York because it's so expensive to establish a studio here. So there are a lot of people who have a post-studio practice. During the boom, there were a lot of artists that you would visit and very often there would be no work at their studio. You will be looking at it through reproductions because they had, for better or for worse, brought it to their gallery for sale, so it was rarely there.

I think that over the years what's changed for me in terms of studio visits, is that at certain moments, it has become a kind of a meeting as opposed to a kind of a discussion over objects.

Carey: *Let's talk a little bit more about how it's become more a meeting than a discussion over objects.*

Hoptman: I remember when I first met Gabriel Orozco—and I met him under other circumstances, I met him in an elevator. We kind of became friends. When he lived in the East Village he used to meet people in one particular place, Veselka, that Ukrainian restaurant. That used to be the place where we went to visit Gabriel and others.

The same with Rirkrit Tiravanija, an artist who I have known ever since I was at the Bronx Museum. He was one of my three hundred studio visits that early time. He was the first project that I did at MoMA when I got there. I remember how we talked about it and Tompkins Square Park was where we sort of worked. So all three of those guys were sort of post studio and that was my first experience of that. Not going into a basement or a studio, a place where there are things like paintings to see or something.

As the 1990s became the 2000s, and as the art market heated up so much, the studio visits became more and more in a way sort of bizarre, because you really were trying to chase the objects. More often than not you didn't find the objects in the studio with the artists, you found them in the backroom of their gallery or some other exhibition space, mostly commercial exhibition space.

I mean, even at art schools I remember very, very well up until four years ago going to art schools and having cases of some people not even having very much work. If I wasn't there for their MSA exhibition they could, some of them could have already dispersed into the commercial ecosystem. It's weird. I mean even to talk about it is weird.

Carey: *Has that changed also since then?*

Hoptman: I'm talking about very recent history now. I can't tell you absolutely whether it has or not, but I can see some changes. I go to a lot of art schools and I really treasure that ability. People ask me to go to places all over the country and also to postgraduate programs like the Core Program—I just came back from there, in Houston.

I think, as of this year, I do see a kind of changed atmosphere, a sort of less charged atmosphere in the studios of younger artists or emerging artists, if you will. There's more

stuff there. There's less of a push to get it out of there. There's less of an object orientation that shouldn't be a surprise to people who are looking at contemporary work. There's less painting. I'm a painting curator, but the ubiquity of painting became almost lugubrious. For someone like me that's hard to say, because I never thought I could get enough of it.

I noticed in art schools now there's a little bit of a chilling out, which I think is really positive. You know, that artists whose practice might not have been conducive to painting or making paintings.

Carey: *You talked about this thing post-studio environment, such as what happened with Rirkrit and Gabriel. They were all conceptual, though, which makes more sense. There are so many other artists who I would think are post-studio, who aren't conceptual artists who also have a studio practice, but it's very difficult to have a studio in Manhattan.*

Hoptman: Yes, that's the second. Yes, I completely agree with you and that's another contribution to the phenomenon of a post-studio practice. To making art in your living room as opposed to your loft in SoHo.

I came to New York in 1983 and I say this to people all the time—it's a long time ago but it doesn't seem that long ago to me—but when I came in 1983, I worked on Rivington Street but I could never afford to live in the Bowery or Rivington Street. Even in 1983, the rent in those bigger spaces, the loft spaces that artists traditionally would move into, cost real money. It's important to remember that those kinds of big spaces cost real money up from the late seventies. So you

have to be a generation and a half older even than me, and I feel ancient, to have been able to have a shot at the space in Manhattan or downtown or even in the East Village. East Village was cheap but it didn't have the big spaces that you think in your mind that maybe a sculptor would need, for example. So my generation lived, might have lived in the East Village, but they were already moving to Williamsburg where the big spaces were.

Carey: *So now that we're in the 2000s, what is happening to your visits? Are you going to Brooklyn more? Is it less feasible? Is there a different kind of process?*

Hoptman: I think so. I think artists are very intrepid and I'm very admiring of the way that artists manage to figure things out. Of course, after a certain generation you're not going to have a studio in Manhattan. After a certain generation you're not going to have studios in the closer areas of Brooklyn either. People push further and further out and manage to find places that they can work in.

I think that as the discourse evolves, so does the kind of work people do. I think when the recession hit everybody was saying, "Oh, the art will change," and it didn't change immediately. People who were painters didn't stop painting because people weren't buying their work anymore.

I think now that we're about almost two years out, about a year and a half out from the biggest crash, the biggest economic problem. I think probably that the pressure might be off a little from that sort of unrelenting pressure to make an object and send it to market.

Carey: *I think that's the case. I think I find artists do talk about how the pressure is off, but the way the pressure is on has always been to earn enough money, to continue staying where you are or to pursue your practice as jobs are more scarce. Or even if the jobs aren't more scarce, there's an even greater push to earn money and keep a studio close enough to Manhattan or a major museum so that you can be involved in the art world.*

Hoptman: I think that's an interesting thought. It's something I talk about with my husband all the time. This idea of whether it's very important to be close to the central marketplace that is New York City, because there are other marketplaces, too, but how important is it now at this moment to be close to the center in terms of economics.

I understand it's good to be close to a center because it's great to be meeting with other artists. I mean, to have a community, to not feel like some weirdo or like some Martian in a community that doesn't understand what you're doing or need what you're doing. But economically, how important is it to be near, do you think?

Carey: *I graduated school and I lived on Block Island for a little while, which was completely off the path, and I established a gallery and a magazine out there and most of the artists I knew from New York came out there and we had a gallery for the summer.*

In my experience, I thought I had really an ideal setup. I could work a few days a week doing carpentry and spend the rest of the day in a beautiful studio that was something like a giant loft—this one was a giant barn. The problem I was

*experiencing was that I felt that even though it was a very tol-
erant community and I knew many people in the community, it
made me feel somehow that it was creatively constricting. And
I think it had to do with the fact that it was a very small com-
munity and everybody knows what you're doing.*

*When I came to New York it was a difficult decision because
I did live this life that was very gratifying and I had a perfect
setup. I was only twenty-two but I felt like a retired artist with
a big studio in a beautiful island. I could make all the work I
wanted, but I didn't feel an involvement with the community.*

*It was more than that, though. When I came to New York,
since it's such a giant city and I didn't know many people, it felt
you have a sense of anonymity that made me feel anything was
possible.*

*At that point I did open up a storefront in the East Village
and began giving out services likes hugs and foot-washings. I
could not have done that or even thought that was possible to
do in the very small community I had been in.*

*My theory is that a very small community can be some-
how claustrophobic as opposed to a giant community like New
York. It's the opposite because of the sense of anonymity. Does
that make sense?*

Hoptman: I completely agree with you. It has nothing to do
with money is what you're saying. It has everything to do
with—I hate this term—but finding a context for yourself so
that you make sense and what you do and who you are makes
sense with the community that you live in.

Yes, New York is huge and there are all these different art
worlds, microcommunities, which are something that we are

exhaustively looking at right now. We're having this sort of contemporary self-examination here about the microcommunities in the city, but it's possible to find an audience, if you will, for what you do and not be alone, I think.

The thing with curators, by the way, is that you can be one anywhere. I grew up in Langley, Virginia, and it's great to be a curator in Langley, Virginia and it's important. But it's easier to be a curator in a community that is looking for contemporary art exhibitions to go to.

Carey: *Exactly. I think there's a certain amount of support. I mean, I don't want to focus too much on New York, although I guess New York is the focus of the art world or much of it, but it was my feeling also that in New York people are encouraged to do anything. My wife is Spanish, she's from Madrid. She feels that way as well. It does seem that there are limitless possibilities for all artists.*

Whereas in the small community that I was in for a little while, or in Madrid, grandiose ideas are thought of as improbable and not worth pursuing. There isn't a lot of support there for that. New York somehow seems to support that or has that feeling, I think, of offering support for all those things.

I don't just think it, it obviously happens. Certainly more unusual projects, from my point of view, happen in New York, whereas they may not happen at all in other cities.

Hoptman: I agree with you.

Carey: *I'd like to talk to you about all the artists that are graduating now. There are artists emerging into this world,*

thousands every year and many of them are attracted to New York or as near to it as they can get, and we can see this kind of expansion outside of New York as well. Just meeting a curator or applying for shows or becoming part of the art world is very much a mystery to a lot of artists—where do they begin? Where do you think an artist should begin in terms of moving, etc.?

Hoptman: It's a good probing question because it comes around to the beginning of the conversation, and I have the same answer. I think artists begin making a world for themselves among other artists. And any way that you can become a part of that, if you can commune with other artists, that's where I think you're going to find your ideological or your artistic home.

There are lots of ways to do that. You can become involved in a post graduate program like the Core Program or Skowhegan, or even a less ambitious one like the one I mentioned that the Bronx Museum still runs—the AIM program, which is one that's not necessarily a residency so you don't have to go live somewhere.

I think that you can go to graduate school. I know that that's been de rigueur now for at least twenty years for professional artists. Most professional artists that I see have master's degrees, although it probably started in my generation. Because artists that are a little bit older than me don't have those master's degrees. They didn't feel it necessary.

It's very similar with curators, there are curatorial programs all over the place. When I started working I knew I wanted to get an art history degree. I never knew that I needed

a curatorial degree. So I'm kind of an old school curator in that way. I'm a historian, not a curatorial studies person, but yes you find your community that way.

I think that the communities are much more permeable now. The museum community, the commercial art world in New York City, the noncommercial art world in New York City, the kind of commercial art world if you want a hybrid, too, and that kind of judgment I don't think is so much a part of people's lives anymore. I'm very happy about that because that was just awful, I think, personally. What an awful way to look at art and make this snap judgments and it was an awful way for artists to have to submit.

I think now art dealers, for example, at least over the past ten years, have been on the hunt for artists. So I think the burden of finding artists are more on these people who realized that there was a very lively market for emerging artists.

What's going to happen now? I don't know if my art dealer colleagues are running around looking for the next big thing, but I certainly know that curators are very focused on emerging artists, what to look for in new talent, and are very interested in finding and gathering information. So I don't know, I mean, I have to ask some young artists, but I think that I wouldn't say it's easier. It's just some of the burdens that were there before aren't there anymore.

Carey: *Right, and you mentioned smaller communities as well as going back to school for graduate programs. I'm thinking also of many artists who are graduating from their MFA programs and are still wondering how to act with a curator and reach those types of programs.*

Hoptman: Yes, I mean, there's the Core Program down in Houston and others like it, things like that, residencies. I know lots of artists do that. I think the art schools are thriving now because so many people are interested in teaching.

It used to be, on the East Coast, it used to be problematic, at least in my time, but now I think almost every artist that I know would probably kill for a teaching a job in New York. It's a wonderful way to be in touch with all the sort of new ideas that are coming up and also have academic stimulation, if you will.

Carey: *And where do you meet new artists? You said mostly through recommendations from other artists—is there another way?*

Hoptman: I still do that. But of course I go to art schools. I go to programs like the LMCC, the Lower Manhattan Cultural Council. I make an appearance at the AIM program. I didn't do it last year but pretty much every year from past twenty years I go up there.

The Bronx Museum has the show every summer. For me it's a kind of organic process and a big challenge because you're most comfortable in your generation and those artists who are closest to your generation. It's a challenge but I was very lucky, for example I participated in this triennial that we did here at the New Museum called Younger Than Jesus. So that was the millennial generation of artists. We looked at five hundred artists' portfolios, it was fantastic, from all over the world.

So if you're lucky enough, as a curator, to be involved in a project like that you immediately have a vocabulary. I spent

three years traveling all over the world for the Carnegie Inter-
national and they're not exactly emerging artists, they're fairly
well-known artists who are part of that kind of pioneer circuit
but I certainly learned a lot, I traveled a lot.

It's important to do that, to get out of your seat. Get away
from the galleries. I mean the galleries are a fountain of infor-
mation, absolutely. I mean they often know way before we
know interesting artists. But I have to say, and this is some-
thing that I have been wagging my finger at some of our very
beloved art critics for—the assumption that curators find their
material in the art galleries drives me bananas. Because more
often than not we find our material before the gallerists do.
And they find that they find their artists through us which is
fine.

I think it's all great, it's all great but the criticism, I don't
buy the criticism that says that many curators or all curators
just follow what the gallerists do because in a lot of cases the
gallerists are following what the curators do. Sometimes there

is simultaneous thing where you see an artwork, and you see an artist's work in a museum and a gallery at the same time.

I think almost every other contemporary curator will tell you this, I don't need the stamp of the famous gallery for me to be interested in somebody's work, that's for sure.

Carey: *That's refreshing to hear for a lot of people.*

Hoptman: But everybody would say that I think. I don't think I'm alone.

Carey: *I don't think you're alone as a curator perhaps, but I think many artists do believe that's exactly what they need on their resumé.*

Hoptman: I know, and I think for a broader population and certainly for the collector class, it certainly doesn't hurt. Although there's a whole area of collecting that's been pumped up over the past ten or fifteen years that concentrates on lesser known artists, unknown artists. Collectors really pride themselves in finding new talent before anybody else. It's a big deal for a lot of contemporary collectors to do that, the hunt.

The world's all turned upside down now, really. We didn't even get into that but, you know, I have one job. I'm very lucky, I get to interact with artists, I've done it my entire career. That's what I wanted to do and I get to do it. I get to travel and I get to look at beautiful things and try to understand them. I'm very, very lucky but my job, the thing that I dedicate myself to, is trying to create a context and interpret these beautiful and interesting things for a wider public, that's what I do.

The Curators Point of View

I think this interview sheds some light on the process from a curator's point of view. She is looking, but she is meeting people and talking. Meeting curators must go beyond emails as soon as possible to build any kind of interest or relationship.

I interviewed another curator which I will not reproduce here, but it was Simone Battisti, director of the Barbara Gladstone Gallery in New York in 2015. That is a major gallery that is one of the key players in the art world market and manages the careers of highly influential artists.

When I asked him what he looks for in artists when he meets them or goes to their studios, he had one word—sincerity. That struck me as odd in a world as aloof as his, and in one of the most important galleries. But he explained more about sincerity. He said that in all relationships he values sincerity, but with artists making work, he want to see work that is not compromised in any way. If it looks like work that is made to be sold, he has no interest. He wants to know what the artist is sincere about. What is their vision, so to speak, of what they want to see and why? I liked the way he said that, and it sums up the most important aspect of this business. Be sincere and straightforward. Your work can be mystifying in any number of ways, but your manner and approach should be sincere.

Chapter 10

Promotion and Networking

This chapter is about how to present papers, give lectures, and engage the community of artists around you, as well as art administrators, with thoughtful presentations.

Promotion is a dirty word for some artists and a calling card for others. In this chapter we will discuss how to promote your work in a way that fits your situation. There is no need to be pushy or awkward about it. It must be done with grace and style, and the elements of that will be discussed here with specific advice to advance your career.

Another word for this is the rather cold-sounding, *networking*, a term that has meaning now as a social media tactic as well as an interpersonal strategy. How you approach this concept will greatly determine your future. The idea that an artist shouldn't promote their work, or that too much promo-

tion hurts work, is one of those ideas that prevents good work from getting out into the world. Without promotion, which really means sharing, how will anyone ever see it? The less promotion, or sharing or networking that you do, the smaller your audience will be.

Networking

This concept of how to share, how to network, and how to engage your audience is the most important in this book, because without it, nothing else will work. Essentially, it boils down to this—make more friends. That is both the easiest thing in the world and for some, one of the hardest. Yes, it is "who you know," but that is not a bad thing, because you need to know more people and have more friends so that your system of support can grow. It is true that we live in a world that can be more isolating, that we spend more time at home, more time with a computer, and less time singing, dancing,

and being part of a community that makes us feel good and part of something larger.

It is also true that we are most comfortable in a mutually supportive environment, and that we must create that environment for ourselves. Let's get down to what that means in terms of how you will create your community of supportive curators, artists, and gallery owners. It is not about getting introductions to all of them, because even if you did get introductions, then what do you do? For the museum shows I have gotten, and my patrons and sponsors, too, I never had any introductions: I contacted them directly. I often asked a foundation or museum for their email, contact information, or office information, and found I was able to get to just about everyone. Why shouldn't you be able to do that? At the highest levels, everyone has a secretary, an office assistant who will pass on your letter if it's good enough. So at the very least, work on writing letters to people you want to reach.

I interviewed Ida Applebroog, an artist now represented by Hauser & Wirth, a very high-end gallery. Her work is also consistently disturbing, that is, the content is often faces that look as though they are distorted or upset, and other work is often challenging on social and political themes. She would never say she promoted her work, because I asked her and she said she did not, but she also had a different definition of that meant. Before she had exhibits or was known, it was the seventies in New York and she was trying to get her work noticed, but as a woman— and in the seventies—it was difficult. She began making small, inexpensive, xeroxed (copied) booklets in black and white. (That process is simply folding four pieces of 8½ x 11 bond paper in half and nesting them all together and putting a staple or string through the binding.)

She copied black and white reproductions of her paintings and words. The words often didn't even connect, so the reader would be puzzled, trying to figure it out.

She sent these inexpensive productions to whomever she wanted to reach, even if she did not know them. That meant gallerists, friends, critics, curators, writers, and anyone she wanted to share work with. She said that sometimes people would write back and tell her to "Stop sending these dark images," and that it ruined their day! Ida said she took that as a compliment.

Was she promoting herself? Of course. We must find a way to share and get work out no matter where you are. You don't have to use Facebook, but of course you can. What Ida did is something you could probably do today. Make small books regularly and send them out. Make the books hard to decipher and memorable perhaps, or whatever you like. In this age of emails and text messages, paper mail is even more special. Receiving a small handmade book in the mail is something special that will be remembered, and if your name is associated with it, why wouldn't you also be remembered?

Presenting Papers

To present a paper means presenting a lecture on a topic of your choice from your perspective. At international biennial and art conferences around the world, papers are always being presented by artists, curators, and others in the art world. The best way to really understand this is to go to lectures, panel discussions, and presentations at museums and nonprofits near you, as well as universities. You will also meet other curators, directors, and artists.

Your topic could be anything, but as an artist, you are talk-
ing about something that will make people think, "Oh, she's
interesting, what is her work like?" Not because you pre-
sented any of your own art or even mentioned your own art
in your presentation, but because you yourself were simply
interesting. An example of "interesting" can be summed up in
a title sometimes, which is what draws people to a lecture in
the first place. I once saw a title for a presentation at a bien-
nial called, "If You're so Smart Then Why Aren't You Rich?" I
liked that title very much. I would think many papers could be
presented on that subject from all different angles on art and
the artist.

You don't have to be an academic to do this, but col-
lege will help unless you are just a good writer or can get
your ideas across easily. One artist, Ken Lum, who repre-
sented Canada in the Venice Biennial one year, presented a
paper that was also based on a question. It was a question
his grandmother asked him when she arrived at an opening
for for a group show where he had some work. As he tells
it, there was a crowd at an opening in a small East Village
gallery and he had a piece in this group show. He said his
grandmother walked in and shouted out his name in Can-
tonese. He went to her and was surprised she came to the
opening. She asked him, "Who are these people and what do
they want?"

He told me he didn't know how to answer that question
and wrote a paper on it. That is, a paper or presentation (lec-
ture, panel discussion) on the question, "Who are these people
and what do they want?" as it relates to the art world. Because
the presentation is to the very people that the presentation is

about, it is of course of interest. It also has a sense of humor and a self-reflective quality which is admirable as well.

Presenting papers is also a great way to meet more people. For now, just go to more presentations at museums, nonprofits, and galleries and you will most likely make interesting friends. You will also see other people presenting papers, or lectures on different topics, and use those as a model for your own if you are drawn to that.

Engagement

Whether you are networking by talking to someone sincerely and potentially building a friendship, or presenting a lecture to a group, the goal is to engage your audience and have then take an interest in how you are thinking and acting. That is why papers and presentations based on questions work out so well, because the entire point of the lecture is to engage by asking questions. That in itself, perhaps a Socratic form,

is a simple rule of thumb as you make more friends on all levels of the art world: keep asking questions. Of course listen and respond as well, but questions as opposed to "here is my information" statements are more interesting because the audience must complete the question, even if it is to themselves.

Chapter 11

Art Fairs

The Art Fair network has grown tremendously in size in the last decade.

The Armory is one of the most well known. In 1994 it started as the Gramercy International Art Fair, and was held in the rooms of the Gramercy Park Hotel in New York City by four art dealers: Colin de Land, Pat Hearn, Matthew Marks, and Paul Morris. As the fair grew, it needed more space and in 1999 the show was renamed the Armory Show when it was first held at the 69th Regiment Armory, which was also the site of the Armory Show of 1913.

Now the Armory show is a huge event, and other fairs have popped up all around it for the week it is open. In 2014 the event attracted crowds of up to 90,000 and more and sales of up to 85 million.

So to begin with, what does an artist do at or with an art fair?

In general, art fairs like the Armory Show are meant for dealers to work directly with clients and also to see their peers

in the business. It was initially not a place to shop for the public, only for serious collectors. Now you have many options as an artist in 2016 and beyond.

You can work with a gallery that takes work to an art fair and sells the work for you. Some galleries go to art fairs and others do not, so just ask. Since the "booths" or spaces at an art fair are usually very expensive to rent, unless a gallery is confident they will sell, it is often a big expense for a small gallery.

Your other option is to work directly with some of the other satellite fairs that exist all around the Armory and Art Basel which are now worldwide in their scheduling. So every time there is a big art fair going on, there are ten or more small ones happening at the same time to cash in on the audience that is coming in for the big fair. Your other option is to find visibility during the art fair week without traditional methods.

One idea would be to rent a booth yourself at new fairs like Fountain, or propose a curated booth with a few friends at one of the other fairs like Pulse or the Affordable Art Fair. A space can cost three thousand and up, so it helps if you are splitting one with friends.

The main consideration if you are renting a booth yourself or sharing one and paying, is this: someone needs to be a salesperson and actually sell the work. In other words, the work won't sell itself, literally. Someone (either you or a friend) has to be outgoing and make new connections with potential buyers. Someone must talk people into buying something. There is nothing wrong with that, but it is a required skill. At all the big fairs, the dealers are at their booths and they are doing essentially that—they are selling to new and old collectors

There are many ways
to advance your career,
but to make more
friends, will also do
the same with less
effort.

and talking about art. The ones who are best at talking have the biggest galleries. Showing your work yourself at a fair is like that—be prepared to sell yourself by talking to people as much as possible.

If that does not appeal to you, then you need to find a gallery that will take your work to a fair in the hopes of selling. The only other option is to do some kind of event or performance or pop-up space during an art fair week.

Pop-Up Art Fair Satellite

The third option is to make your own darn art fair! That's right. At the same time that the other big fairs are going on, you could potentially rent a space with friends in an unused retail/commercial location and yes, start your own version of an art fair. You would benefit from the traffic that all the other fairs generate, and it could also be fun. However, unless you are creating this temporary event for publicity only, there will also have to be a salesperson there to actually close deals if you want that to happen.

You will see versions of this idea around art fairs, from open studios, to artists taking over a storefront or garage space. Some artists with their own pop-up spaces, like the dealers at the fairs, make many sales in that one week, sometimes enough sales to last until the next fair.

Vicki DaSilva

Vicki DaSilva is an artist you might relate to. She is a photographer and is determined to make a living off of her art. She rented her own booth at the Fountain Art Fair and sold enough herself to make it pay. She also breaks the traditional

rules and walks up to dealers at art fairs and talks to them and shows her work to them. In the interview that follows, she explains exactly how she does that, but there are more tips in what she says. She explains how she does projects or installations at places like the Armory in New York by going directly to the person in charge and asking permission. She explains how she dealt with raising children at the same time, and how she sells to corporations and hospitals. Her attitude is upbeat and enthusiastic, but she has had her share of rejection like anyone. I think her story is very inspiring because when you read her backstory, you will see she didn't come from wealth or any particular situation that made things happen for her, she simply worked hard at it, and was determined to make a living from it. After reading her story, you might feel emboldened to talk to dealers at fairs, and to make proposals as well. She also tells the story of how she won a competition and received $10,000 in cash.

The Interview

Carey: *Vicki DaSilva is a light graffiti and light painting pioneer. She's been making single-frame time exposure photographs at night since 1980. Vicki, thanks for talking with me today. I introduced you as a light painting pioneer and making single-frame time exposures and probably some people don't know what that means. Can you explain a little bit what it means to be a light painting pioneer or just the term light painting?*

DaSilva: Sure, light painting is a photographic term. It's a time exposure photograph. The camera's set on a tripod and the images are created at night outside or in a dark interior space and the lens is open and the light, everything in the

photograph is an addition of light, whether it's ambient light or added light. And traditionally what I do is draw with lamps and draw with light to create such specific types of images.

Carey: *So, I've seen a lot of different work of yours, of course, but tell me a little about what you're working on right now. What are your projects? What are you doing in your studio?*

DaSilva: Well, my studio is pretty much the outside world. So right now I am working on creating a new project inside the 69th Regiment Armory in New York for that art fair which I'll be doing during Armory week, March 7–9. And I did a piece inside there last year because it was the one hundredth anniversary of the Armory show and since that art fair is held at the iconic 69th Regiment, I decided to do a piece that was referencing Duchamp and made it in a basement bar of the Armory.

So, typically what I do is contact an organization, in this case the Armory, which also works with the National Guard, and I went to their people and asked permission to come in and have access to the space and they were generous enough to allow me to do that and to allow me to come in again this year to do a different project. Because it's such an interesting structure and architectural icon, I like to make something inside the space that I can show at the show.

Carey: *And when you will be showing at the fair? Is there a particular gallery that's representing you there, or—?*

DaSilva: No, I'm just going to have my own booth. Yeah, I'm representing myself.

Carey: *Which fair is that?*

DaSilva: That's the Fountain Art Fair.

Carey: *The Fountain Art Fair. And this project you did was that image, if I remember correctly, called,* Dude Descending Stairs?

DaSilva: Yes, *Dude Descending a Staircase* was another Duchampian-inspired photograph that I made. That photograph was made in a historic bank in Allentown, Pennsylvania. The piece that I made inside the Armory was a text piece that I made. It was from Duchamp's speech about art brut, about the artist making images and whether good or bad, it's still art. So I took a phrase from his speech and did a text piece in the bar there.

Carey: *And by a text piece you mean you're drawing with light in the air so that it's almost as though you're writing. You are writing in light, you are writing in the air so to speak so through that photographic light painting process we can read those words, is that what you mean?*

DaSilva: Yes, it looks very similar to neon but it's actually happening live and as I'm doing it, of course, I can't see the results. And it's a process that I continually practice over and over to get it exactly the way I want. Sometimes it's a shorter process than others but typically it's something that doesn't happen on the first take.

Carey: *Unlike painting or even a straight photograph, you have to actually do the action and then I imagine check it digitally, is that what happens?*

DaSilva: Yes, I've been shooting film up until 2008 but since 2008, I've been shooting primarily digital. And so that has helped a lot in the ease of filling images instantaneously and being able to really refine the goal of readability and what-not and composition and all that. So yes, writing a phrase kind of like a headline or something like that and the end result looks almost like neon and it's all done in a single exposure.

Carey: *You're approaching these spaces because you want to work with architecture, and it sounds very straightforward and simple. With the Armory, do you go directly to whoever is running it or in charge of the space and ask for permission—is that how it works?*

DaSilva: Yes, that's exactly how it works. I go to the powers that be, and I ask for permission. I've done that in front of the White House; back in 2008, I was inspired to write, "Obama in the house" in June of 2008 for the Obama campaign—not specifically for them, but in support of the Obama White House before anything, before he got elected.

So that was a process of about three months of getting secret service clearance, getting permission from the film department of the city of DC and getting the permits, because you're not allowed to even set up a tripod on Pennsylvania Avenue. So when I got there I had my permit and the secret service met me there. I didn't even have a real meeting time. I just showed up and they were on me with their mountain bikes as soon as they saw somebody getting out a camera and a tripod, and then I had my permit and they were like, "Oh great, we'll be right here with you the whole time."

The art of right now that interests me the most is from artists that are working to kind of call out the government through their work. And I find that extremely interesting—and the Edward Snowden days—and I think it's a great calling for artists.

Carey: *And so what is next for you?*

DaSilva: I'm not quite sure. There is this festival called the Transmediale in Berlin, it's happening right now and they have art, they have technology. It's kind of like this group that comes together and what is now known as the post-digital world and how everything was so exciting and utopian in a way when the internet came around and we were going to

solve all these problems, but in fact the internet and the digital world that we live in has created the most dire circumstances for the poorest in the world.

So that kind of thing of kind of waking up in this post-digital reality and being an artist who is interested in using digital things but at the same time knowing that my computer and my phone, and even the artwork that I'm making and mounting—where's that going to go to and when I'm going to need a new one, who are the little kids that are slaves right now that are making this happen?

All that stuff really kind of came to a head for me when I went to Snap! Orlando which I was invited to participate in last May. And I met with the director who explained to me that there is a girl who is nine years old from California named Vivienne Harr and she had seen a photograph by Lisa Kristine, who has for thirty years been documenting the world's indigenous peoples. And she saw a photograph of two Nepali children who had these big slabs of rock on their back. And this nine-year-old girl, Vivienne Harr, looked at her parents and said, "What is that? What's going on?" And they explained to her that, "Yeah, this is child slavery." And she decided at that moment, she told her parents I want to start a lemonade stand to try to help them.

It went on to be a big giant project that her parents jumped into with both feet. Her father, I believe, used to work for Care so he had experience. And they put together this enormous lemonade making process where almost like a Paul Newman–type format where all the proceeds would go towards helping to free children. And she's raised enough money to free over five hundred children at this point. There's been a documen-

tary that was down there in Orlando because she had been given the city key during this photo festival because her main inspiration had been this photograph by Lisa Kristine that jump-started the whole idea.

And a documentary film crew from Still Motion came in and was documenting her and we were talking—and before I actually went down there I had the idea to go to a lemon grove to find some lemon trees and do a slogan that Vivienne likes to call out, which is, "Be one person." How can we be one person and help change the world in whatever way we can, with whatever we do? And so I did a light piece in front of lemonade, a lemon girl, where the owner allowed me to shoot in front of his lemon trees and I did a "be one person" photograph and that prompted the film crew to ask me to do a piece when I was up in Nova Scotia last summer—a piece called *Stand with Me*, with the hashtag #standwithme to help promote the eponymous movie. It's premiering in San Francisco, and I believe my work is going to be used in the webisode. It's a live filming of me making this hashtag, with me on the beach in Nova Scotia.

So that's really exciting because that's kind of then the biggest jump start for me. I also made a piece called *I am Malala* in February of 2013. I just wrote "I am Malala" over and over and over and I've been trying to contact the powers that be to donate this image as a digital download that people would get for free in order to make a contribution to the organization.

So that for me is the most inspiring and interesting thing as an artist and also as a parent. If there's a way that my images could somehow help raise money for these organizations, especially organizations that help to free children who

are slaves, which is probably in my mind the most important cause of today and it's incredibly sad and the numbers are very staggering. If my work can somehow, in a small way, help, if I can give work away—not so much as prints but as digital downloads, because then I also lower the carbon footprint—people could share these images, and that would be great. That's the way I'm going in but I'm also very interested in exposing more things and I'm going to try to do another shoot in front of the White House but this time I probably won't be saying what I'm going to actually be writing, even though now I'm telling the world through a radio interview. Bring it on!

Carey: *That's a very powerful story about the girl. Holy cow, I can't think of anything more important for the world to be focusing on. But it's also such a counterpoint, the idea of child*

*slavery and also this post-Snowden world we're talking about—
I suppose it's similar in terms of the lack of justice or immoral-
ity, but it couldn't be further apart. The children carrying those
stones on their back and being slaves and then the government
using incredibly deceptive forms of technology of all kinds.*

*Recently I was reading about leaky apps. The government
is tapping into what they call "leaky apps," which means prob-
ably every time you have played games on your phone, when
they have access to your Facebook friends and profile, which
you click through pretty quickly without thinking about it.*

*Let's talk a little bit about the beginnings of your work. So
you now you are in this place, which I relate to in a number of
ways—as a parent, and as an artist that's also maturing in terms
of your vision and what you're doing—how did you get started
in art? What were your first beginnings as a child or a student?*

DaSilva: I love art but I had no art education in the home. I
think my parents' idea of a museum was Las Vegas, to be hon-
est. So I wasn't exposed to it at all. I remember always loving
art, but it wasn't until I got to middle school and my new best
friend was an artist and had been going to classes at an inde-
pendent art school for a long time, since she was probably
nine or ten years old, and she was really good at painting.
And I thought, wow, it's like she's a magician, like superpow-
ers. I couldn't even imagine how you would learn to do this
when you are a kid; you almost have this idea that you're born
with this type of gift to draw.

We all kind of know now that you learn to draw the same
way you learn to play sports or you learn to play the piano or
an instrument. So I started to get into it in middle school and

then the same in high school but I never had any plans to even go to college. And my high school art teacher said to me, "So where are you going to college?" It was about April at that point of my senior year and I said, "I'm not going to college."

My parents really didn't encourage it and talk to me. I didn't visit anything. So I didn't know much about it, I was kind of clueless. And so he said, "Do you want to go? Because I think you could do really well in art school." And I said, "Oh really?" And he said, "Yeah, I would absolutely make a phone call for you. You have enough work here from the past few years that we can put a portfolio together." And he made a phone call, he got me an interview at a state university about twenty minutes from Allentown, and I ended up going to art school there and then I just threw myself into it full force.

Carey: *And what does that mean? You were doing photography, painting, or different mediums?*

DaSilva: I enrolled as a fine arts student and when I took my first photography class, I started studying the history of photography and I was also fortunate to study with a professor named James Carroll. And he would bring major artists from New York City as visiting artists and they would have residencies for two or three days, as students or even members of the public, and you were invited to sign up for one-hour blocks and talk to these people.

So this became an incredible thing, because if you look up the New Arts Program you'll see the list of artists are significant. So I started to become aware of a lot of the major artists of the eighties, seventies, and even sixties. We met every

one from Lawrence Weiner, Richard Serra, and Joan Jonas, who I ended up doing my internship with. All of this was so incredibly huge and life changing for me because I grew up in a typical suburban neighborhood. This was all so mind-blowing and I was so interested in it and I was determined to try and find something that I could do as an artist that would be as original as possible.

And so upon researching the history of photography, I started to become aware of images that were used in scientific studies from like the late 1800s that had used light as a way to study physiology. Étienne-Jules Marey was probably the first one to do a light photograph although his intention was to study the physiology of a human being by affixing incandescent lamps to the human body. To me it looked like art because it was very abstract and I said, "Wow, that's very cool that you could make a light painting." The history of light painting photography highlights these scientific studies because of the study of motion pictures and all that was happening, and so there was these artists along the way, most famously Man Ray, who had done his—what he called "space writing" with a pen light.

And then Gjon Mili, who had done a lot of light painting photography with a *Life* magazine photographer, and he had gone because someone asked him if he would draw with his lamp for his series for *Life* magazine back in—I think it was 1949. It was a very famous series, I'm sure you've seen it. So that's a wow—everybody's kind of seen that.

So I thought, Wow, that's really cool and I want to try that. So I started goofing around with that, it was black and white and kind of a more performative-type thing. So I was also

learning about performance art. So would I set up these kind of stages either inside or outside and fooled around with a lamp and also make props and things like that and one thing led to another. The graffiti movement started going full speed ahead. One of my roommates was best friends with Keith Haring. He had grown up with Keith. Keith was visiting him all the time, Keith didn't go to school in Kutztown but he grow up in Kutztown.

So there were all these different forces that were flying about the street. The graffiti scene, the minimalism scene, the performance art scene, and I was very fortunate to be involved in a little bit of everything, whether as an spectator or as an intern or whatever. And so I thought, you know, it'll be really cool to try and term what I was doing as light graffiti and so I started doing more and more of that until about 1986 when I started thinking about using larger lamps, fluorescent tube lamps so that I could do more installation-based-type work and cover larger areas and think of it more as sculpture.

In my mind in the eighties, I was always worried that somebody was going to do what I was doing. You know as an artist, *You're going to steal my idea, blah, blah blah*, especially when you're young. *Oh, I don't have enough work so I got to keep this all in the down-low, in secret*. But at the same time I thought everybody was going to be doing light graffiti, that didn't happen until the digital revolution. And now everybody is doing light graffiti. Luckily, I got the URL back in the beginning [www.lightgraffiti.com] but I mean it's extremely global and popular and there's lots and lots and lots of light graffiti and light painting photographers out there.

Now, using it as an art form is another calling, being able to think of our history and how you're going to fit into that and if those aren't you're kind of goals it becomes more than an ad campaign. So I try to think of it in those terms and push it in those terms as best I can as an artist. Sure, I like to make abstract images that are beautiful and allow me to be out in a landscape, especially working with my husband who I've been collaborating with since I met him in 1996 in Paris. He's an electrician; we work together.

So all of these photographs that I made since like 1987 have been with Antonio and so it's also a way for me to kind of be with him alone somewhere at night. It's kind of very romantic for me. I don't know if he thinks of it that way but I sure do. So there's all those kind of elements that go along with it. So I make two separate types of work. I make text-based work and I make abstract-based work. Both are important to me for very different reasons.

Carey: *So when you got out of school and were working, what was the beginning of you working with galleries? Or maybe we should move forward to the point where I was talking to you a while ago and I think it was, and correct me if I'm wrong, about when both your daughters were going into college that suddenly you began ramping up your efforts to get your work out there. Is that what happened?*

DaSilva: Okay, it's a little earlier but the short story is that when I landed in New York in an internship in 1981 with Joan Jonas and was exposed to these very intense amazing artists, I knew that I had a lot of work to do. I didn't graduate till 1983 so I went back to Kutztown, and I really just started to focus on my own work.

When I got back to New York in '83, I was also exposed to Richard Serra who I started dog-sitting for. I became Richard Serra's main dog-sitter for about ten years in the eighties. So I was around it all—and the Keith Haring phenomena, I was around so many great, great artists that I knew I had a lot of work to do.

So I didn't really feel comfortable trying to get my work out to a gallery. I was very insecure at that point. I was intimidated and I just didn't think my work was worthy of it. And when I did try to attempt to talk to any galleries, I was rejected as most artists are when they start but I was just very intimidated by that. So I went the full-time job route, I was printing black and white photography for Gary Schneider, who is a great artist in his own right. That went from there to *Time*, *Life*, and *People* magazines, and then I went to HBO and worked in their photo department.

So I went the corporate route and I was doing my light painting and my light graffiti on the weekends. And I was so busy just trying to maintain my lifestyle with my nine to five and then with my own work—that as much as I was involved in the New York art scene I was removed, too, and Antonio moved to New York in 1987 with me and a couple of years later we wanted to try to start a family. And so we moved to Europe and for the next eight years I was having children. I had two children, we lived in Portugal and then we lived in Paris. We had a daughter in Portugal, a daughter in Paris, and I knew that I couldn't be the mom that I wanted to be and the artist that I wanted to be at the same time. I didn't want to resent either and I didn't want to fail at either.

I'm kind of an overachiever in my own mind, so I decided that I would work, started doing night photography. It just wasn't going to happen so I was always thinking about work and I always wanted to continue doing it but I did more like collage-type things that I've never even shown but I had this practice, and I was focused on being a parent. So about when the kids started school, elementary school, I started to get into it a little bit. The first time I went out on a photo shoot, I think I did my last night photo shoot in Portugal in 1989 before I got pregnant and then in 1990, and I didn't really do any until 1999. It was about ten years later that I went back at it. The kids at that point where nine and seven and I was goofing around with stuff inside but I really got back into it about 1999, but at that point I had another full-time job.

We had moved back in the states in '93 and I was freelancing, shooting corporate parties and things like that as a commercial photographer, but really on a low-end scale. Like

okay, I thought, *I do parties and second weddings, that's about it.* Nothing you can really hold me accountable for because I know there's a lot of drinking involved. I did that and then I got another full-time job as the creative photo editor at Rodale which publishes healthy lifestyle magazines such as *Men's Health*, *Women's Health*, *Prevention*, and a slew of books and bicycling magazines, sports magazines. So I was the creative director, the creative photo editor for a year and a half and then I went on to be the photo editor for *Runner's World* magazine for three years.

And in 2000, I was really also back into my photography. Antonio and I, we'd get babysitters and we would go out every weekend and we would shoot. So I was full steam ahead on that, in 2003 I decided that I was, with Antonio's support, going to leave my job and try to do the art full-time and give it a shot. So I was forty-three at that time and I started really

Pataphysics is the science of imaginary solutions, perhaps all art is pataphysical?

pounding the pavement, trying to get into shows, trying to get shows. I got my first solo show in New York in 2006 with a gallery called Art Gotham. They're no longer there. A woman named Kimberly, she was wonderful, she give me a show. It was at Twenty-Seventh Street in Chelsea, and I was ecstatic. So that was kind of my big, *Okay, I can do this.* There's some way, somehow, I can do this. And I was hustling. I've always been a hustler. I sold airport advertising, too, before I had my job at Rodale's so I was comfortable on the sales, and I would just start pounding the pavement with people in my town, whether it was the hospital or corporations or whatever to buy my work, to try and sell something.

Carey: *The hospitals in your town, and pounding the pavement is an interesting process. You would just walk into the hospital and in other places and say what?*

DaSilva: I would find the facilities person. The facilities person is the person you've got to find, they buy the furniture. Whoever's buying the furniture might be putting work on the wall, probably posters and probably not art, but they will consider it, and where there's a will, there's a way and because my work was being made locally—not with the intention to sell local landscapes, it just so happened that I was making these light paintings around my area in various parts, on bridges and things like that—they were images that local people could relate to.

So knowing that art has a positive effect on patients and there's studies that prove that, I used that as well to go to local hospitals and say, "Light is an element that heals. You're using

it in medicine and artists are using it, and these are beautiful images. May I please sell you one?" It kind of starts like that. If you work hard enough and don't take no for an answer, eventually they'll buy something just to get rid of you. But I've always wanted to be and maintain my practice as a New York artist because I know that you can be a local artist or you can be a New York artist. I live two hours away and I knew the city from living there for ten years, and I thought, I can put as much energy into being a New York artist and I would probably reap the rewards much better than trying to just be a local artist. So although I was just trying to sell work just to get some money and fund my practice, I continued to pound the pavement and try to show my work in New York.

Carey: *And you weren't living in New York at the time, right?*

DaSilva: No, I haven't lived in New York since 1989. I've been living in Allentown since 1993 and I've been commuting on a weekly basis for my art and for any potential interaction of my art and to see artists, to haunt galleries and such since 2003 on a full-time basis. So then in 2012, I got incredibly lucky and I applied for—and I always was applying for competitions, having some luck here and then in there . . .

Carey: *In the competitions, wait because I'm excited to hear about that. Where did you find out about applying for competitions? I know you're going around and going to different galleries and places . . .*

DaSilva: Mostly online, online through things like New York Foundation for the Arts and others. Lists like all these

different internet sites that list all the different competitions. Mostly with photography, I started out looking for photography competitions because there's more of those seemingly than there are for painting or sculpture. I mean, there's tons of everything out there. Now there's CaFÉ, a web-based service at www.callforentry.org.

Carey: *So let's talk about what you applied to in 2012.*

DaSilva: There was a new organization called Artists Wanted [now called See.me] that had been around for over a year or two. And they were putting on competitions for fine art to try and give artists new opportunities and they were offering significant prizes of $10,000 and showing your work in Times Square, this kind of elaborate-type project. And I thought, *Wow, this is incredible*, and it's a part of our internet age where when you have the numbers coming in and most of these competitions you would have to pay something to enter, like $25, $30, $50, but this particular competition, which was called Art Takes Times Square, was free. It was free if you got a certain amount of votes; so you set up your website through them, your page through them, and if you got a certain number of votes, you would go on to the next round of voting and so forth but there are also was an option to pay $25 to skip that process of voting and go right to the next round of judging.

So I choose that because I'm not the big fan of "vote for me, vote for me." So I chose that and I got to the next round, and that's rolling round, and I ended up winning. I honestly never dreamed that I would win but it was amazing. And in April of 2011 I was working at—I'd got permission from the city of Easton, Pennsylvania to work at the Simon Silk Mill,

which was being redeveloped but was still extremely raw and abandoned.

So they gave me a permit and access to go in there at night. And we worked in there for about a month and in that time, in April, was when Ai Weiwei was arrested and detained by the Chinese police. So the documentary by Alison Klayman was already in the process called *Never Sorry* and I had wanted to do a text piece, my first text piece that would be from floor to ceiling in an interior abandoned factory space, and we got these scaffolds and I didn't know yet what I was going to do but when this whole thing went down with Weiwei, I decided that okay, I'm going to write "Never Sorry" along six panels of this giant space in one single frame time exposure.

So I worked on that for several days because it took practice to get it to the point where I was satisfied with the handwriting. I made that and I showed the image and Weiwei was released after eighty-one days. He was released the night before my opening. So I was like, *Wow that's amazing. This is just a personal thing, like, wow, cool.* So then after that I entered this competition and I guess it was like early January of 2012. I entered that.

So that was what really interested the judges, that particular element of my work and because of the timing, the stars aligned and everything was happening with Ai Weiwei, the movie was actually coming out in that summer as well, in June. So this whole thing kind of swelled and it just—I was actually in Canada, and I got the phone call and I actually didn't believe it. I was like, "Who is this?" and they said "Oh . . ." I didn't answer the phone, it was on the cell phone

and I didn't want to answer it because of charges so won-
dered, *Who's that?* and then I look at it and thought, *That's
weird,* so I called the number and he said, "Oh yeah, we have
some questions about your entry." And I was like, "Oh, okay,
what's up?" And then they were saying, "Well, we looked at
it, we looked at all your work, we've been researching you for
a while." And then they said, "Hold on a second." And there
was like a group of people and he said, "Well, we're here in
the office. We want to tell you something. Congratulations,
you won the Art Takes Times Square!" I was like, "Oh my God,
really?" And there was just like this great moment for myself
that I had really broken through to an opportunity—not even
because of the $10,000 prize, which is great because I could
buy a camera, but because my work would be on thirteen of
the most iconic billboards in Times Square simultaneously at
night for the month of July.

Carey: *It's amazing—and that was a $10,000 prize?*

DaSilva: Yeah, and so it was a great moment for me because
the *New York Times* was doing an article on on Artists Wanted
and on these companies that are trying to give more opportu-
nities to artists via the internet, that these companies are find-
ing artists through the internet and trying to give exposure to
people who are either young or old or anything in between,
just based on their work. It was a really refreshing, great thing
because we all know that the art world is very structured and
it has traditional hierarchies as any other traditional company
does. People are vetted. You have to be really in the inner cir-
cle sometimes to break through.

So this was a really great opportunity for me not only to have my work exposed in Times Square but it ended up in an article on the cover of the art section of the *New York Times* on June 18, 2012. So I had a half-page image of *Never Sorry* and I then got contacted by someone who had been working with Ai Weiwei in some kind of Twitter or Tumblr fashion and shared the image with him and he told me that he had seen it and he liked it. It just was mind-blowing and at that moment I thought, Wow, everything is just going to take on its own. Everything's going to come to me from this point—but it doesn't work that way.

It became an opportunity but I also knew better because I was winning this prize at fifty-two years old and I was actually kind of shocked that they picked someone who wasn't younger, and that it was really based on the work itself. I was really proud of that, and I was proud that it happened the way it did because it was so organic and I didn't have to ask for anybody's help. It just happened the way that you kind of dream it happening. So I was wise enough to realize that this is an opportunity, it's probably not all going to come to me yet—some things are going to come, opportunities are going to arise, but it's an opportunity for me to take this moment and go to every single person that wouldn't look at my work before and have the images on my phone, two images. One image from the *New York Times*: "Hi, would you look at my work now?" And just put it in front of them. I know the worst thing that you're told never to do is to go to art fairs and ask gallerists anything if you're an artist because they're busy selling their artists' work, but you've got to have your own guerilla work ethic there and your own guerilla marketing. So I

would just take that opportunity, you have to be have your timing, it has to be right.

But you know, you have a little conversation, I was some artist and would say, "I know I'm not supposed to do this but I'm so excited, can I show you one thing." And they'll go, "Yeah." Because they're curious, you make them curious and they'll look at it. "Would you look at my work?" "Not now." "Can I send you something? Can I follow up?" "Sure." So that's how it works. If we get lucky and we get opportunities through our hard work to gain something, you've got to use it, you've got to put it out there and just ask because all anyone really can say is no, and if they do respond to the work they're not going to say, "No, we're not dealing with you because asked me at the Armory Art Fair." They're going to be like, "Wow, you're ballsy. You freakin' have guts to do that."

Carey: *Interesting.*

DaSilva: I really believe in that, it's never too late. So I'm represented and I'm working with a few different galleries. The one I'm most affiliated with and represented by is Cheryl Hazan Contemporary which is in Tribeca. But I'm still look-ing for other opportunities and I'm still kind of a free agent. I'm doing my own shows because it's important, I have to, it's important to me to make my living from selling my work.

And I firmly believe that I could be selling shoes or I could be selling art but whichever way I'm going to make it happen. So you can make arrangements with galleries that enable you to work with them but also enable you to work with others. Anything can be ironed out to work for everybody. It's just

a matter of negotiation. So that's been really great and I do thank her for that. I also thank Woodward Gallery. Kristine and John were awesome and they gave me a great opportunity last spring to have a solo show in the lobby of the iconic Four Seasons Restaurant and so that put my work in front of the clientele that goes to do a power lunch at the Four Seasons. I sold several pieces to them and this kind of thing just keeps going, you take it a day at a time, a year at a time, and every year my chart goes up a little bit. It's not a dramatic rise but it's a steady increase, so that's the good news.

Carey: *It's very exciting to talk to you, Vicki. In closing is there something you want to say to the people who are listening to this that are now thinking,* Wow, that sounds great, maybe I can do what she's doing? *Or, maybe they're thinking,* I can't do what she's doing. I'm not as aggressive or as driven as she is. *Is there anything you want to say?*

DaSilva: Well, if you want to sell your work, that's one frame of mind, one business aspect, that's the business side. If you want to sell your work you have to be aggressive. If you don't want to sell your work and you just want to make work and show work however you can, that's absolutely fine, too. You don't have to sell your work at all if you don't want to. But if you're trying to make a living with your work there are ways to do it and you just have to kind of see it as you would sell anything else and even though art is particular, you pick your price point based on your experience and based on your sales record.

I give a lot of work away to people just as presents or what-ever to try and get into, to get selling something. I've sold stuff to my accountants for their office. They go and do my taxes and I say, "You guys charge a pretty penny for this, you should have one of my works on the wall." This goes both ways. You just have to ask. All they can say is, "No, thank you" and you say, "Okay," but you've done your job and you feel so much better if you're trying to sell your work by asking, because it's really just a matter of asking enough times to enough people. Someone will say yes eventually; it's probability. I believe that.

Chapter 12

Collectors

Ｈow do artists meet and work with collectors? Can artists sell work directly from their studios? This chapter will discuss how collectors operate, how to approach them, and how to make sales from the studio.

Where are all the collectors? They are on the board of all the nonprofit organizations around you from universities to museums, theatres, and art centers. They are in attendance at museum openings that are open to the public. Their names are listed on the brochures of museums under "donors and patrons."

Usually there is a big list of patrons to any major local cultural establishment, and those are all potential collectors. Of course some of those names may no longer be living, but many of them will be, and new names have to be added all the time.

It's easy to find those names with the internet and a search engine like Google. Get a list together of local collectors using

this method, and find lists of donors and patrons to muse-ums and art centers. Then research each one and see if they have their own foundation (many do) and take notes on what a search comes up with so you can get to know this potential collector better.

So that would be assembling a list of twenty or fewer people who you would like to meet and, having researched them all, you are now familiar with them, their foundations, where they like to give money, etc. If that sounds like a lot of work, think of what just one relationship with a collector could yield.

The next step is according to your own style, but you must find a way to meet those people and befriend them with a con-versation. It is that hard and that easy. These people on your list will be available to talk to at openings and arts events you are following, so you must find a way to say hello that is not too uncomfortable and that works.

It is clearly possible to meet these people if you do your research and find the collectors and patrons you want to tar-get. But if a public meeting sounds too daring for you, then you can also email them and introduce yourself online.

However, meeting in person easily trumps the technique of writing an email, because when you meet in person, there is either a rapport, a chemistry, that makes you comfortable or there is not. So I favor in-person meetings because even if it is an awkward first meeting, the email follow-up will be much more meaningful once a face-to-face meeting has occurred.

It's all personal. We tend to be comfortable with people we have been around and trust for some reason. Because of that, I suggest trying to meet people at openings, because even if

they are not on your list, the more friends you have in the art world, the better.

If you are determined to reach out by email first, then this is how to craft your letters.

Your approach to your letter should be personal, not a template of a letter requesting a view of a website. Ideally you have at least researched the person you are writing to, so make the first letter a form of a fan letter, since you will flatter the recipient by having a knowledge of who you are writing to. Anyone who receives a letter with sincere compliments in it is engaged. If the compliments are not sincere it will not work, so writing a letter from the heart is something you will need to practice and be truthful about. It is an art in itself and has a history that is filled with artists writing letters to collectors, charming them, and often asking for money. There are no strict rules to those letters, but politeness and charm tend to go very, very far.

Begin crafting letters that are like works of art in themselves. Send them by email and/or postal mail. If you do this regularly about things you are passionate about, you will get answers with similar passion and build strong relationships while doing so. These letters can be written to collectors as we have outlined above, but also a great letter to a newspaper can get published and a great letter to an artist or intellectual hero of yours often gets an answer. Try it, with all that you've got.

Sue Stoffel

This next interview is with Sue Stoffel, who is a collector and talks about her experience in the art world.

The Interview

Carey: *Today we're talking with Sue Stoffel. She's a collector and an art administrator with twenty-five years of professional art experience in numerous aspects in the art world. Sue, thanks so much for being with us today.*

Stoffel: An honor to be here, thank you.

Carey: *When you were growing up were you influenced a lot by the arts? Were your parents involved in the arts? If we can go back that far, how did you get involved and influenced by the art world?*

Stoffel: Very much influenced through my childhood. I grew up in New York City. I'm a fourth-generation Manhattanite and my mother is an artist, both my grandmothers were artists. One aunt runs the oldest nonprofit cooperative gallery in New York. And my other aunt on my father's side was one of the founders of the

African Art museum in Soho in the eighties. And so my mother was taking me through SoHo in the sixties, a greasy-haired teenager looking at the works of Jasper Johns and Rauschenberg and Warhol, and so it all went in through osmosis.

But it really didn't come out until I moved to Switzerland in 1980 and started collecting. I was getting married and I went to visit a wonderful old dealer named Anne Rotzler, and I asked her what I should buy my future husband as a wedding present and she said there's only one thing and that's art. And so I bought my first piece which was a Christo, and from there it's thirty years later, maybe even more, and three hundred and fifty works later.

Carey: *Wow, three hundred and fifty works—that's how many pieces of art are in your own collection?*

Stoffel: Yes, correct. I am a collector. We call ourselves junkie collectors because it's what we do. We don't do anything else. My husband used to call it "Shoes and Bags" because he would rather me spend $2,000 on a Prada bag than on a work of art—and I disagreed, so we were collecting Swiss art when we were living there. Then I started to go to Art Basel in 1985 and that changed my perspective globally in terms of what was happening in the contemporary world. And that's when our art collection started to expand.

Carey: *And what was the first Christo that you bought?*

Stoffel: It was the *Wrapped Leonardo in Milano*. It was a work on paper that he had attached a wrapped sculpture to, and

then there was the matching photograph that went with it. So this was from 1982.

Carey: *I didn't know that. Could you just describe that a little bit more.*

Stoffel: Sure, I'm going to walk over and look at it. Yeah, I don't know exactly which Piazza in Milano it is, maybe it says on here. Yes, here it is, *Wrapped Monumental Leonardo, Project for Piazza della Scala in Milano*, it's signed and it is a piece of a cotton-wrapped sculpture with his iconic string stapled onto a photograph that he has penciled around of the Piazza della Scala.

There are some really old 1950s, 1960s cars parked in the background. So it's a cool piece and you'll see it as you come into my apartment. It's the first piece you see and kind of opens the dialogue to everything else that's hanging in the apartment now.

Carey: *That's amazing, it sounds gorgeous and also of course is now a very, very valuable piece. Those are quite amazing things to have. That's essentially an early preparatory drawing of his, isn't it?*

Stoffel: It's more than a preparatory drawing. There is a depth, there is a third dimension. It is actually a sculpture on the wall.

Carey: *So then let's move forward from there. That was the beginning of your foray into collecting. You're in Switzerland,*

what happened next? And I assume at this point you're not involved in art administration?

Stoffel: Not yet, but that kind of changed in 1994, 1995 when we were collecting quite intensely. I came back to New York for a trip and went to visit the marketing directors of the Whitney and MoMA and put together some best practices of how museums were approaching their contemporary collectors. And I took that to the Kunsthaus in Zürich and I said, "Listen I've got this idea, there are a lot of contemporary collectors now out there who don't feel connected to the museum. I'd like to develop a program," and they actually bought it and asked me to direct it. So I did that for five years before coming back to New York.

I was working with other collectors around Switzerland and organizing lectures and tours and getting into private collections and taking them to art fairs, to the opening of the Bilbao Guggenheim, I developed a network of very interested contemporary art collectors around Europe and I brought that back to New York with me.

Carey: *That's very interesting. What you're doing for the museums, or what you offer to the museums in New York, is to help educate people about collecting. It was something they weren't doing. Is that correct?*

Stoffel: It was a longterm plan to develop patronage in Switzerland, because that didn't exist. You have Rockefellers, Carnegies, Vanderbilts, and Whitneys and even the three women behind MoMA who were starting museums on their own, in

the US, particularly by women, which is an interesting fact as well.

Carey: *So that began your career in both collecting and in arts administration and fundraising. It sounds like it was all wrapped up in that to some degree.*

Stoffel: Absolutely. I came back to New York in '98, joined the board of Creative Time in 1999 and the Brooklyn Museum right in the middle of the *Sensation* exhibition, which was an interesting time of course to be a new trustee of a museum.

Carey: *Right, the museum was really under fire then.*

Stoffel: Under fire, yes, and former Mayor Giuliani never even came to see the show. He didn't know what he was talking about.

Carey: *What always seems to be ironic about that, is that it also created worldwide attention for those "controversial" works that many people may not have known otherwise. I think censorship is awful, and that kind of thing is awful, but what's incredible is how those acts of censorship make this work almost iconic and part of the public consciousness in the way that nothing else really does.*

Stoffel: Contemporary art museums are a repository for the art of our time, it is the history of our time, it is a truer documentary process than written history. Art reflects the times

and the society in which the artist lived and that's something that sometimes gets lost in translation.

If you think back to Manet and *The Execution of Maximilian,* and Marcel Duchamp during World War I, it was absolutely retaliatory against what was the norm. Even the Impressionists, they decided they were not going to paint what other people saw but they were going to paint what they saw. And that was a major milestone in the realization that contemporary art is a very vital contribution to history.

Carey: *Absolutely. So now you're back in New York, we're moving into the early 2000s, you've been on the board or still are at Creative Time and at that point and I know the history of Creative Time so well because that's when Anne Pasternak was beginning.*

Stoffel: Correct, and she's a force, she's a major force. It was an honor and a pleasure to work with her and the other board in developing Creative Time into what it is today. I think she came on in 1994. I joined in 1998 and stayed for ten years.

Carey: *So part of your role there was also to organize fundraising and also exhibits?*

Stoffel: On both ends. I worked with artists, I worked with Vik Muniz on the skywriting project he did over the skies in New York in 2000.

Carey: *That was a beautiful project. I'll never forget that project.*

Stoffel: Yes, it was gorgeous. Of course that could never happen now, after 9/11, but we were busy on the phones trying to find a sky writer who would work for nothing and get that project financed and off the ground. It was so much fun. That's the best part of being able to contribute to the contemporary fabric is to help projects get realized like that.

Carey: *There were a number of things that changed pre- and post-9/11, like all the giant shows in the base of the Brooklyn Bridge, which was called the Anchorage, the shows were absolutely wonderful but I guess that's impossible now.*

Stoffel: Right, that's correct.

Carey: *So what happened after that?*

Stoffel: I went back to school. That was an important catalyst. I went back to Columbia and got my masters in arts administration. I figured that I have been doing that for so long that it was time to put the diploma behind it. So my mentor at Columbia, Joan Jeffri, who was the founder of the arts administration program there and put me under her wing and it professionalized all this intuitive knowledge and experience that I had and with that I was able to go to work and establish my professional credentials in New York. And that was a major moment as well.

Carey: *So let's talk a little bit about your professional credentials—before that you didn't have any degrees in arts administration or the arts?*

Stoffel: Not in arts administration. I have a couple of degrees in art history. I do have a huge art historical background but not in arts administration, which is different because you're working with funders, with granters, with foundations, government, sponsors, boards, budgets—very different than just having an art history background.

Carey: *Right, and since then what's been happening?*

Stoffel: In 2005, I started a contemporary photography collection for a law firm in New York. I was given a ground floor mandate for the six floors of their New York offices acquiring contemporary photography which was very rewarding. I loved every minute of it, it was a great acquisition committee of lawyers who understood the value of putting art in their conference rooms and in their hallways and in their public spaces.

And then 2008 hit, and I watched my 2009 budget disappear. The whole world changed when Lehman Brothers fell. I partnered with Dede Young to start a new business teaching contemporary art. I do collections management for collectors who would like to acquire emerging art.

Carey: *And maybe we can talk a little bit about how a collection is built.*

Stoffel: The art market has changed so dramatically. I think you probably know that just from reading the papers this week?

Carey: *Right, it hit the billion-dollar mark this week in just one art auction.*

Stoffel: Yes, the billion-dollar mark in only one auction house alone. Collecting contemporary art is a very long process and I've worked with clients for maybe even a year before they write their first check. And so there's a huge learning curve involved in understanding what artists are doing, why they're doing it and why contemporary art looks like it does today. And so it's very hands-on and I love working with people who don't know a lot about contemporary art, because I watch their eyes brighten up and they start to get it after a while—that it's just not garbage or junk or mishmash or "my kids could do that." The understanding is that there is a process and a talent. Something I call the mind, heart, hand continuum, where you need to see the hand of the artist, and the heart of the artist in the final product, and to understand what his mind is thinking while he's creating. And that takes time and dialogue and conversation and looking at a lot of art and going to galleries and museum shows and reading and following what's going on in the world. And, of course, working with artists as well. I go to studio visits, I start to figure out what they're doing, and it's very much a labor of love because I put into practice what I do for myself; therefore, I can speak to it in a way that appeals to people who are trying to start a collection.

Carey: *And so the artists that they're collecting, they're not just necessarily known artists, they're also emerging artists or unknown artists?*

Stoffel: They're all emerging artists. I worked with a lot of the galleries on the Lower East Side of Manhattan who were once the directors of the major Chelsea galleries now and who are

going out on their own and starting their own stables and they bring extraordinary institutional memory with them. I never show the same client the same work. I get to know how my clients live in their own residences. I do everything from delivery, installation, lighting, framing, insurance, tax planning, loans, everything.

Carey: *Wow, that sounds like you'd need another degree to learn all of that. That was part of what you've learned in arts administration?*

Stoffel: Yes. It's a fantastic program. It teaches you what everyone used to learn by the seat of their pants. Curators used to become museum directors and now museum directors need an MBA.

Carey: *I'd like to talk a little bit now about fundraising as well. I know you've worked with organizations to help with fundrais-*

ing. I'm not sure if you're doing that anymore—are you still helping with fundraising?

Stoffel: Yes, on a project basis. If I can buy into the project and it's well conceived and they've a realistic budget and they know how much it's going to cost, I'm happy to make a few phone calls and say, "I think this is where you could make a commitment."

But fundraising is—Anne Pastenak taught me that fundraising is about fit. It's about the project and about the funder, and you can only know that after having done it for a long time. So you have three sources of fundraising. You have corporate, you have government, and you have private. And so you need to have a good healthy mix of all three of them in order to successfully fund any projects.

She also taught me that it takes a dollar to raise a dollar. And so you need to have some kind of tools first before you go out to other sponsors and potential funders for grants and say, "Look I've got this. It's going to cost me this, I need you to underwrite a third." And sometimes they say, "I won't write a third. I'll write a tenth," but that's how you get projects funded on a case-by-case basis.

Carey: *Is it possible for artists to use this paradigm? I know places like Creative Capital and others are beginning to suggest to artists that they could run their studios almost like their own nonprofit and begin raising monies for their activity. Is that something you would encourage, or do you think it's possible, this idea of artists' fundraisers for their projects?*

Stoffel: I have never heard of that.

Carey: *Organizations, like the LMCC [Lower Manhattan Cul-tural Council] and some other new organizations, are offering artists fiscal sponsorships where they will act as the nonprofit to accept the funds on behalf of the artist. So if the artist raises money or gets a commitment from a corporation or an indi-vidual to donate money to that project, it will go first to, let's say, in a case of the LMCC, it'll go to them and then they take a small percentage and write a check to the artist. My wife and I are a collaborative, and when we raised some money we used Performance Space 122 as our fiscal sponsor. Artists are using other organizations as fiscal sponsors to essentially create their own fundraising platform.*

Stoffel: I have a question back at you then. Is that fiscal spon-sor responsible for the end product?

Carey: *No.*

Stoffel: Did they oversee the end product?

Carey: *No, I mean, they obviously want something to happen. Let's say in the case of me working with Performance Space 122, I'm responsible for communicating with that funder about the progress of the project and what ultimately happens with it. The funder is really using Performance Space 122 as a way to donate to a 501(c)(3) [a registered nonprofit] so they get the appropriate tax write-off.*

Stoffel: Correct.

Carey: *This is similar almost to Kickstarter, which is like the 501(c)(3). They're not responsible for the end product and of course there are sometimes problems with project completion.*

Stoffel: I did know that the LMCC takes sponsorship, that artists would be given studio space or . . .

Carey: *No. Now they're just doing fiscal sponsorship because essentially it's book work. It's their bookkeeper that is committing to accepting donations on the artists' behalf and creating a separate section in their book to keep track of this project—it could be anyone with a 501(c)(3), really.*

Stoffel: I'd like to know more about that, that's an interesting model.

Carey: *That's the idea. I think Creative Capital was encouraging fiscal sponsorship, because in a way this is what a lot of nonprofits know how to do, Creative Time as well.*

What they know very well are those wonderful things that Anne told you, even about raising money; if artists were able to use this level of expertise, it'd be really conversive. They're pros in how to do that. I haven't seen this happen a lot, and I think it's very difficult for artists to raise money. Right now the art world seems to be changing so much—or perhaps that's just the whole world is always changing so much.

Stoffel: Well, one of the projects I'm working on going forward, which has to remain nameless now, is finding exhibition space, living space and production space for visual artists and performance artists.

I think that's the most pressing need right now, and the fact is that every creative person in New York is being priced-out, real estate–wise. We've watched that in Brooklyn, we've watched that on the Lower East Side, and going to Hoboken and to Philadelphia is not the answer. So I'm working with a nonprofit to market empty storefronts, empty buildings, empty spaces on a temporary basis to artists in need so that they can have a studio or even an exhibition.

So it's working with the real estate industry to make them understand that social responsibility will come back to them in a big way by working with the creative community here in New York.

I think that's a viable alternative to building new studios and new buildings—to work with existing structures and to make them suitable for artists to use even on a temporary basis. So that's one of the projects that I'm working on now.

Carey: *You're working with galleries at the Lower East Side and I assume that's how you find artists and work with art- ists—what are you seeing happening in the art world now? Are you excited about what you see coming out? I've talked with so many different people, and some people say there's great work coming out, while other people complain of the lack of depth in work being produced too fast, that artists are thinking too much of the market. What's your perspective on the new art?*

Stoffel: I'm the eternal optimist. I mean, there's such a discon- nect between the art market, the art world, and the emerging art world, and artists are creating extraordinary work with very resourceful materials.

I don't agree that they're making work too fast for the market. I think smart dealers and good dealers and longterm dealers allow artists to work at their own pace. It gets a little stressful a couple of weeks before the opening of the show,

imagine
a giant
red heart
emoji for you
—

but I think that model still works. The pricing structure is still where it should be. You shouldn't have to mortgage your children to pay for a work of art. It's the last priority at the bottom of the totem pole in terms of life's necessities, and it is actually disposable income.

So I'm not discounting art as an asset class nor art investment funds, but it's not something that I'm interested in professionally or personally. I've been buying art for thirty years and the value of the collection has grown astronomically, but it's not why I do what I do. It's not about the value. It's about the support and the encouragement and the commitment of believing in these artists who are coming out of art school and have this incredible need to do what they do.

Afterword

Self-worth, delusion, and other aspects of how an artist presents himself or herself is essential to any artist's career. Enthusiasm is a big part of the puzzle to learn how to make contacts and influence people.

When I read biographies of artists + scientists, I find it inspiring. Try it!

The idea of "believing in yourself" has a different meaning for artists, because it is not initially about self-esteem or confidence; even with psychological issues aside, artists tend to have one thing in common. It is a belief in something they do, however small or large—and that is what makes an artist different from every other professional. For some it starts in childhood, but either way, the seed is always there. Then the belief has to be nurtured to some degree by a parent, a teacher, or a friend, and then you learn to nurture it yourself by making more art and exploring more ideas. So this process of "believing in yourself" to me means working in the studio or wherever you work, because the art is the center of it all. If you do too much "business" or "networking," you will lose studio time and a balance is necessary. The center is always the studio, as Betty Cuningham said.

The idea of the "artfully constructed personality" is not always as cold as it sounds. Andy Warhol might have been an example of a certain artsy self-consciousness about how he appeared and acted in public. Dalí and others were performers in that sense as well, but Warhol seemed to play up his ability to bore rather than entertain. Another example of an artfully constructed personality is Lady Gaga, the performer who once said that Stefani Germanotta (her real name) could never be as bold and do the things Lady Gaga does.

I mention these examples to say you can take "believing in yourself" to another level as well, and construct an artful approach to dress, manner of speech, and ambitions. It would be perfect for experimenting while networking and meeting people, but of course you already have your own style, and it's just a matter of doing it more and trying new approaches.

Motivation

There is no greater stumbling block for an artist than rejection. Even after a great solo show is mounted, if there are little or no sales, it can send an artist into a downward spiral. How can anyone withstand these slings and arrows? As Robert Storr alluded to in the first interview, it is about what you do with failure. We will all fail at a variety of attempts and projects, but how will you retool that failure so you can even use it to move forward? That is a personal technique not taught by schools or mentors, but by the passion that exists with you, within any given individual. It has also been said that art should be something that you must be compelled to do by an inner desire, a force you can't stop.

I think that is one way to battle failure and never give up, but there are other ways as well.

Another way is to approach failure as a learning tool. If you were a scientist, failure would not be considered a mis-

take or setback, but needed information to make something better. In art it is similar; we could choose to look at mistakes, setbacks, and rejections as tools to make a better presentation or a better series of works.

Another way to endure and retool failure might be to grin and bear it, so to speak. That is, to keep working, keep making art, even if you are feeling set back by failure or disappointment. Have faith that the sheer continuance of working will generate a breakthrough, and you will work with a lighter burden.

Another way to deal with failure is to give up. Leave your studio. Go somewhere that is at least three thousand miles away, or the furthest you can go. Stay there for three days to a week, and don't make art. Just think. Then come back and begin again.

There are many ways you could deal with setbacks and challenges, but an awareness that you are in a battle might

help, especially if you gather fellow friends, peers, who are all in this with you together.

John Currin talked about friends just getting together to help each other. You could call it a support group, but it comes in many forms, and could also be a salon, a revolution, or a reading group.

Finding a group of friends that is supportive is also, I believe, what might save our planet and our species! More and more articles are written about our relative isolation as a community in our jobs and homes as opposed to working together with friends all day and eating and dancing afterwards.

A community that eats, dances, and works together is a happy one. I hope that some of the suggestions in this book will bring you more relationships, more friends, maybe even more dancing, and more laughing.

After all, "It's who you know," as they say, so why not get busy having fun and meeting people?

It's why we are here on the planet, I believe—we are here to make more friends, to be generous and kind, to dance and sing.

Phrases like that may sound like the stuff of cliché, but as artists, we are the ones to actually make that happen, we are the ones to gather friends, to invite others to dance, and ultimately to invite others to experience a universal form—your form—of beauty, which of course, is art.

Index